ART DECO

The Golden Age of Graphic Art & Illustration

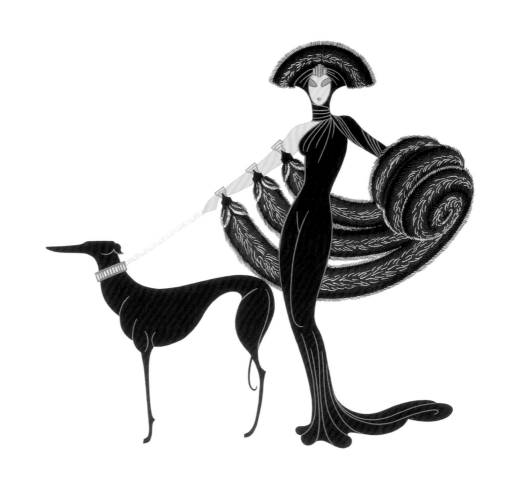

Publisher and Creative Director: Nick Wells
Project Editor and Picture Research: Sara Robson
Art Director and Layout Design: Mike Spender
Digital Design and Production: Chris Herbert

Special thanks to: Frances Bodiam, Chelsea Edwards, Cat Emslie, Victoria Lyle and Claire Walker

FLAME TREE PUBLISHING

Crabtree Hall, Crabtree Lane
Fulham, London SW6 6TY
United Kingdom

www.flametreepublishing.com

13 15 17 16 14

7 9 10 8

A CIP record for this book is available from the British Library.

ISBN: 978-1-84786-279-2

Every effort has been made to contact copyright holders. We apologize in advance for any omissions and would be pleased to insert the appropriate acknowledgement in subsequent editions of this publication.

Printed in China

ART DECO

The Golden Age of Graphic Art & Illustration

Michael Robinson & Rosalind Ormiston

FLAME TREE
PUBLISHING

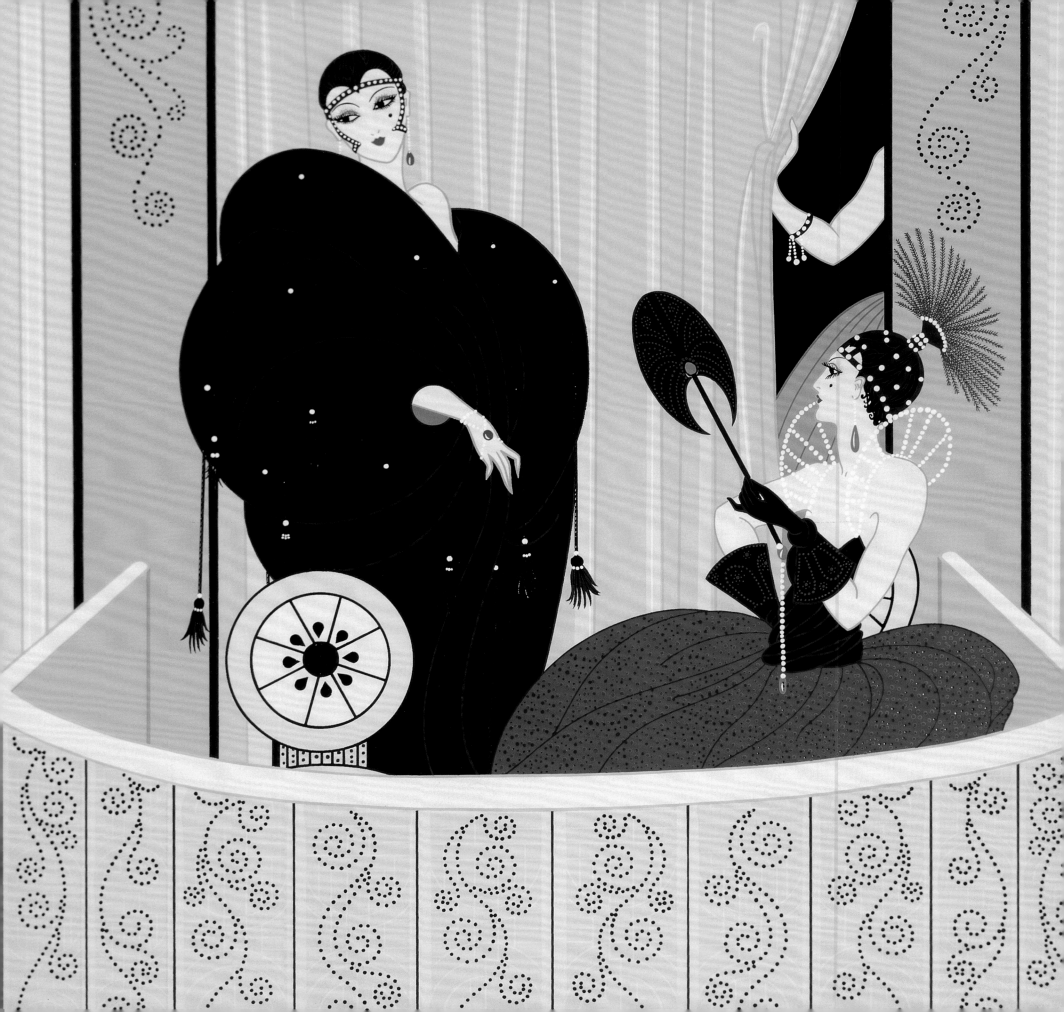

CONTENTS

INTRODUCTION

Few people who have any knowledge of or interest in fashion and the decorative arts, are unaware of the term 'Art Deco', used to denote a particular style that found its zenith in the interwar period. But how was it, and is it, defined? Each of us can probably point to a defining example of the style: architectural icons such as the Chrysler building in New York or the De la Warr pavilion in Britain; the so-called 'flapper' dresses and cloche hats popular in America and Europe; and the posters of Cassandre that romanticized and popularized travel on both sides of the Atlantic.

'Art Deco' is a retrospective term first coined in the 1960s to denote the prevalent styles in architecture, the decorative arts, graphics and fashion of the interwar years. It was not a singular style, but the culmination of a number of design ideas that came together in about 1909 and were developed during the next 30 years. A key feature of its early development was the arrival in Paris of the Ballets Russes in 1909 with its exotic costumes. During the latter period of development, the style was known as *moderne* and was not just concerned with design aesthetics but the impact of modernism and the rise in middle-class consumerism that this facilitated. An example was the travel industry and the effect of new technologies used in ocean-liner design and construction. The increased demand for overseas travel in the pre-jet age occasioned the building of larger, faster and more elegant ships, creating a need for opulently designed interiors decorated in the latest (Art Deco) style. The graphics created to advertise these vessels, and ocean travel generally, were also echoed in other design areas, such as fashion. In turn fashion magazines often displayed their models in Art Deco settings, where the furniture and home interiors followed the style, informing those who wished to stay abreast of the latest trends. Most importantly, poster and magazine advertising followed suit, using rich sensuous blocks of colour and strong line in the enticing illustrations. Even at the time, there was recognition that this was the 'golden age' of graphic art and illustration.

In many ways the whole notion of a complete design ethos was born, not just for the elite as in previous generations but for most of the middle classes. Indeed as the epoch drew to its close at the outbreak of the Second World War, most people had access to Art Deco design whether it was in ready-to-wear fashion, rail travel or cinema design. What began as an elite style in 1909 became considerably more egalitarian 30 years on. The pivotal moment for the style was the *Exposition Internationale des Arts Décoratifs et Industriels Modernes* held in Paris in 1925. In the postwar era France needed to show that she was still the arbiter of good taste, and was forging a new international style as she had done at the *Exposition Universelle* held in 1900, when the Art Nouveau style prevailed. For the 1925 *Exposition*, however, the content was altogether more exotic, influenced by a combination of France's colonial interests, the modern pan-European movements in art and design, and a general interest in such

ART DECO

The Golden Age of Graphic Art & Illustration

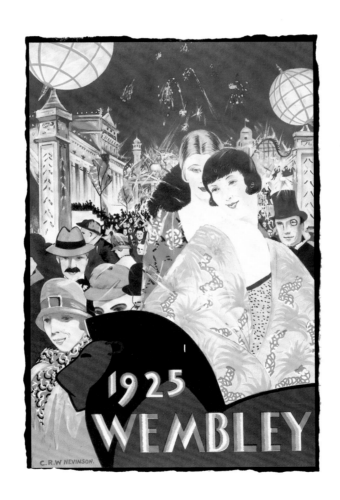

Michael Robinson & Rosalind Ormiston

FLAME TREE
PUBLISHING

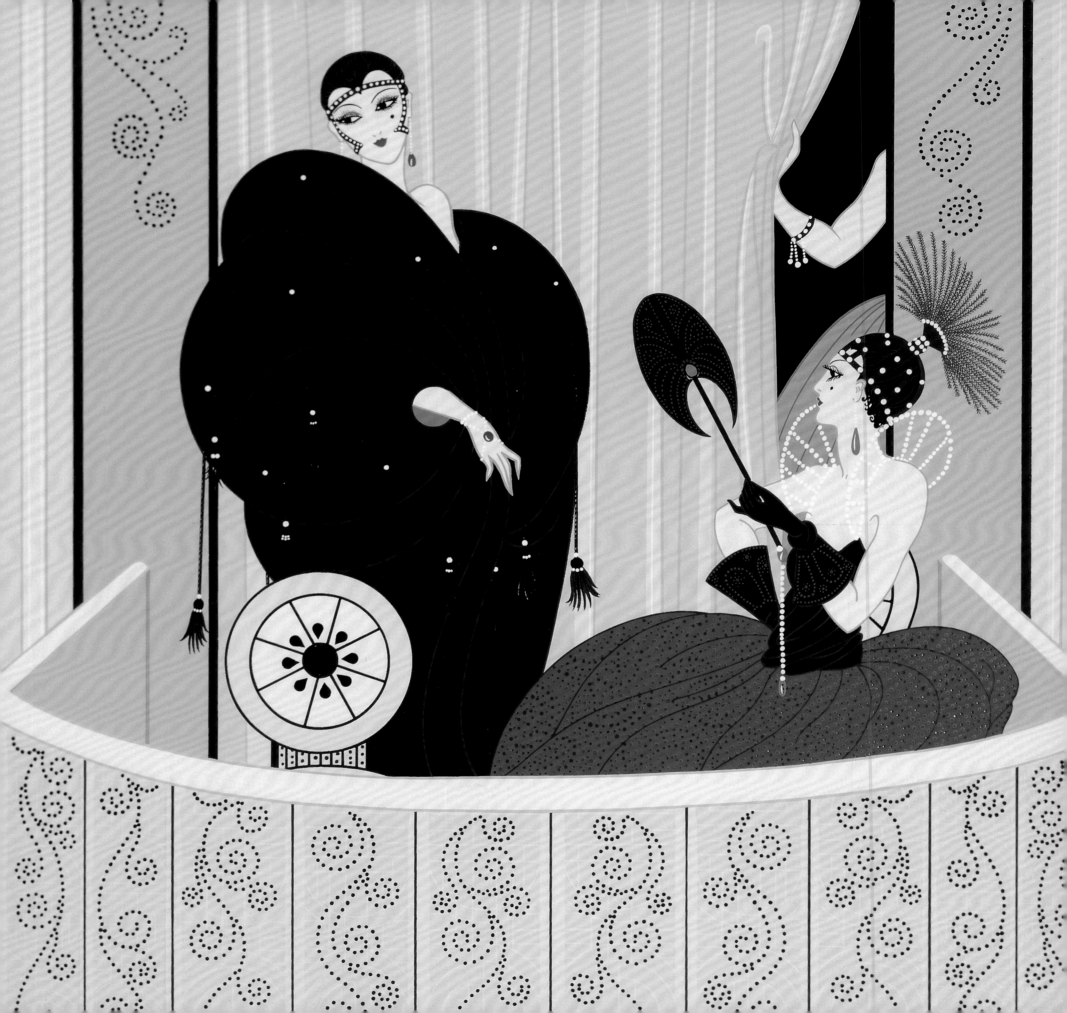

subjects as Egyptology. Parisians and visitors from around the world were able to see an exhibition that promoted all that was current in design at the time: in fashion, jewellery, fine art, architecture, interiors, the decorative arts and graphics. Although luxurious handcrafted goods were the main feature, the presence of four Parisian department stores with an emphasis on *bon marché* suggested a future trend towards well-designed mass consumer goods in fashion and the decorative arts. At the same exhibition, and by way of contrast to the prevalence of the high-end decorative style, was the Pavilion de L'Esprit Nouveau designed and built by Le Corbusier, demonstrating the anti-historicist movement in *moderne* architecture and interior design. Unlike other pavilions it was austere, a reflection of Le Corbusier's Purism and his notion that a house was 'a machine for living'. After 1925, Art Deco was to adopt a number of modernist tenets: a paring down of ornament, more simplified geometric forms and the use of less expensive materials in manufacturing. This latter concept enabled more people to enjoy good design without compromising good design principles. These were based on a combination of arts and crafts ideals and considerations of industrial design. Even if the goods were mass-produced people wanted the items to express luxury as well as functionality.

The arrival in 1925 of the American dancer Josephine Baker and her *Revue Nègre* in Paris also had a profound effect on Parisian life and changed the mood of the time. In many ways this event paralleled a long-held Parisian fascination with exoticism. Since the late nineteenth century, Paris had been the centre for cabaret entertainment such as that found at the Moulin Rouge and the Folies-Bergère, made famous as much by the brightly-coloured posters of artists such as Henri de Toulouse-Lautrec as by the performances themselves. Baker's arrival introduced Paris to a new black Jazz culture, spawning a new generation of poster art that captured the new mood.

Although making reference to architecture and the decorative arts, this book concerns itself with fine art and graphics since it was those two disciplines that not only seemed to encapsulate the Art Deco style but were also the medium for promoting its aesthetic. There is no finer expression of the language of Art Deco in fine art than the paintings of Tamara de Lempicka. Her pictures expressed many of the design qualities of the era,

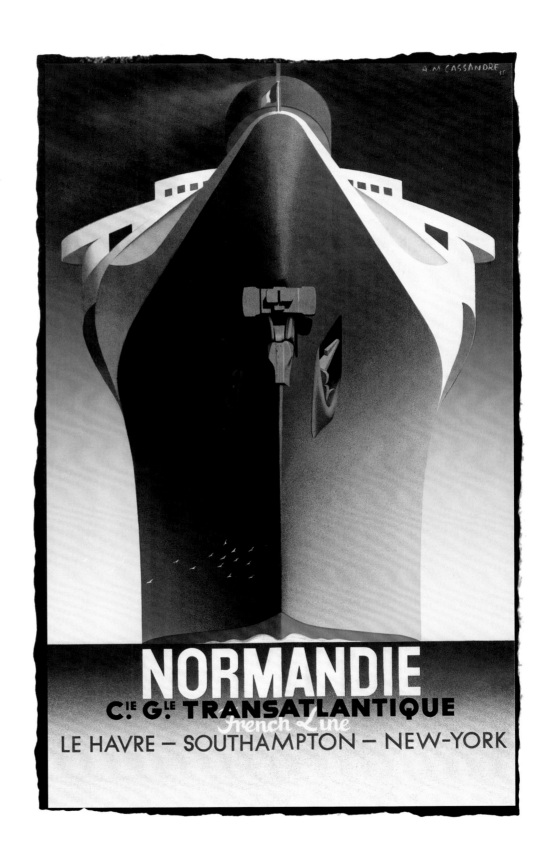

such as striking hard lines and bold colour, but the artist herself was also symbolic of the emancipated and modern woman of her time, her privileged class facilitating a hedonistic lifestyle. Graphic arts reached new heights in the immediate postwar period and into the 1920s, which was a reflection of a new optimism in Europe. With France needing to retain its position as the fashion centre of the world, new modes of illustration were employed to promulgate this notion. Fashion illustration's pinnacle was achieved at the *Gazette du Bon Ton* magazine with its series of *pochoir* prints executed by Georges Barbier and Georges Lepape to illustrate the *haute-couture* designs of Paul Poiret. Their equal was Erté, whose delicate and fantastical illustrations for stage costumes and sets did much to promote the Art Deco 'look' in fashion.

Immediately after the First World War, a new artisan had emerged in Europe – the graphic artist. His roots can be traced back to the end of the previous century, when commercial artists were beginning to be recognized as fine artists – Alphonse Mucha's

colour lithographic theatre posters of Sarah Bernhardt are seen as early exemplars. The fine art poster was born. Its early incarnations were in fashion and stage-show promotions but by the 1920s it had developed as a specific marketing tool for promoting new lifestyles, such as home and overseas travel. Fashion-conscious retailers of clothing, accessories, homewares and decorative objects also exploited the potential of the poster for greater consumer awareness. New typefaces were developed – especially those that appeared *moderne*, such as various modes of sans serif. Following the lead of the Bauhaus school in Germany, other art-and-design institutions were set up across Europe encouraging experimentation in graphic design and typography. Graphic designers themselves produced manuals and books on the subject, for example Edward McKnight Kauffer, whose book *The Art of the Poster* was published in 1924. After the 1925 *Expo* a group of artists founded the *Union des Artistes Modernes*, to promote craftsmanship within mass production, which had a direct influence on high-quality poster design. What practitioners, educationalists and marketers recognized was the potential of this new discipline as a mass-communication, advertising medium for a modern urban population. The fine art poster had come of age.

This book begins with an overview of the Art Deco movement, exploring most of the ideas and influences that contributed to the emerging style. It examines many early pioneers and considers the contributions they made, together with their influences, both European and non-European, artistic and cultural. The chapter also considers the diversity of disciplines to which Art Deco aesthetics have been applied – architecture, decorative arts, fashion and advertising – and shows how widespread the practice of the style was geographically, in Europe and in America. The following two chapters examine many of the main graphic arts protagonists of the Art Deco style, under the broad headings of fashion and advertising.

The focus of this book is on the graphic and fine arts of the Art Deco epoch, when anything and everything seemed possible. It is hardly surprising then that the style was revived briefly in the 1960s and continues to be of interest in our post-modern era.

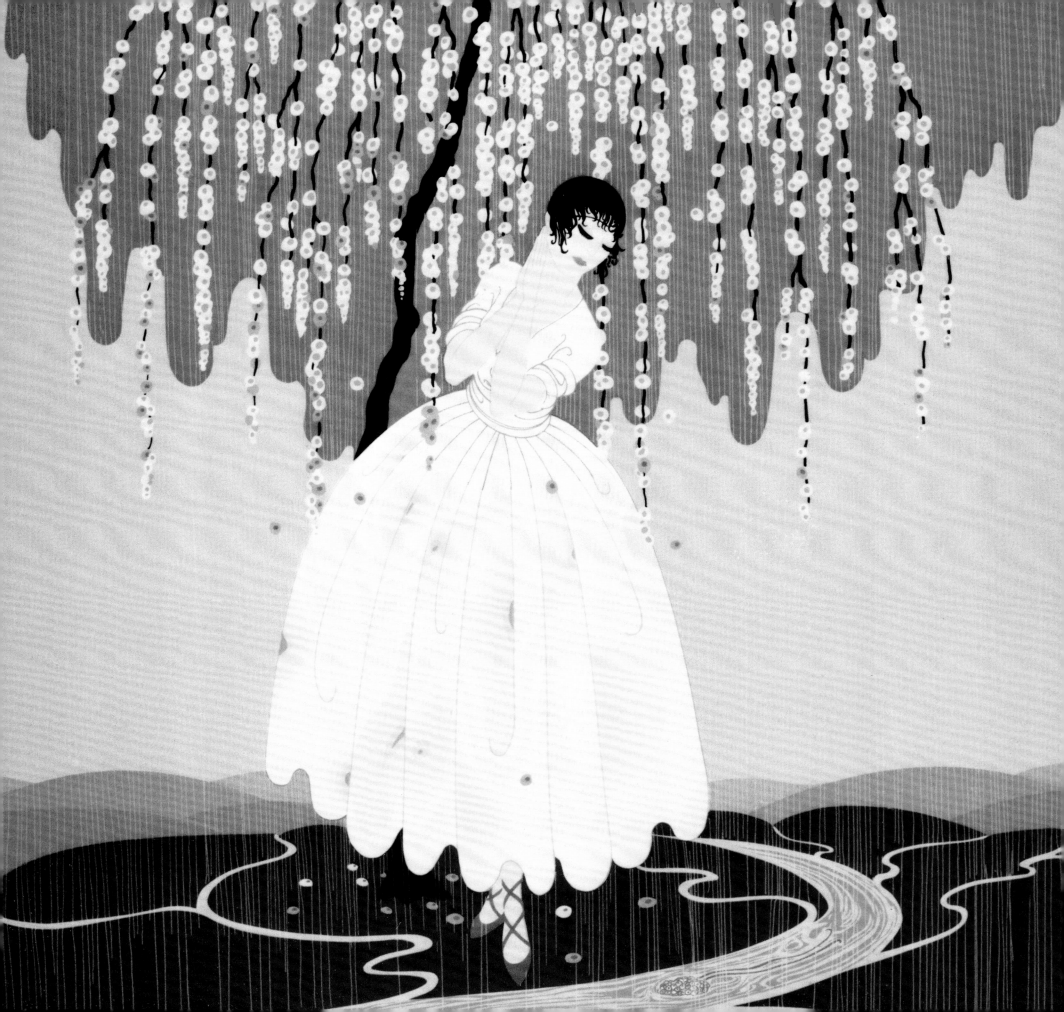

SECTION ONE:

THE MOVEMENT

The term 'Art Deco' was coined by the English art historian Bevis Hillier (b. 1940) in 1968, in reference to a fashionable and contemporary revival of interest in *Art Décoratif*, a movement that cultivated a style of luxury and opulence in the twentieth century, from 1909–39. The visual culture of the original Art Deco is defined through a variety of mediums: graphic design, fashion, jewellery, interior design, fine art, sculpture, textiles and architecture. In 1925 it reached a peak at the exhibition *L'Exposition Internationale des Arts Décoratifs et Industriels Modernes*, in Paris, and continued to influence architecture and design, particularly in the United States, until the onset of the Second World War. The 1960s revival was short-lived and the term is now once again associated with the original, brilliantly vibrant style, which spread from northern Europe to America in the early twentieth century.

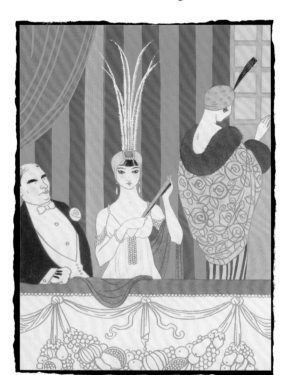

Beginnings of Art Deco

The roots of Art Deco lie in the late-nineteenth-century movement of Art Nouveau, so named after a Parisian shop called 'La Maison de l'Art Nouveau', which was opened *c.* 1875 by Siegfried ('Samuel') Bing (1838–1905), selling art and decorative wares from Japan. Consumer passion for Orientalism and Symbolism combined to create this style (known too as *Jugendstil* and the

'whiplash' style) and it quickly spread through all forms of European design: fine art, graphics, illustration, sculpture and architecture. A high point was Bing's 'Salon of Art Nouveau', held on his premises in 1895. Art Nouveau gripped and held the attention of Europe and America until the first decade of the twentieth century. As a decadent, stylized art, avant-garde groups of artists and designers eventually reacted against it and Art Nouveau faded *c.* 1905–10.

New Technology Inspires Creative Graphic Design

The beginnings of the graphic art of Art Deco lie in the inspirational works of commercial artists such as the Czech artist Alphonse Mucha (1860–1939), who revolutionized poster art in Paris in 1895, and the French artists Jules Chéret (1836–1932) and Henri de Toulouse-Lautrec (1864–1901). Their sensational poster depictions of cabaret at the Moulin Rouge in Paris influenced a generation of illustrators. However, their output was dependent on the advances in technology made by the print foundries. The new, much brighter multi-layered prints created an enthusiasm for graphic illustration. What had started in print foundries in the 1890s then flourished in the first decade of the twentieth century. Pivotal to the rise in popularity of graphic design and the huge increase in the amount of artists training as graphic illustrators, is the creation of many new techniques in the print industry. Advances in mechanized printing – and the creation of new typefaces – caused a demand for more forms of colour print advertising through posters, flyers, brochures and magazines. Advances in colour printing created a market to sell more through the advertising industry thus creating more work for printers and artists.

Georges Barbier
La Loge, c. 1914, from *Modes et Manières d'Aujourd'hui*
© V&A Images, Victoria and Albert Museum

MEDIUM: Pochoir print

RELATED WORKS: A.E. Marty, *Evening Cape Coat,* 1922; Edward Steichen (1879–1973), *Art et Décoration,* 1911

SAD and UAM

In the first decade of the new century a change in the graphic-arts industry was clearly visible. In 1902, in France, the *Société des Artistes Décorateurs* (SAD) was formed to organize annual

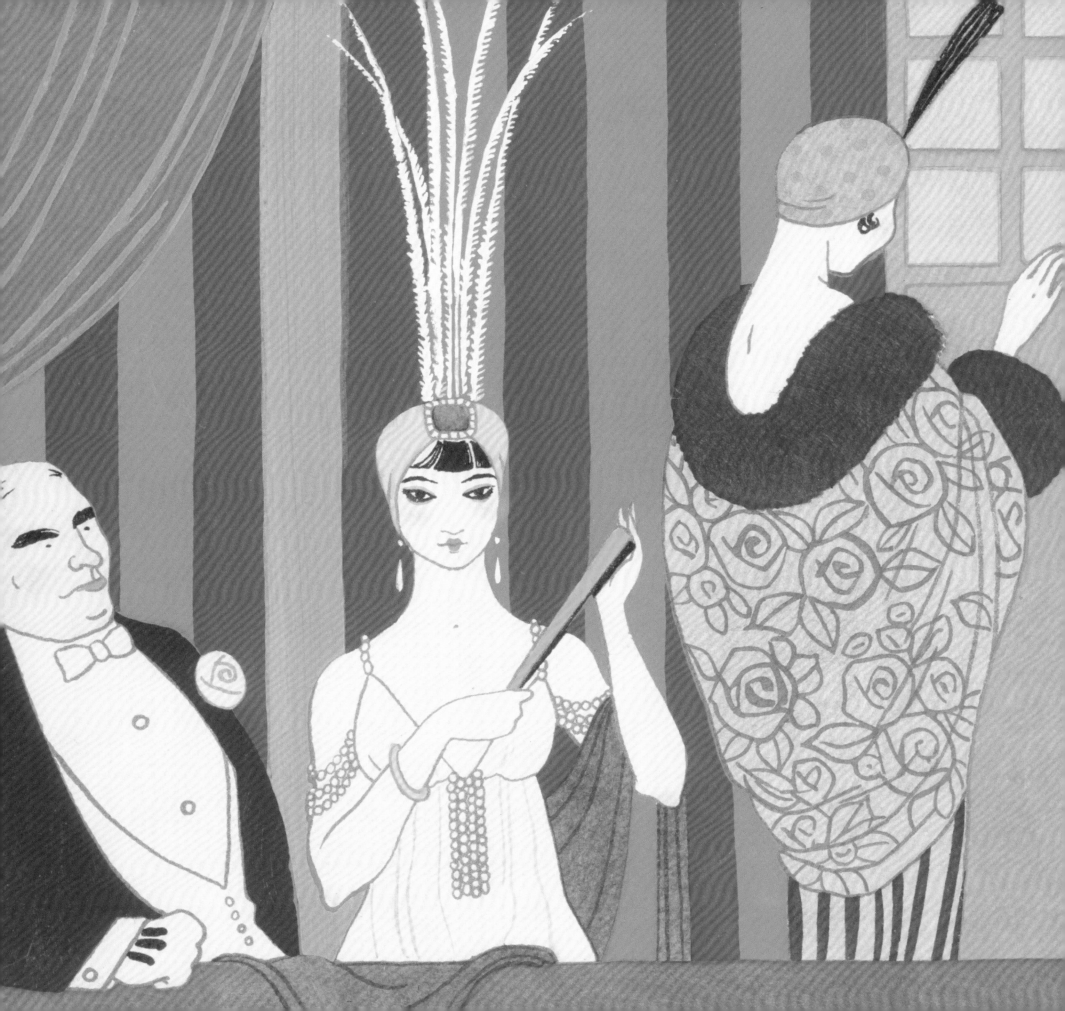

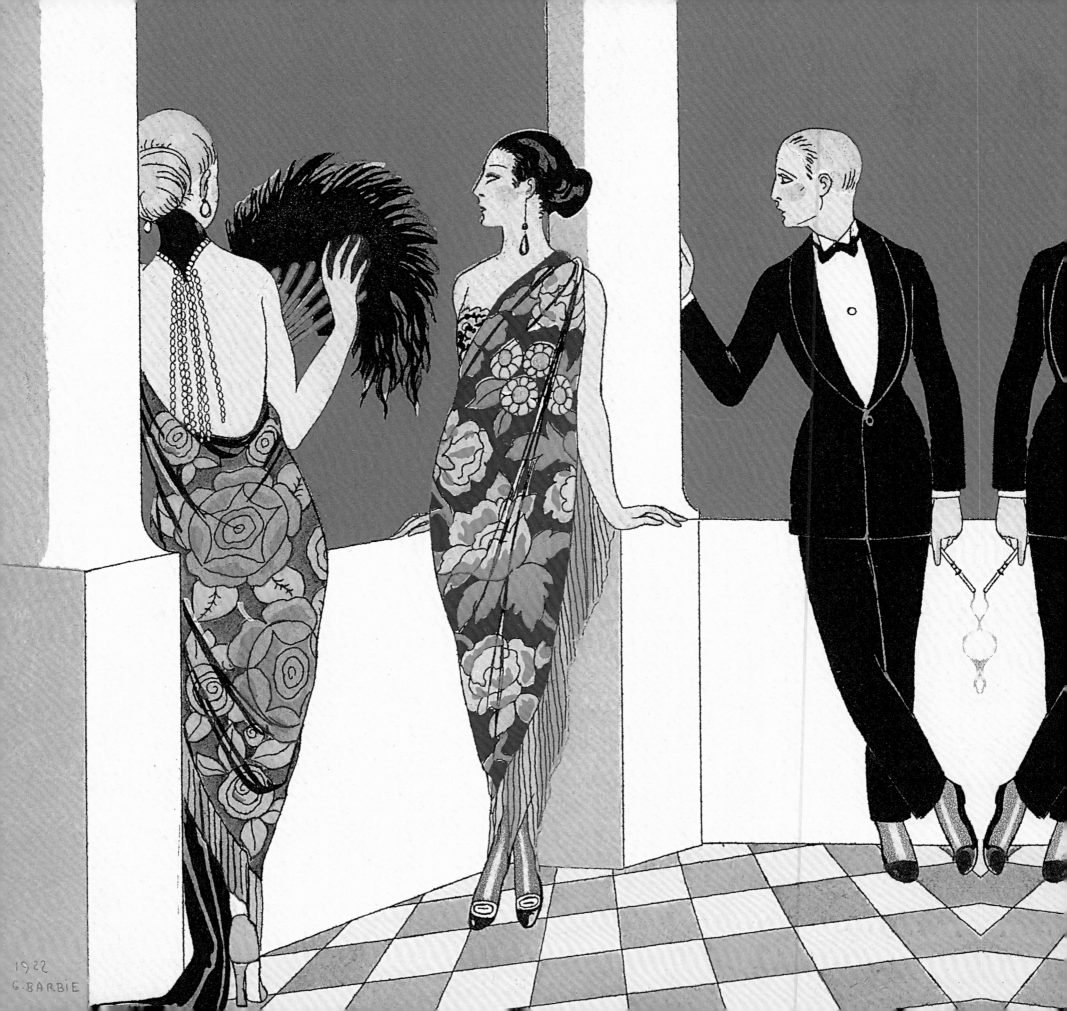

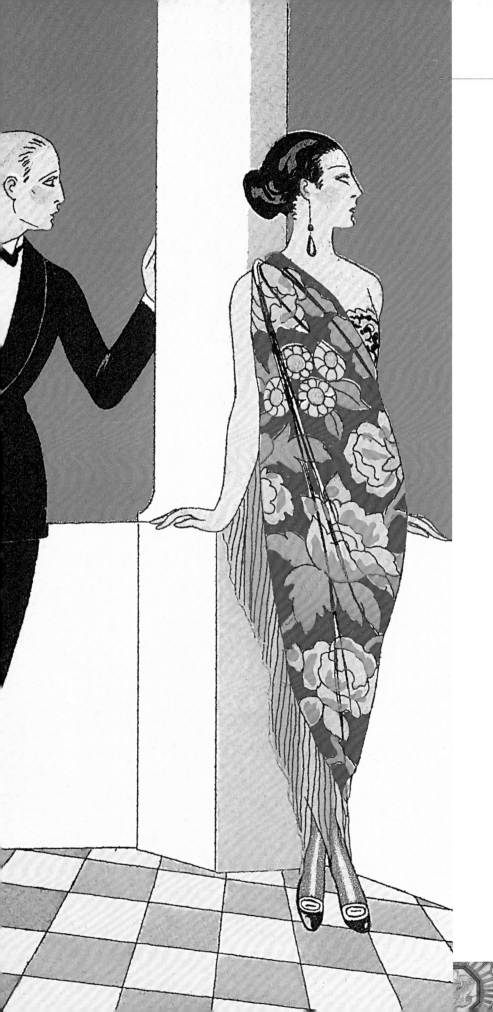

exhibitions and to publicize the new work of illustrators,
graphic artists, bookbinders and lithographers, with an
emphasis on the importance of handcrafted work. It is in
the formation of SAD that one can see the beginnings of Art
Deco and the rise of graphic art and illustration, which would
culminate in the 1925 exhibition of decorative art in Paris.
Following this exhibition a group of artists formed the *Union
des Artistes Modernes* (UAM) in 1927, to create unity amongst
artists and promote craftsmanship and technology, aimed at
mass production, whether poster advertising or new housing.

The emergence of Art Deco corresponded with an
international use of new typefaces and the introduction of
Monotype and Linotype, which accelerated the printing process.
Print foundries played their part in the promotion of graphic
design; one notable company, Deberny and Peignot, commissioned
typefaces for advertising. Charles Peignot (1897–1983), the
owner-director of the company, and Maximilian Fox (1894–1974),
an artist, draughtsman and typographer, publicized their ideas in
two publications aimed at the graphic arts and print industry: *Arts
et Métiers Graphiques* (1927–39) and *Les Divertissements
Typographiques* (1928–33).

Influences: Fauvists, Cubists and Futurists

From 1905 to 1910 the French artists Georges Braque
(1882–1963), Henri Matisse (1869–1954), André Derain
(1880–1954), Raoul Dufy (1877–1953) and others in their group
of friends produced exciting and vibrantly colourful works of art.
They were collectively known as *Les Fauves*, the 'Wild Beasts',
the nickname given by a critic to describe the raw style of their
colour-obsessed paintings. The concept would be woven into

the threads of the graphic art of Art Deco. The death in 1906 of the French Impressionist painter Paul Cézanne (1839–1906) had marked a seminal moment for many new art forms. In Paris, Braque and the Spanish artist Pablo Picasso (1881–1973) brought the sculptural quality and painterly three-dimensional

technique of Cubism to public attention. It too had an effect on the new wave of Art Deco. In Milan, the Italian poet Filippo Tommaso Marinetti (1876–1944) spoke for a group artists, architects and sculptors known collectively as The Futurists. He announced their *Manifesto of Futurism*; a denunciation of the past and embracement of the new, envisaged through war, speed and the machine. Notably the manifesto was graphically printed on the front page of the French newspaper *Le Figaro* on 20 February 1909. The Futurists' vision played a part in creating a clamour for the edgy, streamlined Deco style.

Influences:
William Morris and Co.

Modern-day interest in graphics and typography arguably stems from the European 'Arts and Crafts' movement, its most well-known proponent – the English-born poet, writer and designer William Morris (1834–96) – and his friends, particularly Edward Burne-Jones (1833–1898), an artist and designer, and the architect Philip Webb (1831–1915). All three were strongly convinced that the Gothic Revival architect and designer A.W.N. Pugin (1812–52) and the historian John Ruskin (1819–1900), who both argued against industrialization and for vernacular crafts, were correct in their belief of the need to return to the recognizable values of handcrafted workmanship. This included typography and illustration and Morris opened his own publishing house, Kelmscott Press, to print his books. He created new typefaces, borders and illustrations.

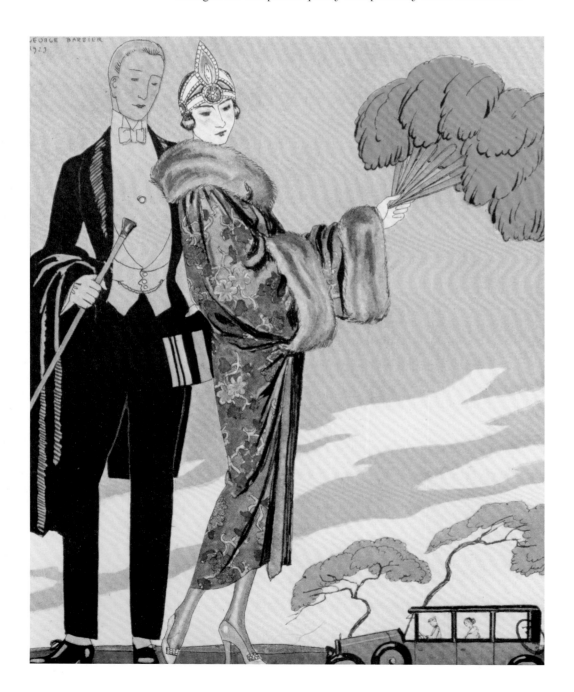

Georges Barbier
Leaving for the Casino, 1923,
from *Gazette du Bon Ton*
© Private Collection, Archives Charmet/
The Bridgeman Art Library

MEDIUM: Pochoir print

RELATED WORKS: Georges Barbier,
A Taste for Shawls, 1922

Georges Barbier
Worth Evening Dress (detail), 1925,
from *Gazette du Bon Ton*
© Bibliothèque des Arts Décoratifs, Paris, France,
Archives Charmet/The Bridgeman Art Library

MEDIUM: Pochoir print

RELATED WORKS: A.E. Marty,
La Soubrette Annamite, 1920

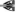

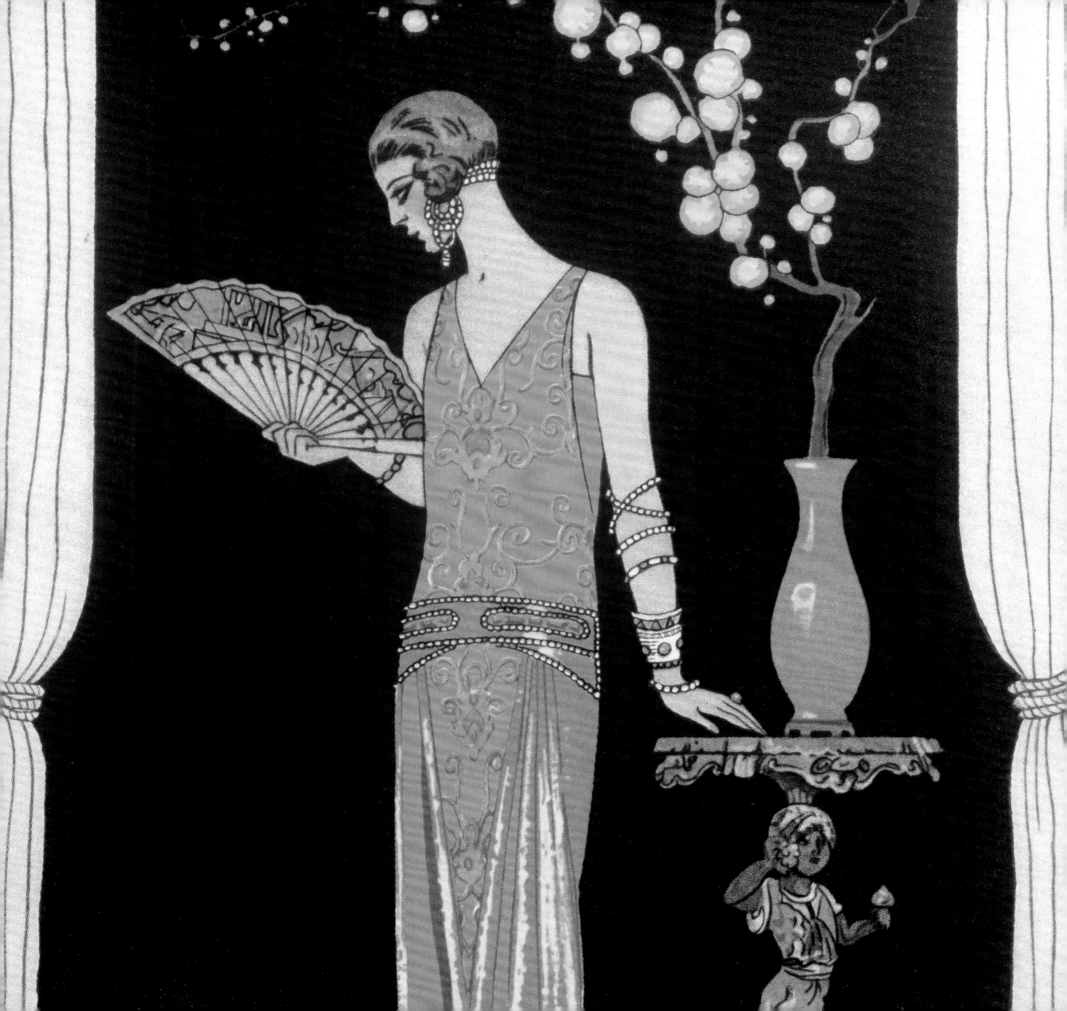

MARTY

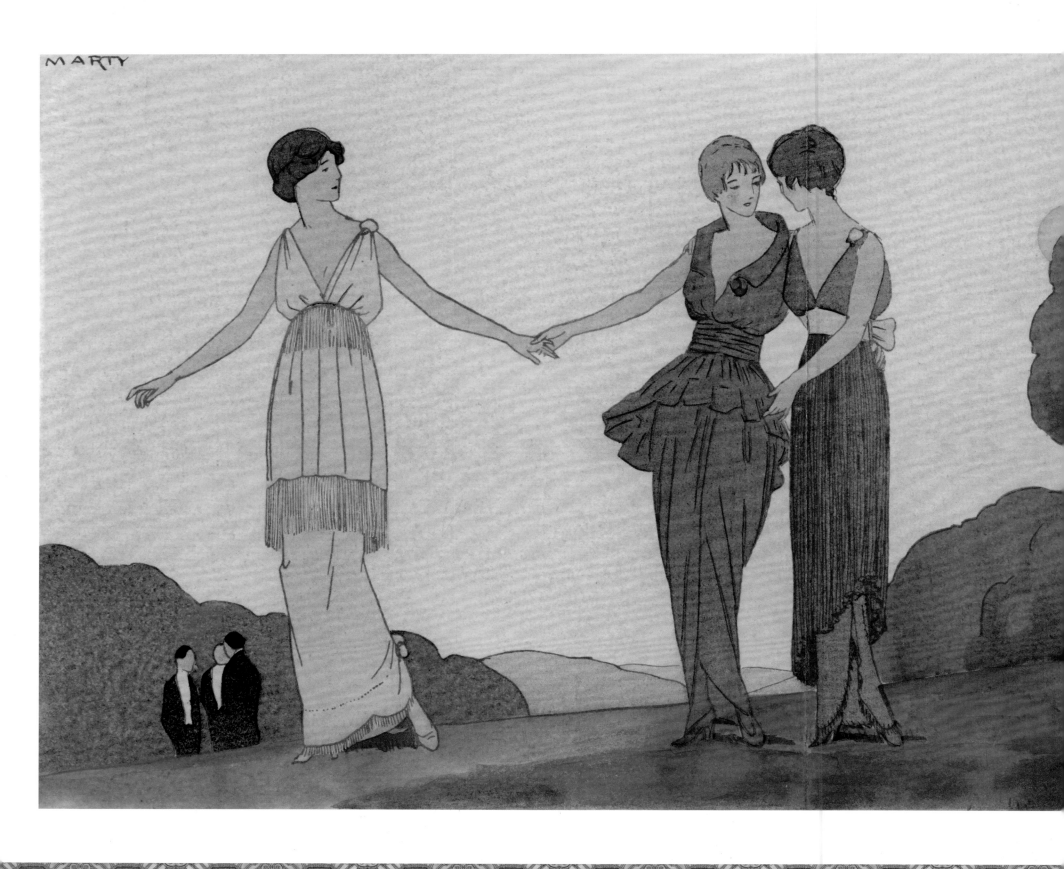

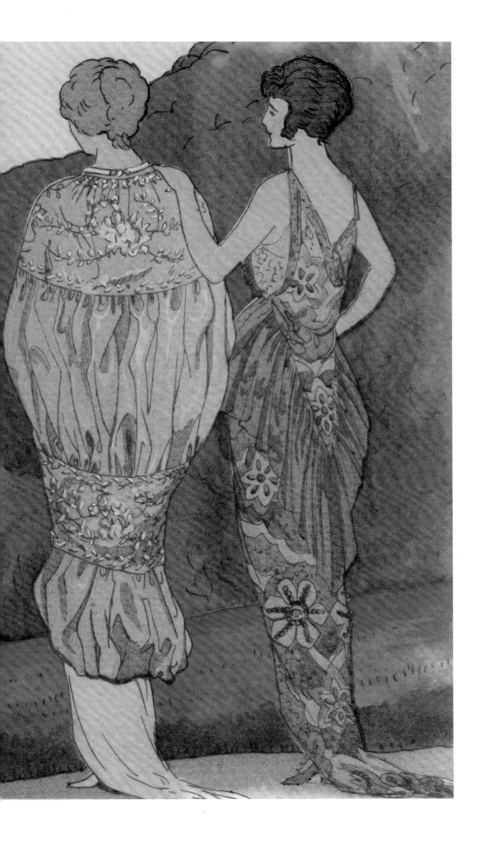

Aspects of the design ideals of William Morris and the Arts and Crafts movement were to be carried forward into Art Deco via the initial interest of a German diplomat, Hermann Muthesius (1861–1927).

Influences:
Das Englische Haus

From 1896 to 1903 Muthesius worked as an 'attaché for architecture' at the German Embassy in London, studying British vernacular architecture and design. In 1898 he published an article in *Dekorative Kunst* magazine, on the English furniture, furnishings and jewellery designer Charles Robert Ashbee (1863–1942) and his Guild and School of Handicrafts. Muthesius published the results of his design research in a three-volume work *Das Englische Haus* (*The English House*, 1904–05), which included the Arts and Crafts work of English designer and architect Charles Francis Annesley Voysey (1857–1941). The aesthetic of Arts and Crafts idealists from William Morris to Charles Robert Ashbee and the designs of Muthesius's friend, the Scottish architect Charles Rennie Mackintosh (1868–1928), were revealed to a wider audience of artists, craftsmen and architects in northern Europe. Both Ashbee and Mackintosh were instrumental in the move towards graphic design and typography. Both designed new typefaces, which were integrated into their designs. The building blocks of the early artist-decorators culminated in the luxury aesthetic of Art Deco style, promoted by designers of handmade, crafted goods. However, the Arts and Crafts socialist ideals were not carried forward by manufacturers of quality objects, particularly cabinet makers such as Emile-Jacques Ruhlmann (1879–1933).

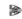

André Edouard Marty
Evening Dresses by Doeuillet,
1914, from *Gazette du Bon Ton*
© Estate of André Edouard Marty/
Mary Evans Picture Library

MEDIUM: Pochoir print

RELATED WORKS: A.E. Marty,
Paquin Evening Robe, 1913

André Edouard Marty
Paquin Evening Robe, 1913,
from *Gazette du Bon Ton*

© Estate of André Edouard Marty/
Mary Evans Picture Library

MEDIUM: Pochoir print

RELATED WORKS: E.M.A. Steinmetz
(dates unknown), Cover of *Vogue*, December
1913; Erté, *New Bridges for the Seven Seas*, 1919
(Cover of *Harper's Bazaar*, March 1919)

Decorative Art and Graphic Design: a Dichotomy

In England the Arts and Crafts movement officially formed in
1888. Made up of various guilds and societies, it combined their
aims: to promote the work of the honest craftsman, to recognize
the importance of regional vernacular architecture and good
design, to reject the onslaught of cheaply produced machine-
made goods, to source natural woods to make furniture and
to use hand-operated looms to create textiles. A respect for
collective joy in labour and skilled workmanship was the aim of
the many guilds that were part of the movement. However, whilst
sound in theory, these aims were near-impossible in practice due
to the expense of handcrafted labour and the cost of materials.
The man-hours spent by one craftsman to create a table or chair
or chest of drawers could hardly be recovered in the cost of the
item. The socialist ideal, inspired by a desire to recreate the
working craft shops of the 1200s failed to take into account
that only the very rich could afford to pay for the standard of
workmanship they aspired to. In this respect the Arts and Crafts
movement, by training specialist craftsmen and women, lost sight
of the modern world where, in the right hands, the machine could
produce acceptable, fit-for-purpose goods. This was particularly
true of the print industry where use of graphic design was to
flourish. A dichotomy materialized during the 1925 Paris
exhibition, whereby the luxury goods items were produced only
for an elite clientele, and everyone else had to rely on industry
and the machine tool of mass-production to supply the demand
created for the popular Art Deco style. The answer for the
French department stores was to create their own design shops,
and employ designers and architects who could achieve the Art
Deco look in goods that were inexpensive to produce and sell.

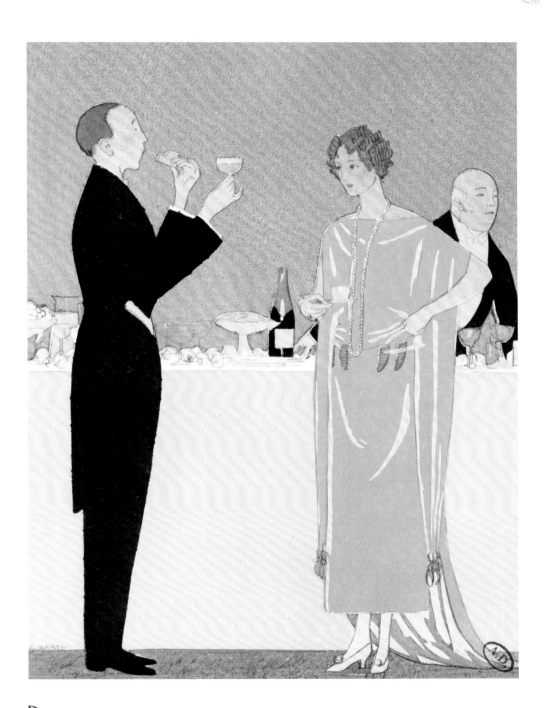

André Edouard Marty
Que Pensez-Vous des Six?, 1921,
from *Gazette du Bon Ton*

© Estate of André Edouard Marty/Bibliothèque
des Arts Décoratifs, Paris, France, Archives
Charmet/The Bridgeman Art Library

MEDIUM: Pochoir print

RELATED WORKS: Georges Goursat,
aka SEM (1863–1934), *Un Bar Chez le
Couturier à la Mode*, 1929, from *L'Illustration*

André Edouard Marty
La Belle Affligée, 1922,
from *Gazette du Bon Ton*

© Estate of André Edouard Marty/Bibliothèque
des Arts Décoratifs, Paris, France, Archives
Charmet/The Bridgeman Art Library

MEDIUM: Pochoir print

RELATED WORKS: Gustave Klimt
(1862–1918), *Portrait of Rose van Rosthorn
Friedmann*, 1900–01

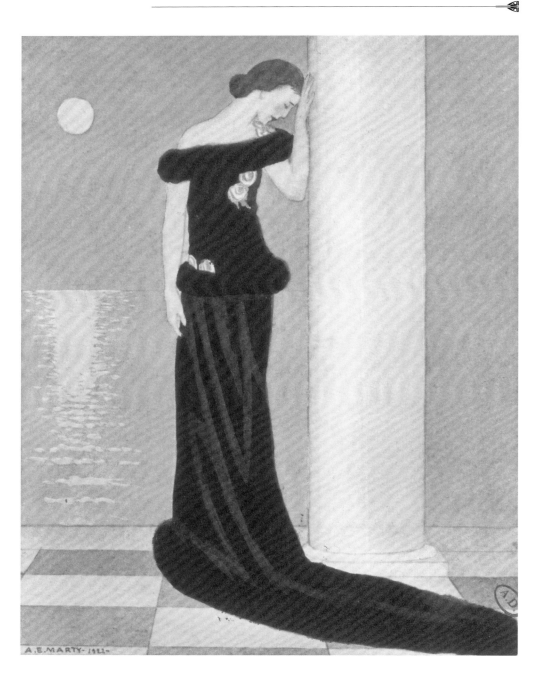

A.E.MARTY-1922-

New Design Schools and Guilds in Europe

On Muthesius' return to Germany he actively promoted
reform in German design schools and in industry. His key role
in introducing an Arts and Crafts aesthetic to industry was
confirmed in his appointment in 1904 as privy councillor to the
Prussian Board of Trade and superintendent of schools of applied
arts. In 1907 he instigated the foundation of the Deutscher
Werkbund, in similar format to the English Arts and Crafts
guilds with the exception of the Werkbund's embracement of the
machine aesthetic. Amongst the Werkbund's notable designers
were the German graphic designer Peter Behrens (1868–1940)
and the Austrian designer Josef Maria Olbrich (1867–1908).
In graphic design Behrens is noted for his creation of new
typefaces, commissioned by the German print foundries and
intrinsic to the development the Werkbund's aesthetic. In Austria
the Wiener Sezession (Vienna Secession) – independently set up
in 1897 by a group of artists and designers, including Olbrich,
Gustave Klimt (1862–1918), Josef Hoffmann (1870–1956) and
Koloman Moser (1868–1918) – turned away from Art Nouveau
and embraced the work of C.R. Ashbee and C.R. Mackintosh.
Ashbee's and Mackintosh's pioneering work in graphic design
informed the style of the Secession artists. In 1903 the Wiener
Werkstätte, the Secession's commercial venture, was established,
based on Ashbee's School of Handicrafts. It was the formation
of craft schools in Germany and Austria that encouraged France
to form Arts societies for *artistes-décorateurs*, to compete with
their European counterparts.

André Edouard Marty
*La Glace ou Un Coup d'Oeil en
Passant (Poiret Evening Coat)*,
1922, from *Gazette du Bon Ton*

© Estate of André Edouard Marty/
Mary Evans Picture Library

MEDIUM: Pochoir print

RELATED WORKS: Salvador Dalí
(1904–89), *I Dream About an Evening Dress*,
1937, from American *Vogue*

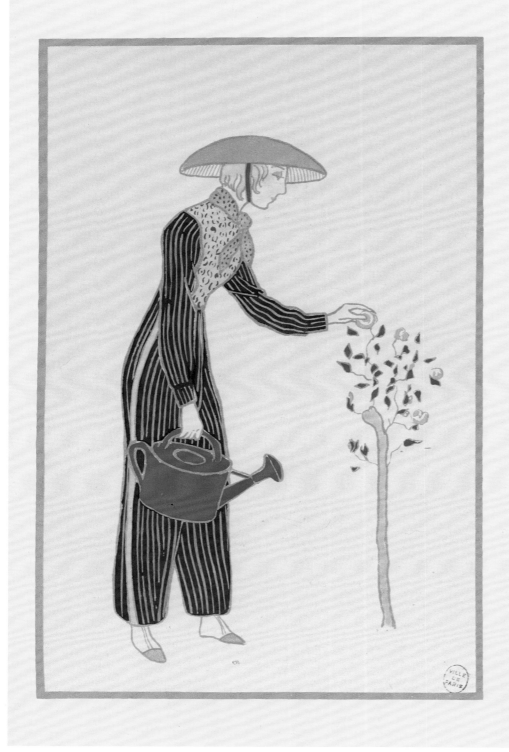

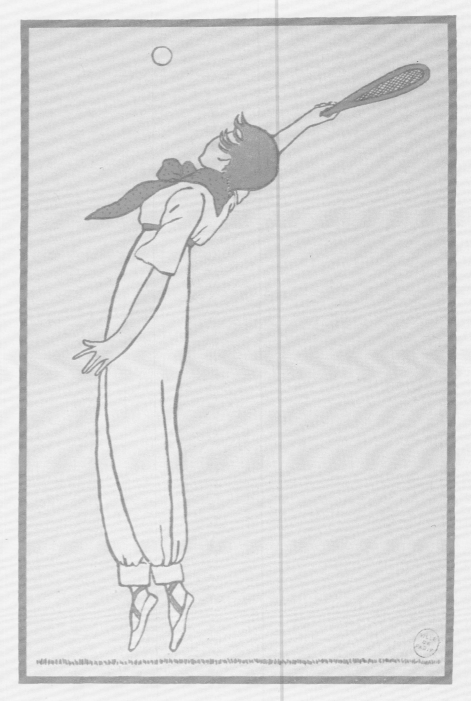

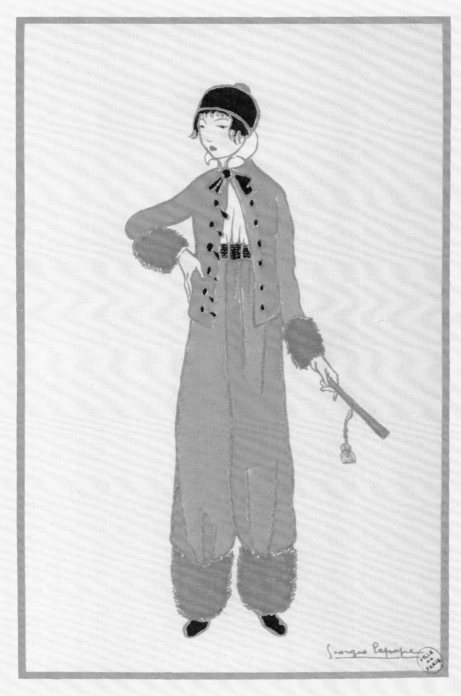

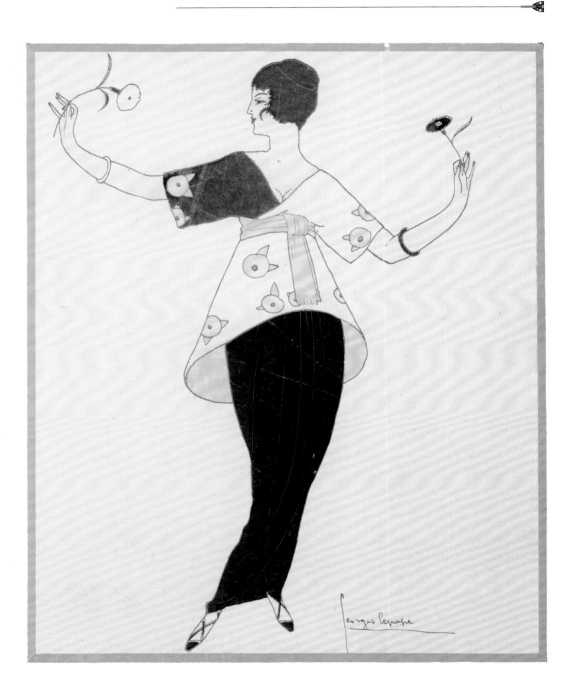

World of Art in St Petersburg

In 1908 in St Petersburg, Russia a group of aesthetes formed the 'World of Art' collective. Their joint goal, that there should be no delineation between various art forms, such as fine art and design, led them to create works that informed the Art Deco style. The group produced a *World of Art* journal to promote new Russian art and design to a wider audience whilst embracing Russia's cultural past. Founder members included the theatrical impresario Sergei Diaghilev (1872–1929), the highly gifted artist and illustrator Léon Bakst (1866–1924) and the Russian illustrator, artist and set designer Alexandr Benois (1870–1960). Benois was an admirer of the Russian ballet, and particularly the avant-garde performances created by the Russian dancer and choreographer Michel Fokine (1880–1942). He suggested to Diaghilev that World of Art create a dance troupe, employing Fokine to choreograph. In 1909 Diaghilev took this dance collective, the Ballets Russes, to Paris. Fokine was to produce and choreograph the many, now famous, ballets for the troupe, including *Prince Igor* in 1909 and *L'Oiseau de Feu* (*The Firebird*), notably by the Russian composer Igor Stravinsky (1882–1971), which premiered at the Paris Opéra in 1910. Fokine and Stravinsky worked together to incorporate vigorous interpretations of Russian folk dances with athletic ballet routines unseen before. In *The Firebird* the stamping, raw rhythm of 'Infernal Dance of King of Katschei', combined with the striking costumes, wowed the Parisian audiences and inspired a generation of artists and designers who flocked to the performances.

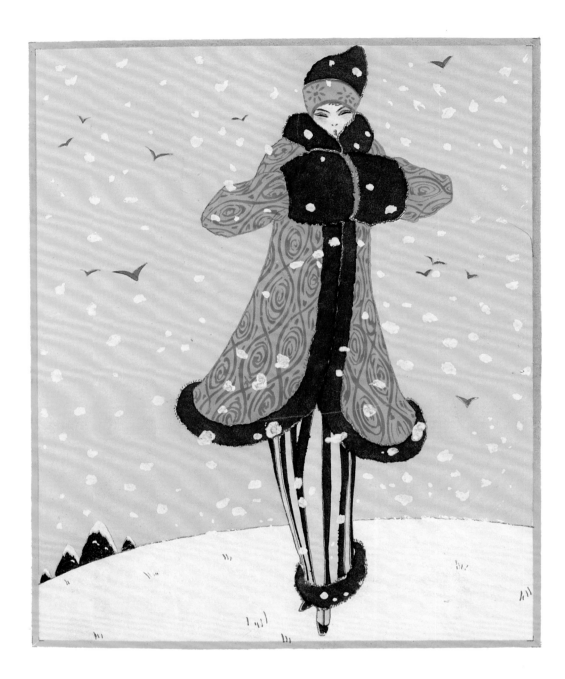

Russian Ballet Informs the Art Deco Style

The exotic spectacle of the Ballets Russes in performance caused, at times, near riots amongst its most ardent fans. In his illustration *La Loge, c.* 1914 (*see* pages 12–13), for the publication *Modes et Manières d'Aujourd'hui*, Georges Barbier (1882–1932) captures the theatricality of the fashion worn by female spectators of the time. The young woman with a fan wearing a *Directoire*-style dress displays the ultimate in high-fashion style with exotic, bejewelled, turban headwear mounted with feathers. To the right a turbaned young woman reveals her naked back wearing a low, loosely gathered voluminous shawl coat. The heady mix of Stravinsky and Diaghilev's *Petrouchka* and the pagan-ritual 'barbarism' of *Le Sacre du Printemps* (*The Rite of Spring*) had audiences typical of those in Barbier's illustration, applauding and baying for more. It is in Bakst's exotic costume design, for the character of Madame Trouhanowa in a production of *La Péri* (1911) for instance, that one can appreciate the clash of colour, fabric and pattern design, which produced a risqué, daring ensemble to transfix the spectator at Ballets Russes performances. Many years later the Russian fashion designer Erté (1892–1990) recaptured the intensity and passion of the Ballet Russes in a fantasy 'firebird'-style costume illustrated in *Applause*, 1981 (*see* pages 34–35).

A Move Towards Modern Design

As the move towards Arts and Crafts in Europe took hold in Germany, Austria and Russia, the decadently decorative Art Nouveau lost its appeal to designers and to patrons. Its sinuous

Georges Lepape
Goodness! How Cold It Is, 1913,
from *Gazette du Bon Ton*

Courtesy of Private Collection, The Stapleton
Collection/The Bridgeman Art Library/
© ADAGP, Paris and DACS, London

MEDIUM: Pochoir print

RELATED WORKS: Helen Dryden (dates
unknown), Cover of *Vogue*, December 1916

Erté
New Bridges for the Seven Seas (detail)
1919, (Cover of *Harper's Bazaar*)
© Sevenarts Ltd
MEDIUM: Serigraph

RELATED WORKS: A.E. Marty, *Paquin
Evening Robe*, 1913, from *Gazette du Bon Ton*;
A.E. Marty, Illustration for *Fémina-Noël*,
1920 by Dominique Sylvaire

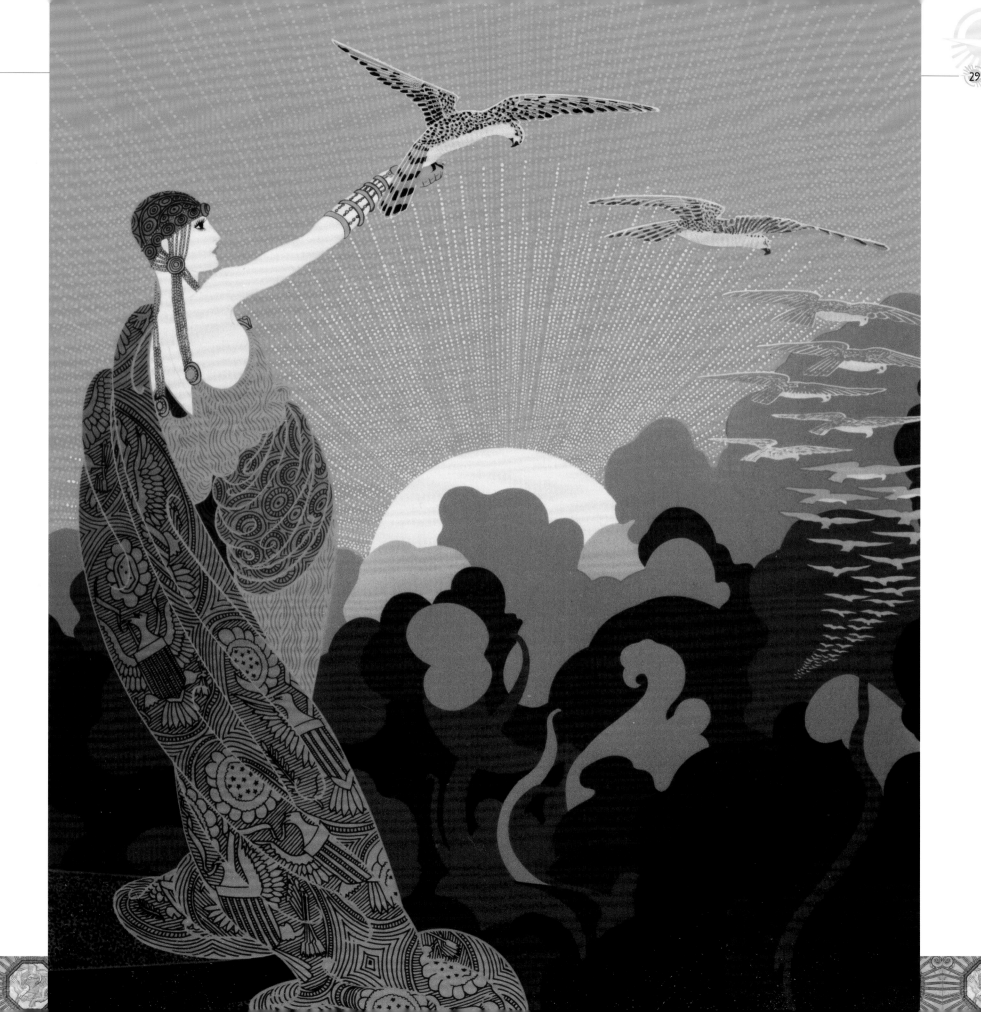

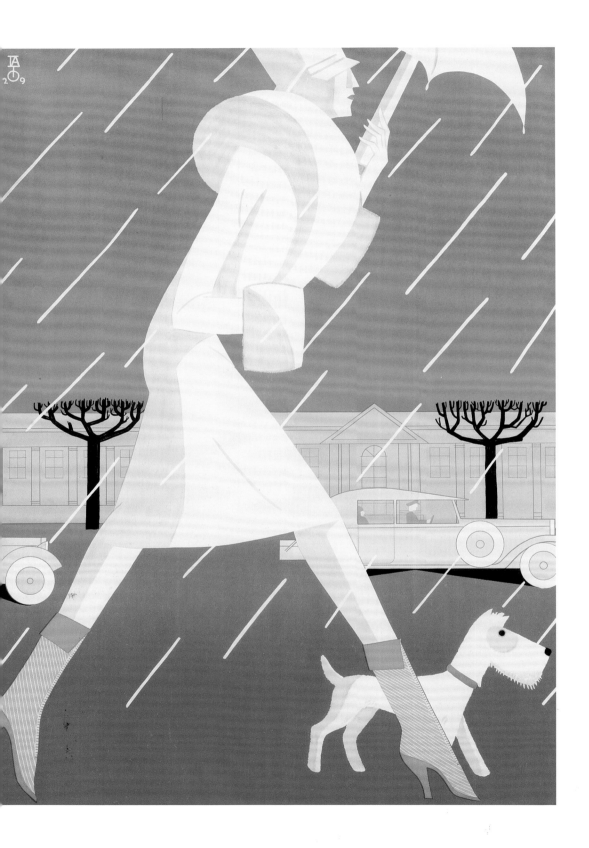

Unknown artist
Poster for *Candee Snow-Boots
Cautchoucs*, 1929
© Christie's Images Ltd

MEDIUM: Lithograph

RELATED WORKS: Ernst Deutsche-
Dryden, Poster for *Salamander*, 1912

lines and dark rich colours faded in the light of a move towards
cleaner, classical lines and less decorative craft designs. Though
this move pushed forward Arts and Crafts's socialist message
entwined in the idea of craftsmanship, and whilst Hoffmann
et al. in Vienna rigidly aspired to the crafts ideals of joy in
labour and refused to use industrial technology, the Deutscher
Werkbund embraced the machine tool and utilized industrial
materials, to effectively construct a new socialism through
architecture, interior design, decorative art, graphic design
and painting. In Russia the Constructivists, led by Alexander
Rodchenko (1891–1956), were instrumental in the advance
of modern graphic illustration. Rodchenko produced graphic
designs for poster illustrations, manifestos and magazines, using
photomontage, strong blocks of colour, new typefaces and bold
slogans in complementary colours.

The Deco Style

Art Nouveau seemingly
'died' in the throes of the
birth of a new movement
called Modernism, but
from it was also born
a sharper, classier style,
soon to be referred to
as *Art Décoratif* (and later
to be known as 'Art Deco')
a style that reflected the
modernity of city life,
notably illustrated in
the splash of advertising
posters. Whilst the
architects and designers

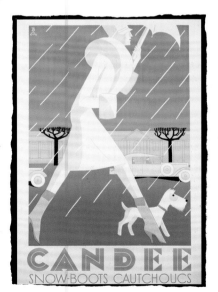

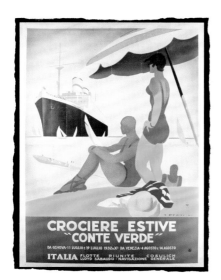

issued manifestos and directives on whether the use of ornament and decoration was acceptable in architecture and interior design, a new taste for a rich, sumptuous, expensive style, which could be modified for the masses, was developing. The Deco style would spread from Europe to America, peaking in Europe in the 1920s to 1930s and enjoying a free ride in the US through association with dance crazes such as the Charleston, and the musical taste for jazz syncopation. It would even hitch a ride on the design cult of America's 'Streamline' look in the 1930s until the onset of war in 1939 curtailed enthusiasm.

Art Deco Unfolds

Thus far, the new socialism – just visible in flat-roof, white-cube architecture of iron, glass and concrete, simplistic interior design and pared-down everyday material objects – was not favoured by every patron of the Arts, whereas the luxury element of Art Deco appeared in a variety of forms in Paris from *c*. 1909. In 1908 Paul Poiret (1879–1944), an established French couturier who styled himself as the 'King of Fashion', had revealed a portfolio of dress designs – *Les Robes de Paul Poiret Racontées par Paul Iribe* – which heralded a 'new female' look for women. Paul Iribe (1883–1935), a talented French designer and illustrator, was instrumental to the success of Poiret's publication of new designs. His illustrations drew attention to Poiret's new-look fashion, influenced by a combination of the high-waisted *Directoire* style (1795–99), a transitional style that linked the monarchy of King Louis XVI to the new Empire, and a passion for Orientalism. The *Directoire* style was fashionable again for furniture design too in 1908, so Poiret designed his twentieth-century clothes in response to the popular desire for the elegance of the original eighteenth-century

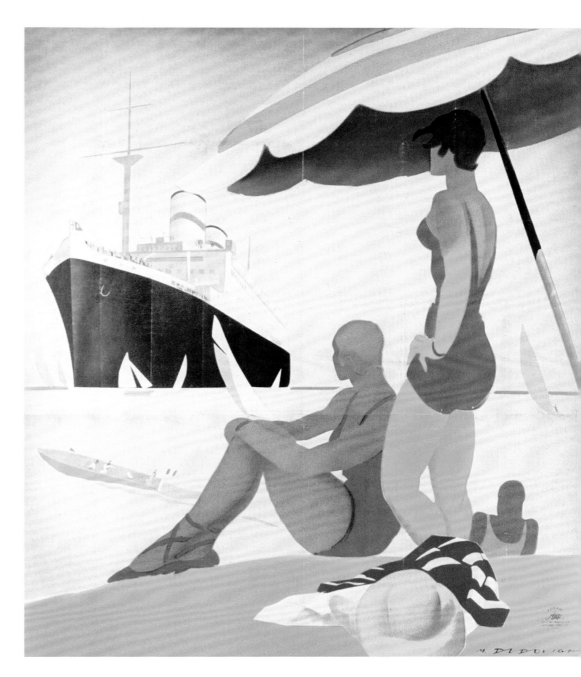

Unknown artist
Poster for *Crociere Estive*
***'Conte Verde'*, 1932**
© Private Collection/The Bridgeman Art Library

MEDIUM: Lithograph

RELATED WORKS: A. M. Cassandre,
Poster for the *Normandie*, 1935

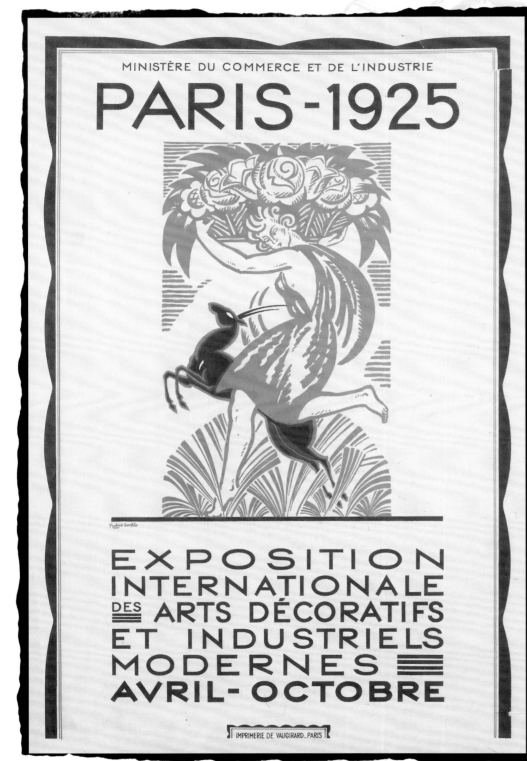

MINISTÈRE DU COMMERCE ET DE L'INDUSTRIE

PARIS · 1925

EXPOSITION INTERNATIONALE DES ARTS DÉCORATIFS ET INDUSTRIELS MODERNES AVRIL - OCTOBRE

IMPRIMERIE DE VAUGIRARD – PARIS

furniture, to complement the new room interiors. Around the same time, what was happening in the Parisian arts world – whether it be Cubism or Futurism, or later, Suprematism or Constructivism – was translating into the fashion world. It was firstly in fashion that Art Deco became a cogent movement.

Fashion Reflects the Desire for Change

Poiret was a self-taught designer. After successfully selling his fashion designs to couturiers, he worked as an assistant in the House of Doucet in Paris in 1896, followed by a position as pattern maker and designer of daywear at the House of Worth in 1901. The clients of Worth found some of Poiret's designs too extreme, too avant-garde, to be wearable but Poiret had by then become well known as a designer in his own right. He left the House of Worth and established a showroom in Paris in 1904, at 5, rue Auber. His friendship with the Fauvists André Derain and Maurice de Vlaminck (1876–1958) inspired him to create colourful clothes for the new century. After sketching initial designs Poiret's method was to hold a fabric against the body and trace and cut the fabric in place. The unusual method produced fluid soft lines and draped fabric, which did away with the need for corsetry. This innovative method heralded new shapes, such as Poiret's cone dresses and famed harem pantaloons. Not every client was taken with the new look but the stride forward that

Robert Bonfils
Paris-1925, Poster for the *Exposition Internationale des Arts Décoratifs et Industriels Modernes*, 1925
© Estate of Robert Bonfils/V&A Images, Victoria and Albert Museum

MEDIUM: Woodcut and lithograph

RELATED WORKS: Emile-Antoine Bourdelle (1861–1929), Poster for the *Exposition Internationale des Arts Décoratifs et Industriels Modernes*, 1925

Edgar Brandt
Wall light, c. 1922
Courtesy of V&A Images, Victoria and Albert Museum/© ADAGP, Paris and DACS, London

MEDIUM: Metal and glass

RELATED WORKS: Edgar Brandt, *Perse* (*Persia*) screen, c. 1923

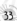

Poiret made was to free women from the bustle, tight corsetry and restricted movement (unless the restriction was fashionable, as in his 'hobble' skirt).

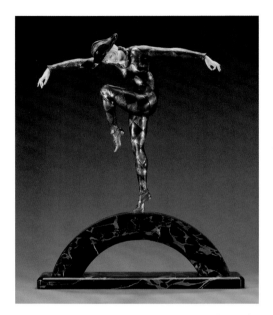

A Strident Move Towards Art Deco

In 1911 Poiret produced a second series of designs for publication, illustrated by a young Frenchman called Georges Lepape (1887–1971), an artist who had trained in the atelier of Fernand Cormon (1845–1924), notable for students such as Vincent Van Gogh (1853–90), Henri Matisse and Henri de Toulouse-Lautrec. Lepape mixed in the circle that included Diaghilev's ballet company, Ballets Russes. It is clear that the colourful costumes designed by Bakst informed Lepape's own direction. In Poiret's brochure, *Les Choses de Paul Poiret Vues par Georges Lepape*, one can see the original ideas of Poiret and the modernity of Lepape's illustrations combining to produce a creative, new art. One thousand copies of the brochure were published and sold. The new look was spreading, which was to herald the formative fashion for Art Deco. One page from the brochure is an example of Lepape's style and Poiret's easy, loose-fitting fashion for women – even suitable for various activities such as gardening and tennis (*see* pages 24–25). This is also seen in Lepape's illustration of Poiret's 'minaret' or 'lampshade' dress – *Sorbet*, 1912 (*see* page 26) – a style originally designed for the ballet *Les Minarets*; and the voluminous dress in *Au Clair de la Lune*, 1913 (*see* page 27), designed by Poiret and drawn by Lepape.

Gazette du Bon Ton (1912–25)

A unique new fashion publication, the *Gazette du Bon Ton* (*Good Taste Gazette*), motivated many imitators of its form, content and style, and was to become highly popular amongst those in the

Marcel-André Bouraine
Harlequin, 1925
© Estate of Marcel-André Bouraine/
Christie's Images Ltd

MEDIUM: Patinated and cold-painted bronze and ivory

RELATED WORKS: Marcel-André Bouraine, *Fan Dancer*, c. 1925

Erté
Applause, 1981,
(Cover of *Harper's Bazaar*,
November 1920)
© Sevenarts Ltd

MEDIUM: Serigraph

RELATED WORKS: Léon Bakst, Costume design for *L'Oiseau de Feu*, 1910

Parisian fashion world. Directly from its inception in 1911 and limited edition publication in 1912 it was instrumental in spreading interest in the fledgling style of Art Deco to a much wider audience. Inspired by the *Journal des Dames et des Modes* and the colourful art of the Fauves, the French photographer and publisher Lucien Vogel (1886–1954) launched *Gazette du Bon Ton* through subscriptions from Parisian couturiers. Vogel teamed up with illustrator Georges Lepape to produce an innovative magazine, which linked art to fashion design, and persuaded couturiers in Paris to contribute money in return for a magazine that would promote their fashions. His publication forwarded the careers of now-famous artists, designers, illustrators and couturiers. Many of the fashion plates, which were sold as limited edition *pochoir* prints in the magazine, were illustrated by names now synonymous with Art Deco: Paul Iribe, Georges Lepape, Georges Barbier and André Edouard Marty (1882–1974). Illustrators were able to showcase a whole range of garments in one image, such as *Evening Dresses* (*see* pages 18–19), a hand-coloured plate by Marty for the June 1914 issue of the magazine. Here we see five women in various poses in an idyllic pastoral landscape wearing evening dresses by Georges Doeuillet (b. 1875) – being early in Art Deco's development they hint at what the style was to become: Doeuillet's designs were highly

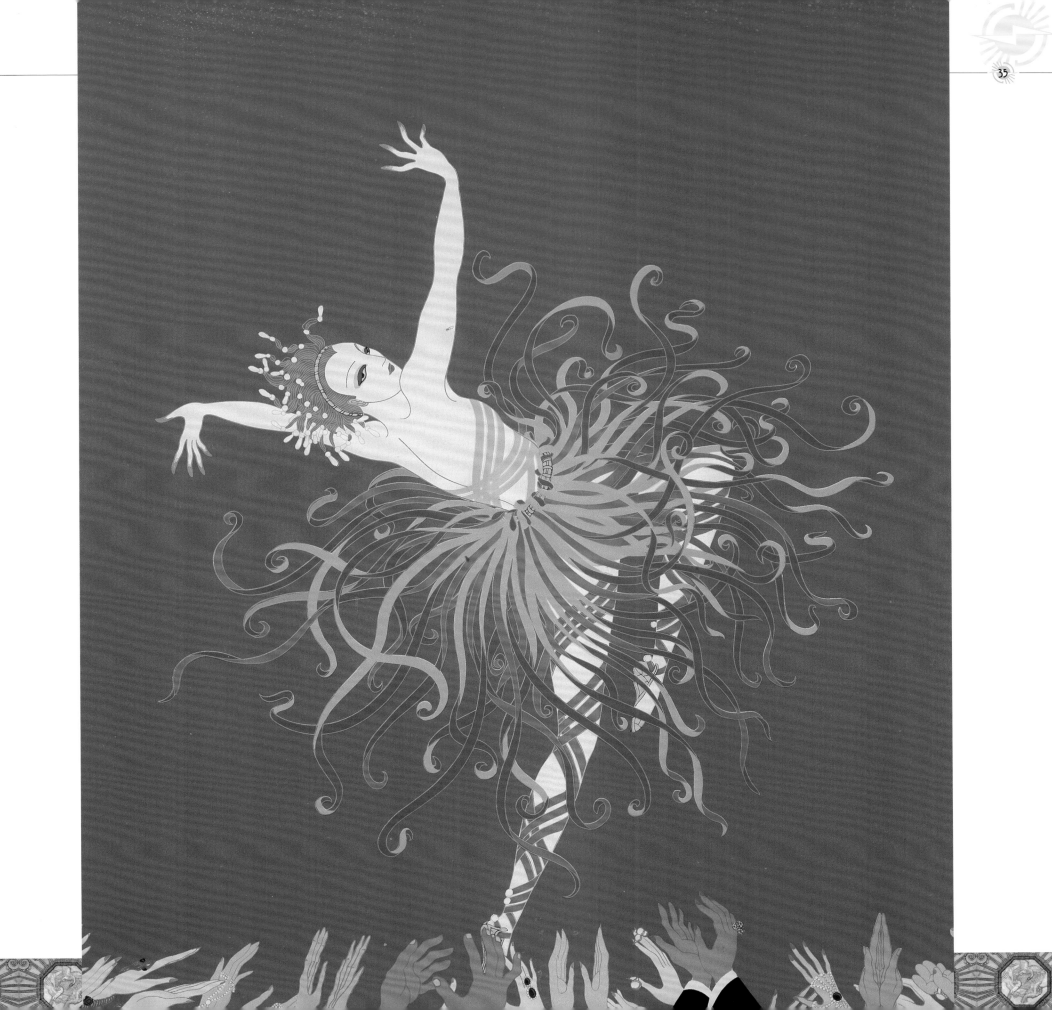

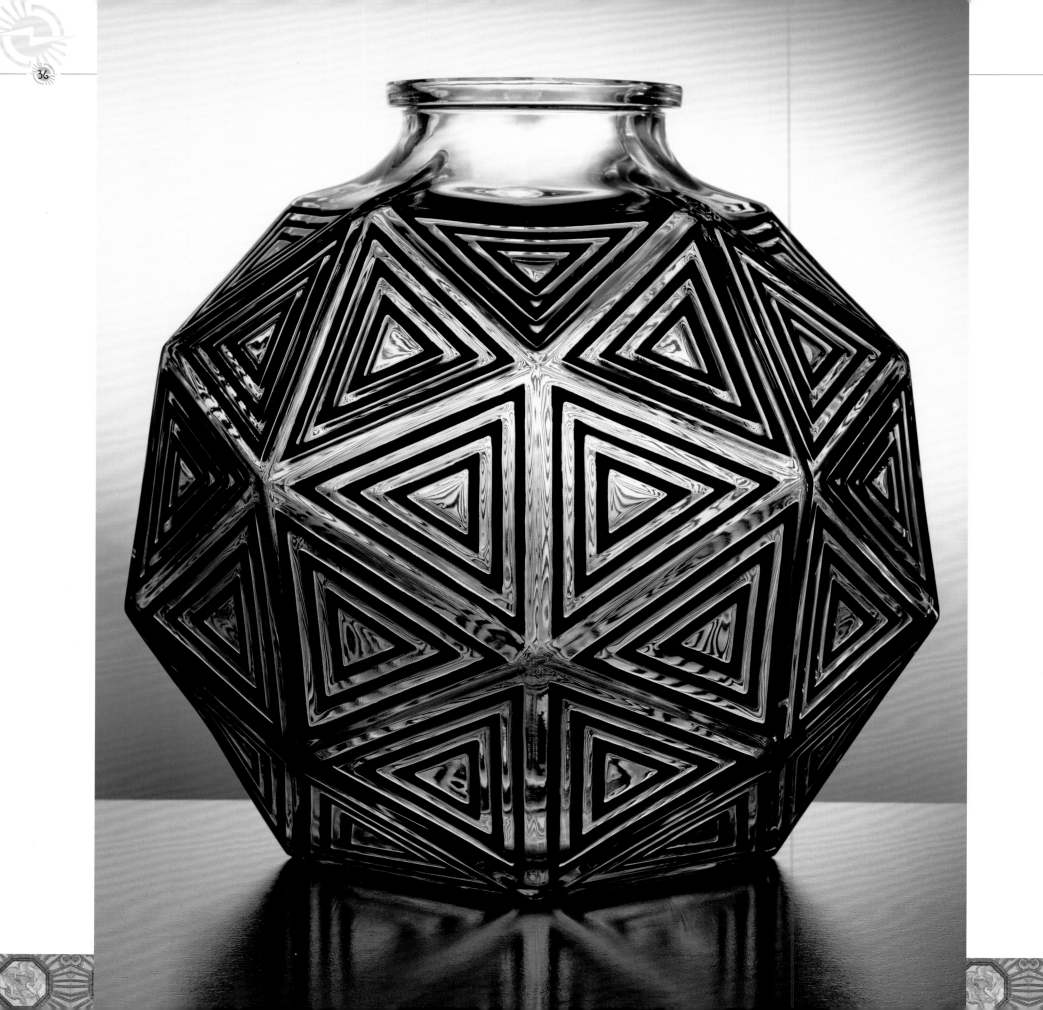

René Lalique
Nanking vase, 1925

Courtesy of Private Collection/
The Bridgeman Art Library/
© ADAGP, Paris and DACS, London

MEDIUM: Press-moulded glass
with black enamel

RELATED WORKS: René Lalique,
Tourbillons vase, c. 1925

**Raymond Templier, Jean
Fouquet and Georges Fouquet**
Selection of Art Deco Jewellery,
1920s–30s

© Estates of Raymond Templier/Jean
Fouquet/Georges Fouquet/Christie's Images Ltd

MEDIUM: Various (diamonds,
enamel, gold, coral, onyx)

RELATED WORKS: Cartier,
Various jewellery, 1920s–30s

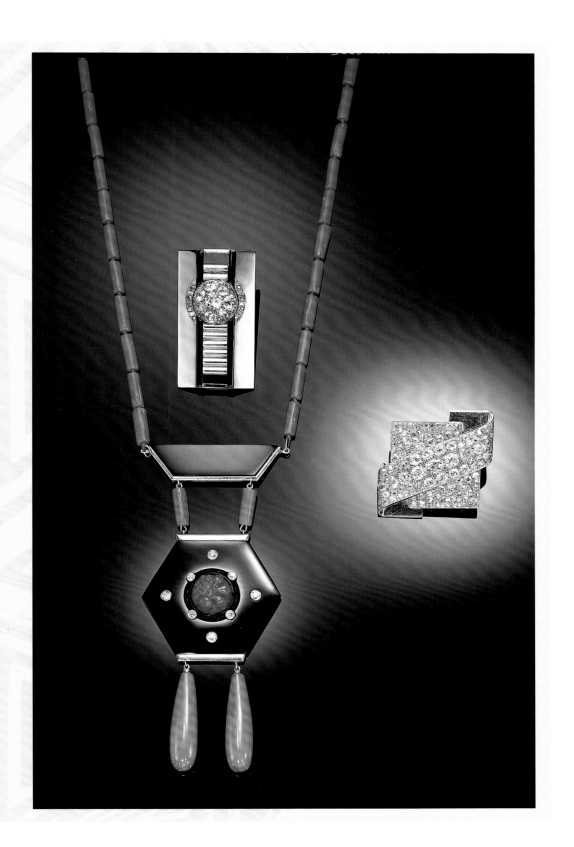

detailed and elaborate, with tiering and ruching, but his loose-fitting and high-waisted style breaks away from the corsets of old. These ideas were fully developed during and after the war by removing the waist altogether and creating the so-called 'sack' dress as worn by the 'flappers' in the 1920s.

Illustrations for Poiret and Paquin

Jeanne Paquin was a regular contributor to *Gazette du Bon Ton*. She worked with the foremost architects, designers and illustrators. *Paquin Evening Robe*, 1913 (*see* page 20), illustrated by André Edouard Marty (1882–1974) for the April edition, shows Paquin and Marty at their most creative. We are presented with the low-back of the evening dress, its high-waisted polonaise-style tunic gathered behind the knee, with a long narrow skirt and train, and 'sleeves' created from a transparent panel of fabric, draped over the shoulders. Marty's seemingly effortless effect of a midnight sky as a backdrop to the young woman leaning on a classical Beaux-Arts balustrade evokes an atmosphere of luxury and elitism. It was the daring fashion illustrations that created a corps of devoted readers who turned to *Gazette du Bon Ton* for the latest creations by the avant-garde of the design world. Marty's *Que Pensez-Vous des Six?* (*see* page 21), a 1921 illustration for the magazine,

adds humour whilst revealing the socialite lifestyle enjoyed or aspired to by readers. The superb Poiret evening dress in this work is illustrated as a natural part of the scene, rather than the reason for its inclusion. So too in Marty's 1922 illustration of a Poiret evening cape coat, *La Glace ou Un Coup d'Oeil en Passant* (*see* page 23),which uses a full-length mirror as backdrop. This allows focus both on the front and rear design and shape of the cape: its loose structure with a long oblong yoke in a floral fabric and rounded hem at the back, and the red border on the front.

A Combination of Classicism and the Exotic

In contrast, Marty's 1922 illustration *La Belle Affligée* (*see* page 22) uses Beaux-Arts classicism in the design of the setting to focus attention on the desolation of the female pictured and, most importantly, on the ravishing spectacle of the Paul Poiret black evening dress that she wears. Towards the end of its life, *Gazette du Bon Ton*'s illustrations were still of the same high quality that had inspired Vogel and Lepape to create the magazine. George Barbier's fashion plate *Worth Evening Dress*, 1925 (*see* page 17), portrays a distinctive form and beauty in the dress and the woman, and also reveals – in the minimalist décor – the continuing taste for Orientalism. After years of success, *Gazette du Bon Ton* ceased publication in 1914 at the outbreak of war. One copy was then produced in 1915, publication recommenced in 1920 and in 1921 it was bought by Condé Nast, who continued to publish the magazine until 1925.

Jean Dunand
Panneau de Laque D'Or Gravé,
date unknown
Courtesy of Christie's Images Ltd/
© ADAGP, Paris and DACS, London

MEDIUM: Laquer and metal relief

RELATED WORKS: Jean Dunand,
Panel (Portrait), 1928–30

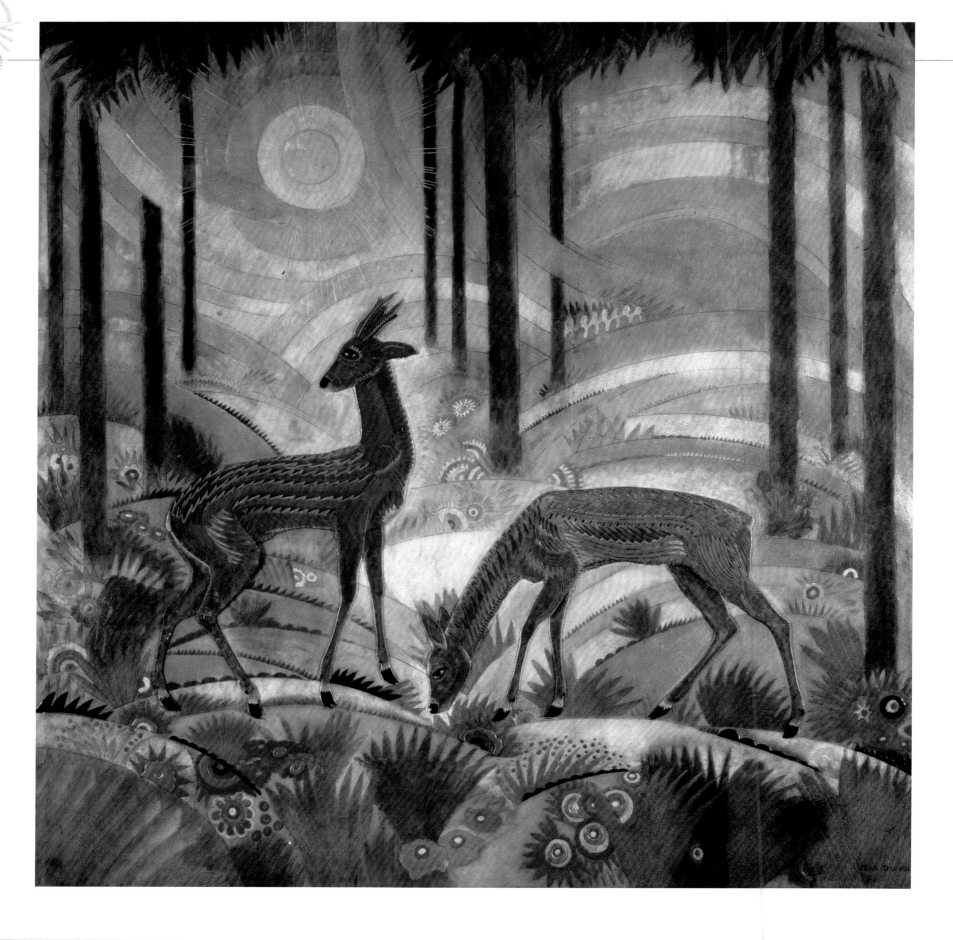

Pochoir Prints

Adding excitement to the new craze for Poiret's lampshade tunics and harem pants was the re-use of the traditional fashion plate. The *pochoir* print was an illustrative technique, a type of stencilling in which the illustrated design was etched into a thin plate of metal before printing on paper. This method allowed artists to capture the intensity, or delicacy, of colour in the design and relate it to the texture of the fabric, whether a silky sheen or crunchy wool, as it allowed the original colour of the artist's illustration to be preserved in duplication. *Pochoir* was favoured by Poiret, who helped to reignite the popularity of this ancient technique and traditional form of distinctive colouring. The fun of Poiret's decorative style can be seen in Lepape's superb *pochoir* print *Goodness! How Cold It Is*, 1913 (*see* page 28), showing a fashionable young woman dressed up for cold winter weather and a flurry of snow. It captures the strong colour of a richly patterned winter coat made in cut silk velvet and trimmed with skunk. The vertical monotone stripes of the slim-fitting skirt accentuate its length and the elegant figure of the model. In the background a scattering of birds fly across a strawberry-pink backdrop.

Dazzling Fashion Collections from Paris

The pre-1914 womenswear fashion designs of Paul Poiret formulated a new age of couture. He was the first to inspire a new look based on a synthesis of the new European movements in art, dance and design; he utilized the new printing techniques and employed the young generation of commercial illustrators in Paris to stamp a unique signature on his brand. The variety of ideas from the ateliers and studios of artists and designers in Paris in the first decade of the twentieth century culminated in Diaghilev's Ballets Russes as entertainment, sparking a *joie de vivre* that continued until the onset of the First World War. Poiret's style quintessentially illustrated, in the mode of exotic headwear, sleek, short hairstyles and loosely cut draped clothing,

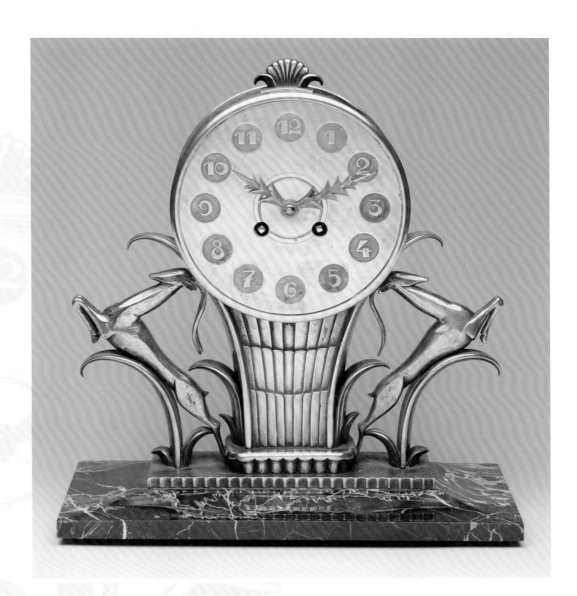

Jean Dunand
A Grand and Fine Laquered Wood Panel, c. **1929**

Courtesy of Christie's Images Ltd/
© ADAGP, Paris and DACS, London

MEDIUM: Laquered wood

RELATED WORKS: Jean Dunand,
Monkey Climbing a Vine, c. 1925;
Narotamdas Bhau, *Indian Tea Service, c.* 1929

Edgar Brandt
Silvered bronze clock, date unknown

Courtesy of Christie's Images Ltd/
© ADAGP, Paris and DACS, London

MEDIUM: Silvered bronze

RELATED WORKS: Edgar Brandt,
Oasis screen, *c.* 1924

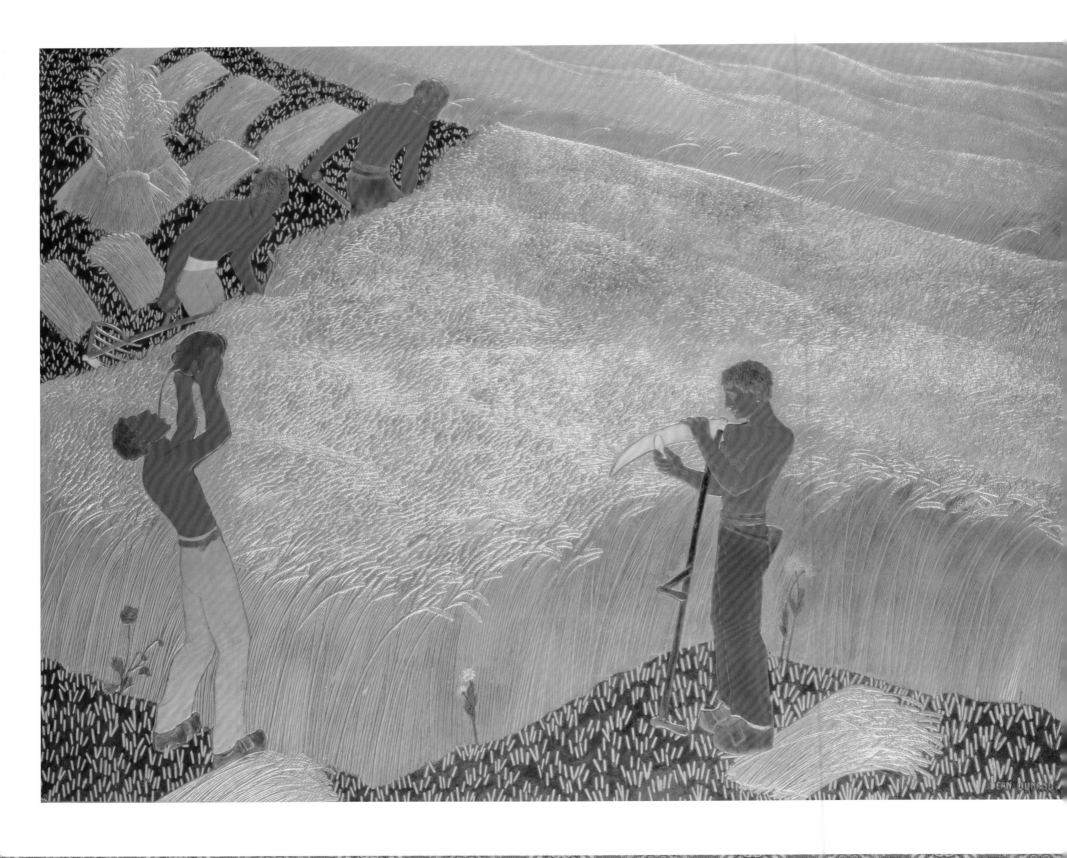

accentuated femininity and elite modernity. Perhaps the dress which summed up the Poiret look was made in 1911, for his wife. The sleeveless sheath dress in white satin (now in the V&A collection) with decorative geometric pattern was worn without sash. Its resemblance to the later sack dresses of the 1920s shows the early use of neutral, repetitive geometric pattern.

Chevrons and Cubes ... Geometric Patterns Take Hold

Paintings, and textiles used for fashion and interior furnishings, were the simplest form to show a new style emerging and to replicate in poster and advertising design. The Cubist paintings of 1907–14 created by Braque and Picasso exemplified the artists' rejection of the notion that art should copy nature. The geometry of the content emphasized the flat, two-dimensional surface of the painting whilst tricking the eye to see a myriad of cubic forms, a technique observed in the paintings of Paul Cézanne. The art theory of Cézanne was that nature could be synthesized; that objects should be reduced to the cone, sphere and cylinder:

> '…treat nature by means of the cylinder, the sphere, the cone, everything brought into proper perspective so that each side of an object or a plane is directed towards a central point. Lines parallel to the horizon give breadth … lines perpendicular to this horizon give depth.' (Paul Cézanne to Emile Bernard, 15 April 1904).

From Cézanne's paintings to the cubist experiments made by Picasso and Braque, the French interest in cubist paintings, sculpture and furniture spread through Europe and influenced

Jean Dunand
La Moisson (The Harvest), c. 1935
Courtesy of Christie's Images Ltd/
© ADAGP, Paris and DACS, London

MEDIUM: Laquered wood

RELATED WORKS: Jean Dunand and Jean Dupas, *The Chariot of Aurora*, 1935

artists from Moscow to Madrid, from Berlin to London. From 1910 to 1914 Orphism, a by-product of Cubism, synthesized the earlier form. Group members included the Spanish artist Juan Gris (1887–1927), the French artists Fernand Léger (1881–1955) and Robert Delaunay (1885–1941) and the latter's wife, Sonia Delaunay (1885–1979), née Terk, the Russian-born artist and exceptionally gifted textile designer. It is Cubism, both synthetic and analytical in form, that influenced the textile designs used by the fashion and furnishings industry; one feature of the cubist-inspired aesthetic that gained popularity was the 'chevron' motif. In other fields using decorative art, from the automobile industry to architectural design, one can see geometric design take hold.

France, 1914–18

The prewar frenzy of fashion, dance and art movements gave artists and illustrators the opportunity to experiment with graphics. André Edouard Marty, the French illustrator, painter and designer, was popular with Poiret and other couturiers, particularly those that were keen to employ illustrators who could capture the *Zeitgeist* of the new century. The Russian born designer and illustrator Romain de Tertoff (1892–1990) – better known as Erté, a nom de plume derived from the pronunciation of his initials – worked for Poiret too. The war years disrupted and changed the lives of many. Paul Poiret enlisted in 1914, closing his emporium. He reopened his fashion house at the end of the war, although the excitement of those early years did not return completely. However, the style and motifs of prewar Art Deco graphic art, particularly visible in editorial and advertising typography for fashion and poster illustrations, carried on after the war, spreading its influence wider, to the rest of Europe and America.

Art Deco 1918–24

Postwar Europe, particularly France, slowly saw a re-emergence of the café society that had frequented the boulevards, theatres, dance halls and opera houses in the first decade of the century. In France the aim was to return to the inspirational years prior

to 1914, to revitalize the economy through promotion of French industrial and decorative design in France, Europe and America. Many of the gifted men who had had that exciting vision of modernity for the new twentieth century, had sadly died during the war, but there were artists, architects and designers who had moved away from France and Germany to live and set up studios in Britain or America during the war years, taking with them the new interest in Art Deco.

Modernism in Architecture

The Italian Futurist architect Antonio Sant'Elia (1888–1916) had visualized new cities, with traffic lanes specifically planned for the rise in car ownership, and modern, everyday living in stepped-back glass skyscrapers. His personal view was short-lived, yet, in many ways, eventually carried forward by European and American architects including the Swiss artist and architect Charles-Edouard Jeanneret-Gris (1887–1965), known as Le Corbusier, the German architect Ludwig Mies van der Rohe (1886–1969) and the American, Philip Johnson (1906–2005). The postwar period was felt to be liberating, and architects, employed to rebuild cities, were given the opportunity to put into practice that which had only been an avant-garde plan for the future. For Mies van der Rohe in Berlin it allowed him, from 1919 to 1924, the freedom to design buildings for modern-day living, a socialist vision, using industrial materials: concrete, reinforced steel and glass – and swathes of it. Luxury was still very much enjoyed, however: for the socialites, the casinos and the Mediterranean once more drew them in – well illustrated by Georges Barbier in the *pochoir* print *A Taste for Shawls*, 1922 (*see* pages 14–15), and the Japanese-inspired colour lithograph *Leaving for the Casino*, 1923 (*see* page 16).

Changes and New Beginnings

The artistic fraternity had suffered the conflicts of war. Many had found it necessary to flee France, Russia and Germany in 1914. In France the coequal partnership and friendship between

Tamara de Lempicka
Perspective, 1923
Courtesy of Petit Palais, Geneva, Switzerland/The Bridgeman Art Library/ © ADAGP, Paris and DACS, London

MEDIUM: Oil on canvas

RELATED WORKS: Pierre-Auguste Renoir (1841–1919), *Bathers*, 1918–19; Henri Matisse (1869–1954), *Blue Nude (Souvenir of Biskra)*, 1907

Braque and Picasso had dissipated at the onset of war due to Braque's enlistment. The arts world was changing, and those who remained – such as Picasso, a Spaniard not involved in the war – would witness the arrival of new idealists with a greater interest in the social aspect of architecture and design.

Bauhaus

The Deutscher Werkbund of 1907–14 was reborn in the Bauhaus (1919–33), which was based first in Weimar, Germany, from 1919 to 1925. Here Walter Gropius (1883–1969) formed a collective of trainees who studied art, interior design, decorative art, sculpture and pottery. For those involved, great emphasis was placed on branding the Bauhaus aesthetic through graphic design, for which new typefaces and print techniques were invented. The Bauhaus group placed emphasis on craftwork and purer forms of decorative design, which influenced the production of furniture and interior design leading to the Art Deco style.

Purism and L'Esprit Nouveau

Le Corbusier and a friend, the French Cubist painter Amédée Ozenfant (1886–1966), developed a new form of Cubism, which they referred to as 'Purism', holding an exhibition of their paintings in 1917. Purism was a form of non-decorative Cubism with emphasis on the machine. Both men looked to geometry, particularly the 'Golden Section' (the concept of the ideal, most aesthetically pleasing proportions provided by a mathematical formula), to rationalize their paintings. The results were original works which explored the use of geometry and very bright colour.

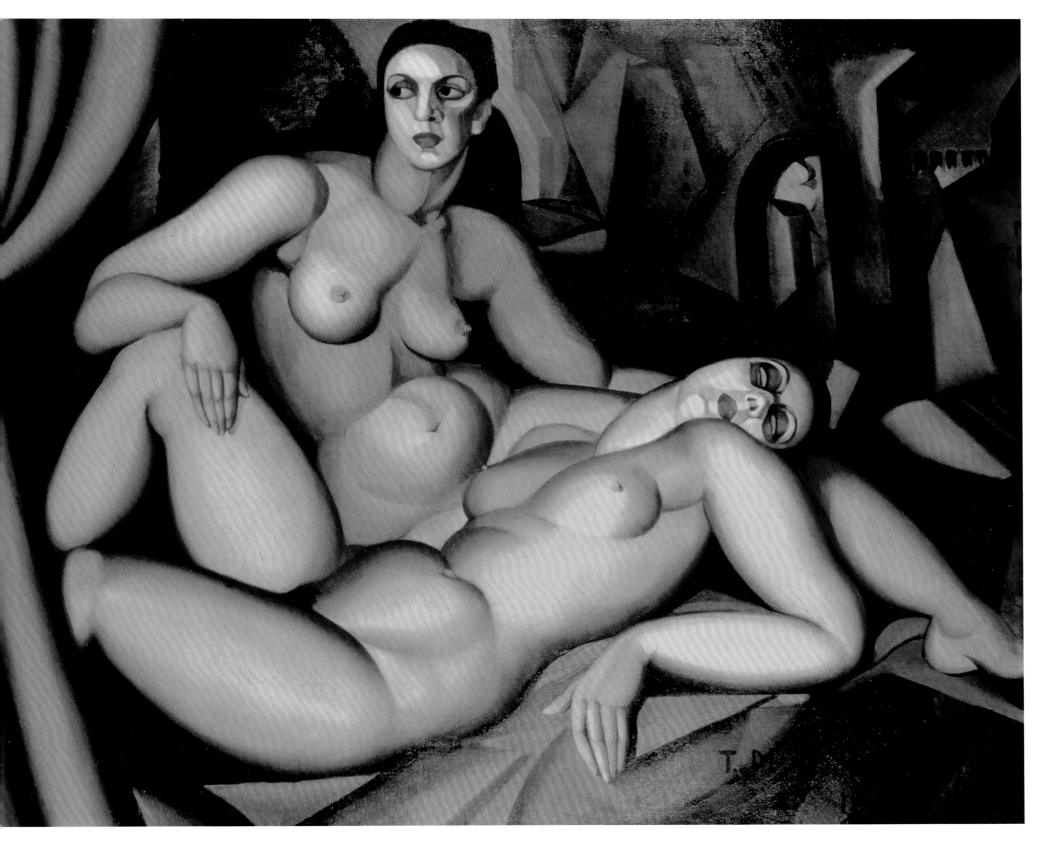

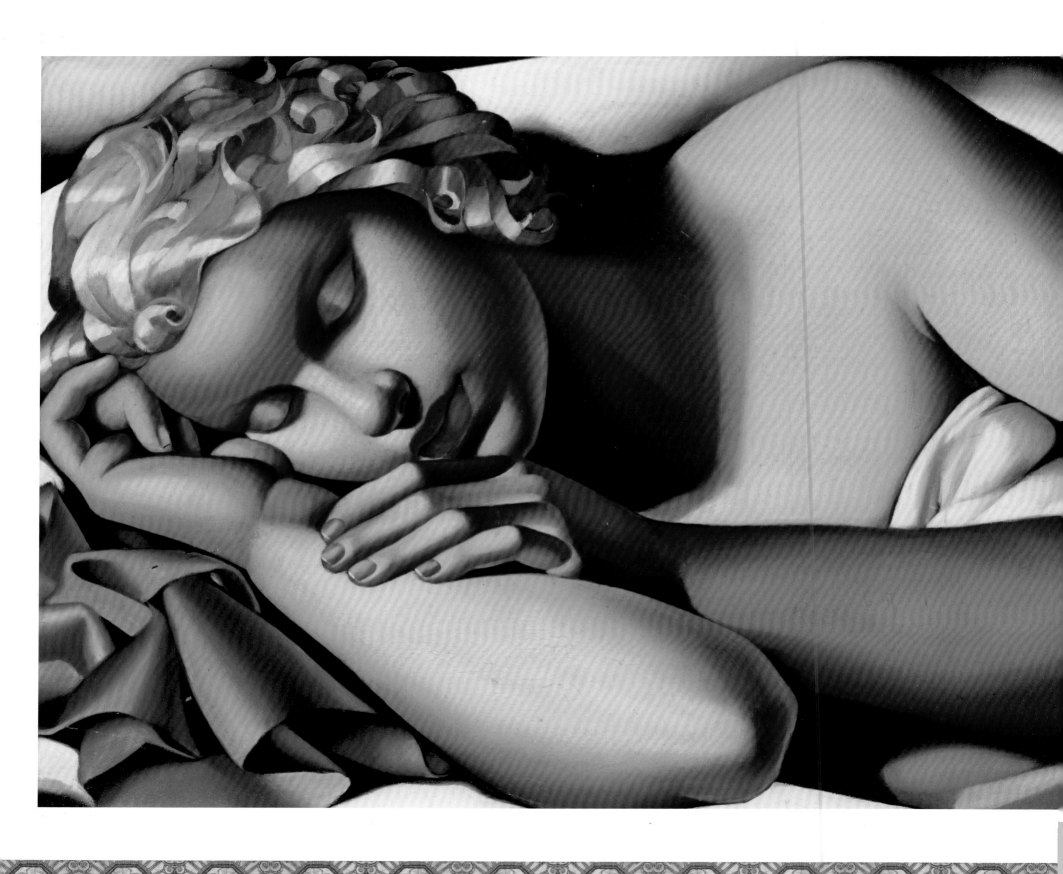

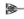

Tamara de Lempicka
Sleeping Woman, 1935

Courtesy of Christie's Images/Corbis/
© ADAGP, Paris and DACS, London

MEDIUM: Oil on canvas

RELATED WORKS: Tamara de
Lempicka, *Kizette on the Balcony*, 1927

Tamara de Lempicka
Andromeda, 1929

Courtesy of Private Collection/akg-images/
© ADAGP, Paris and DACS, London

MEDIUM: Oil on canvas

RELATED WORKS: Tamara de
Lempicka, *Model*, 1925

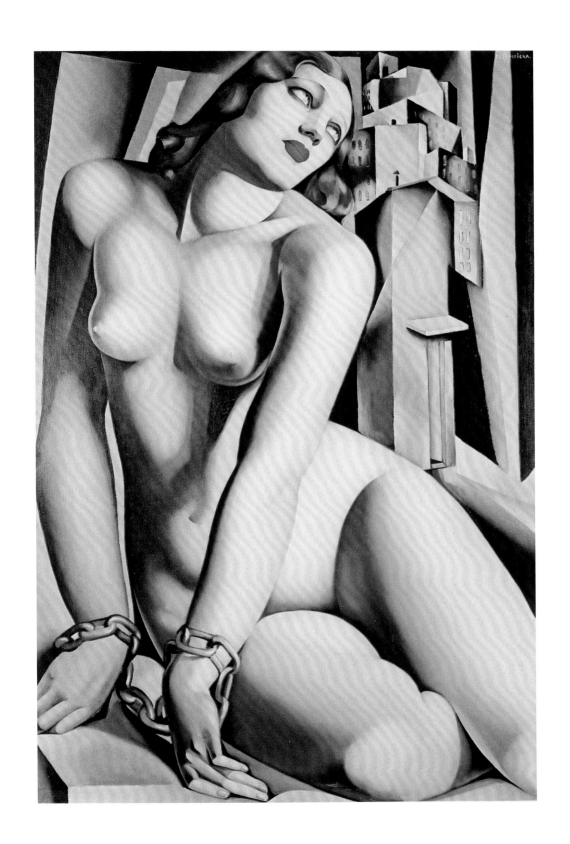

Purism was to become, unintentionally, part of the legacy
of Art Deco, including a new form of housing and lifestyle –
L'Esprit Nouveau – promoted by Le Corbusier and Ozenfant at
L'Exposition des Art Décoratifs et Industriels Modernes in Paris in 1925.

Graphic Design Reflects a New Europe

Graphic design illustration in France *c.* 1919–22 reflected a
new mood of levity. The slick designs of the prewar era, notably
Poiret's, continued anew with even greater emphasis on luxury
and opulence. The ability and desire for the élite upper classes,
and upper middle class families, to own a motor car, and to
travel by sea on world-class cruise ships, added to the visibly
elitist approach to illustration in graphic art and design. In
Erté's *New Bridges for the Seven Seas*, 1919 (*see* page 29), a cover
design in gouache for the March issue of the American magazine
Harper's Bazaar, the sinuous Art Nouveau-style abstract tendrils
of a forest of smoky blue trees and clouds are combined with
more modern elements to form a decorative sleek artwork. To
symbolize a new world rising from the ashes of postwar Europe
a young woman dressed in gold releases a flock of birds towards
a golden sunburst sky (the sunburst motif was to become one
of most popular in Art Deco style, the decoration on the 1930
Chrysler building in New York being a well-known example).
In an Italian poster advertising the *Conte Verde*, 1932 (*see* page
31), a cruise line operator promotes luxury holidays using
the modern flat, two-dimensional style. A slightly different
effect is produced in the German advertising poster for

Candee Snow-Boots Cautchoucs, 1929 (*see* page 30), where the way the images are overlaid creates movement. The outfit worn by the model reveals the fashionable slim silhouette and the level to which skirt hems had risen by 1929.

Exposition Internationale des Arts Décoratifs et Industriels Modernes, Paris, 1925

The exhibition in Paris in 1925 brought together many different facets of the Art Deco style. For the first time the wider world would see the visual impact that modern art had had on the decorative and industrial arts. Plans for a major international exhibition to promote the decorative arts had been put forward by the French *Société des Artistes Décorateurs* (SAD) in 1911 with approval for it confirmed in 1912 and a proposed date given of 1915. With the onset of war the preparations were postponed in 1914. From 1917 the plan was pushed again and two smaller national exhibitions of decorative art were held in that year in preparation for a larger international exposition. The *Société d'Encouragement à l'Art et à l'Industrie* (SEAI), whose members included the luxury goods company Gaston-Louis Vuitton, pushed for it too, as a needed opportunity to promote French design. In addition, a magazine periodical was launched in 1919, *La Renaissance de l'Art Français et des Industries de Luxe*, to promote luxury French goods. It was considered a necessity in light of the prevailing influx of foreign, cheaper goods, mainly from Germany, into France.

Tamara de Lempicka
Portrait of Madame Boucard, 1928
Courtesy of The Art Archive/Eileen Tweedy/
© ADAGP, Paris and DACS, London

MEDIUM: Oil on canvas

RELATED WORKS: Tamara de Lempicka,
Portrait of Arlette Boucard with Arums, 1931

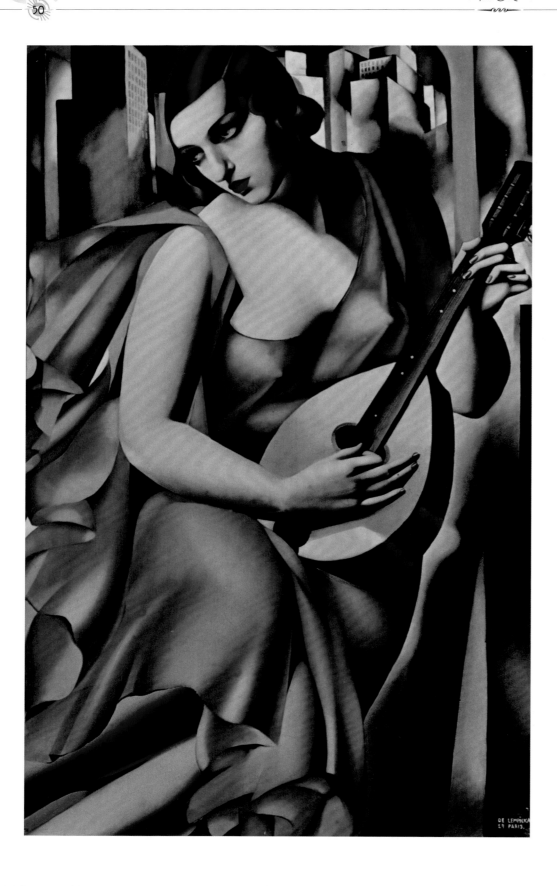

Out with Historicism, in with Modernism

When the go-ahead was given for the *Exposition* to take place, the prevailing dictum from the committee, which included members such as the French Art Nouveau architect and designer Hector Guimard (1867–1942) and the Modernist architect and painter of Cubism and Purism, Le Corbusier, was a rule that forbade any works to be displayed that were based on historicism. Exhibitors could only include works of modern character, and none were to be based on the styles or art forms of the past. It was a rule created to encourage modern design and to galvanize less-informed graphic artists, interior designers, craftsmen, furniture makers and architects to embrace the new age.

Art Deco Flirts with Europe

The event in 1925 would internationally promote the skills of the decorative-arts designers, particularly those that worked in the luxury goods market, and the manufacturers of quality mass-produced objects. It gained public recognition for architects, such as Le Corbusier, pushing city life towards the flat roofed, ribbon-windows of Modernism. It would also reveal the many forms of French decorative art originating from other art and design movements; it was an opportunity for visitors to see, perhaps for the first time, how far these different styles

Tamara de Lempicka
La Musicienne, 1929

Courtesy of akg-images/© ADAGP,
Paris and DACS, London

MEDIUM: Oil on canvas

RELATED WORKS: Tamara de Lempicka,
Amethyste, 1946; Jean-Auguste-Dominique
Ingres (1780–1867), *Le Bain Turc*, 1862

Raphael Delorme
The Dancer, 1920s

© Estate of Raphael Delorme/Private
Collection, Whitford & Hughes, London,
UK/The Bridgeman Art Library

MEDIUM: Oil on canvas

RELATED WORKS: Raphael Delorme,
Deux Filles avec des Colombes, c. 1925

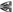

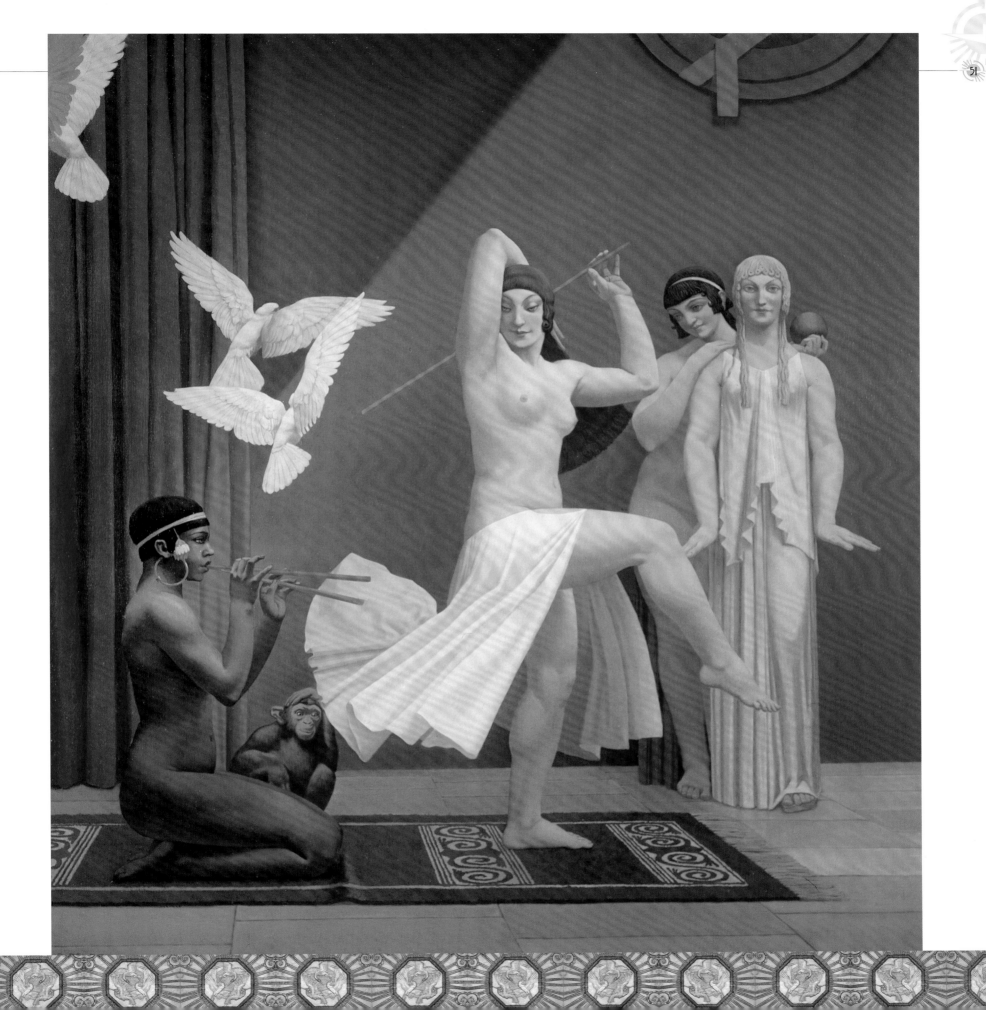

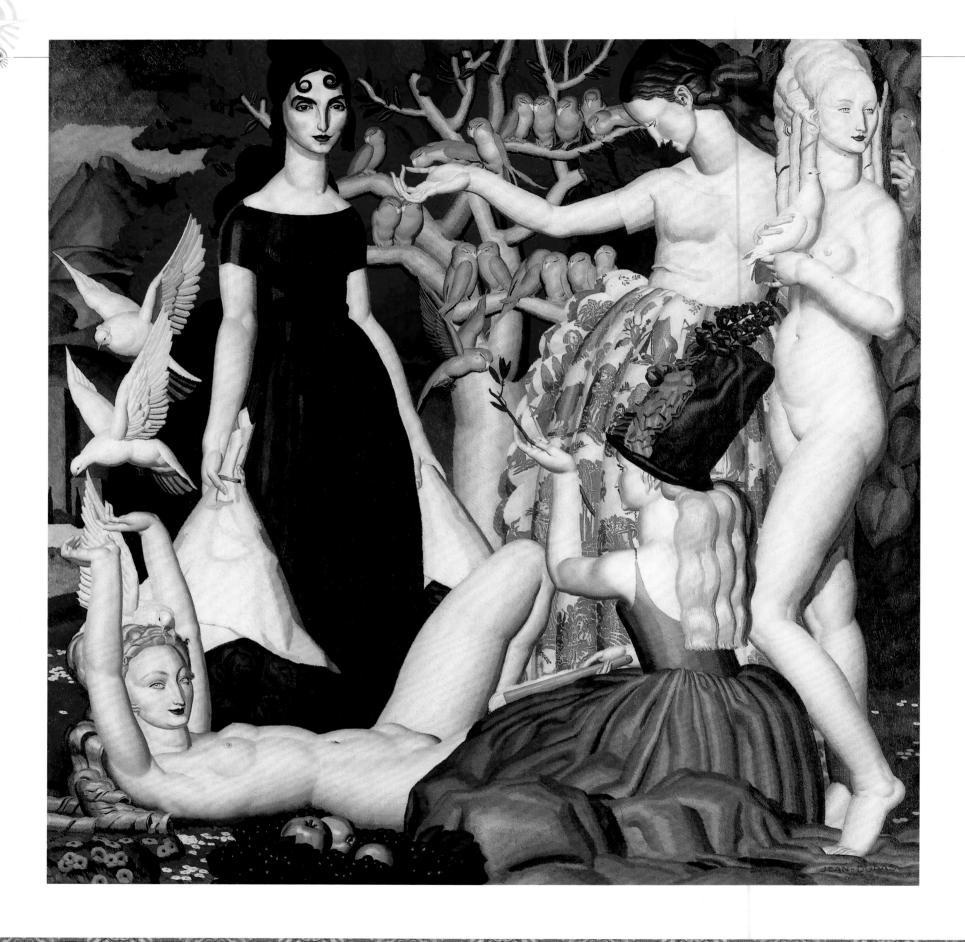

– from Orientalism, Fauvism and
Cubism to Futurism, Constructivism
and Purism, from the Ballets
Russes to Beaux-Arts classicism
– had woven together to influence
the Art Deco style. Of course,
it was the 1925 exhibition that
inspired the recognizable term 'Art
Deco' – one permanently
associated with luxury,
opulence and modernity.

1925 Exposition: Modernism v. Art Décoratif

A woodcut-style image by the French artist Robert Bonfils
(1886–1972) was one of many works chosen to represent the
modernist theme of the 1925 *Exposition*. In his poster for the Paris
Exhibition (*see* page 32), Bonfils portrays an energetic gazelle
leaping to keep pace with a young girl who carries on her head
a large basket overflowing with flowers. The floral arrangement
is of the Cubist-rose type, which was to become an emblem of
the *Exposition*; its design shares similarities with a decorative
metal wall light, *c.* 1922 (*see* page 33), created by
Edgar Brandt (1880–1960). The girl's billowing
short peasant dress hints at Fokine and Stravinsky's
The Rite of Spring ballet of 1911. Another poster, by
Emile-Antoine Bourdelle (1861–1929), uses classical
symbolism to portray the roots of modernity and the
joy of labour. Commercial artist Adolphe Jean-Marie
Mouron Cassandre (1901–68), known as Cassandre,
was awarded first prize for his poster *Au Bûcheron*,
produced in 1923. The poster, widely distributed in
Paris, is significant as the first to integrate words and
images in a post-Cubist format. Many of the graphic
artists who produced publicity posters for the Expo
are difficult to trace as the work commissioned was
unsigned. One contributor stands out: Edouard
Bénédictus (1878–1930) produced complete sets of *pochoir* prints
with vibrant use of colour in floral and abstract designs, such as
Variations: Quatre-vingt-six Motifs Décoratifs and *Nouvelle Variations:
Soixante-quinze Motifs Décoratifs*, printed by J. Saude.

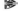

LE POUF

Jean Dupas
Les Perruches (The Parakeets), 1925
© Estate of Jean Dupas/Christie's Images Ltd

MEDIUM: Oil on canvas

RELATED WORKS: Pablo Picasso
(1881–1973), *Les Demoiselles d'Avignon*, 1907

Jean Bernier and Léon Bakst
Le Pouf (Robe du Soir), 1924, from
Gazette du Bon Ton
© V&A Images, Victoria and Albert Museum

MEDIUM: Lithograph

RELATED WORKS:
Georges Barbier, *Le Jugement de Paris*,
1924, from *Falbalas & Fanfreluches*

Leather, Jewellery and Glass – Luxury Goods

From France the exhibitors included the luxury, leather goods company Gaston-Louis Vuitton, the silversmith and goldsmith Christofle and the glassmaker René Lalique (1860–1945), who had built a vast pavilion complete with a monumental glass water fountain at its entrance. *Nanking* vase, 1925 (*see* page 36), is one example of the distinctive output from this period. Typical of the beautiful variety of designs in Lalique glass, this exquisite vase, *c.* 34 cm (13½ in) and signed by Lalique, has a geometric design of triangles in black-enamelled and clear glass.

Georges Fouquet – from Art Nouveau to Art Deco

The renowned French jewellery designer Georges Fouquet (1862–1957) also exhibited in 1925. Expectations were high due to his sensational display of jewellery at the centennial *Exposition Universelle* of 1900 in Paris. At that exhibition, when the trend for Art Nouveau strongly influenced high-fashion jewellery design, the display and jewellery were designed for Fouquet by the Czech artist and designer, Alphonse Mucha (although Mucha would not be typecast as a designer of Art Nouveau). But for the later 1925 *Exposition*, Fouquet and his son Jean Fouquet (1899–1984) looked for younger, innovative designers of the 1920s to inspire their new collection. The results, such as *Pendant Necklace in Coral, Black Onyx and Diamonds* (*see* page 37), by Georges, and *Brooch in Enamel and White Gold Set with Diamonds* (*see* page 37), by Jean, display the

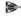

Unknown artist
Feminine Elegance **(dresses by Paul Poiret et al.), 1924, from** *Art, Goût, Beauté*
© Mary Evans Picture Library

MEDIUM: Pochoir print

RELATED WORKS: Eric (Carl Erickson) (1891–1958), *Dress by Jean Patou (Feminine Elegance)*, 1933, from American *Vogue*

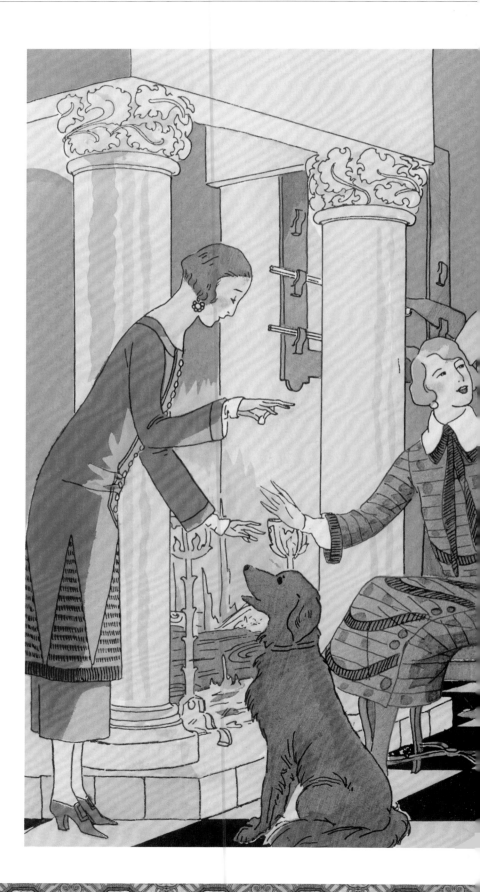

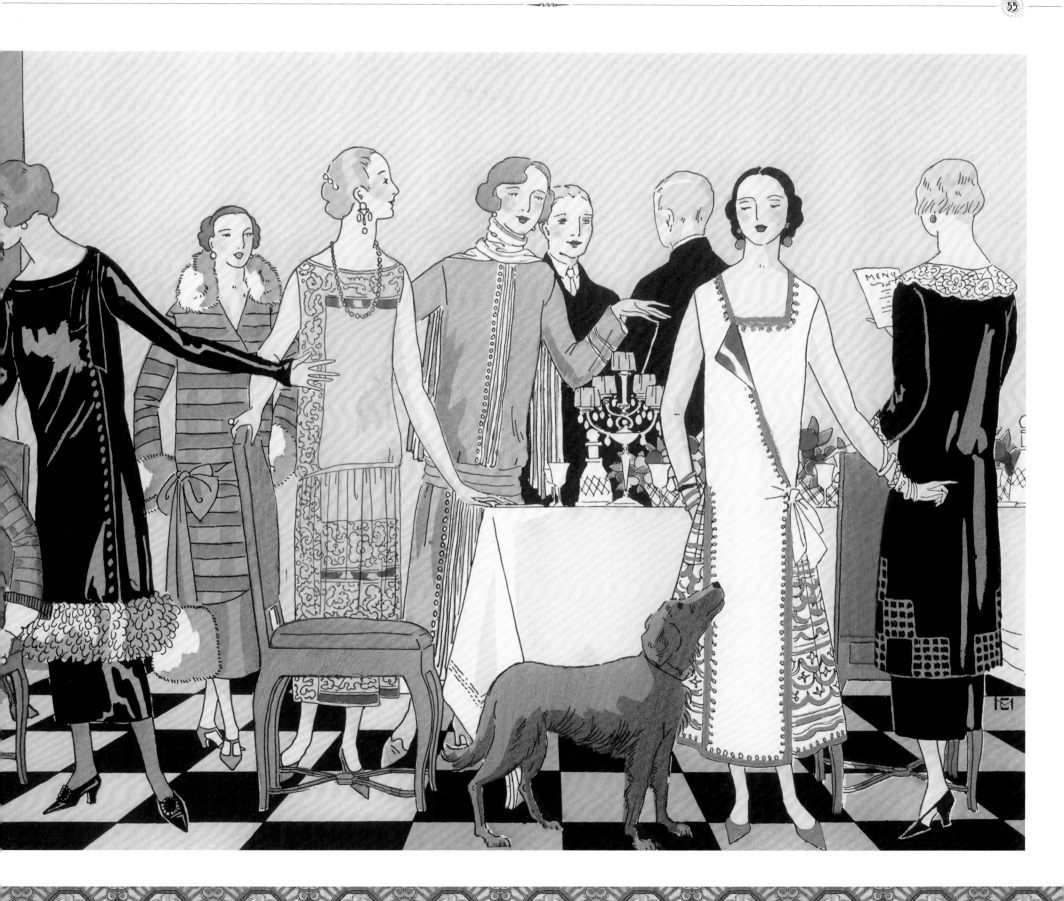

idea of ultimate opulence that the exhibition committee hoped to impart on all visitors. The *Exposition* had been specifically created to promote French decorative and industrial design as much as the individual designers wished to promote themselves.

Exotic, Classic and Original

The designers and manufacturers of expensive Art Deco jewellery competed vigorously with each other. The work of French designer Raymond Templier (1891–1968) shows how creative the jewellery business was, luring buyers to invest in opulent, luxurious pieces, such as his geometric Art Deco *Brooch Set with Diamonds* (*see* page 37). With this in mind, to create his latest collection Georges Fouquet chose the young French architect Eric Bagge (1890–1978), the talented French-Ukrainian poster artist Cassandre and an older artist, the French painter André Léveillé (1880–1963). One can see in Léveillé's designs the direct influence of African art and Synthetic Cubism, while Cassandre was inspired by Cubism and Surrealism, particularly the works of Picasso and the German artist Max Ernst (1891–1976). The influence of those artists on Cassandre's work is evident in his early poster designs.

Furniture, Furnishings and Objets d'Art

Alongside the contemporary style created by Lalique and Fouquet et al., the small *objets d'art* on display were the more affordable luxury pieces. The French designer Marcel-André

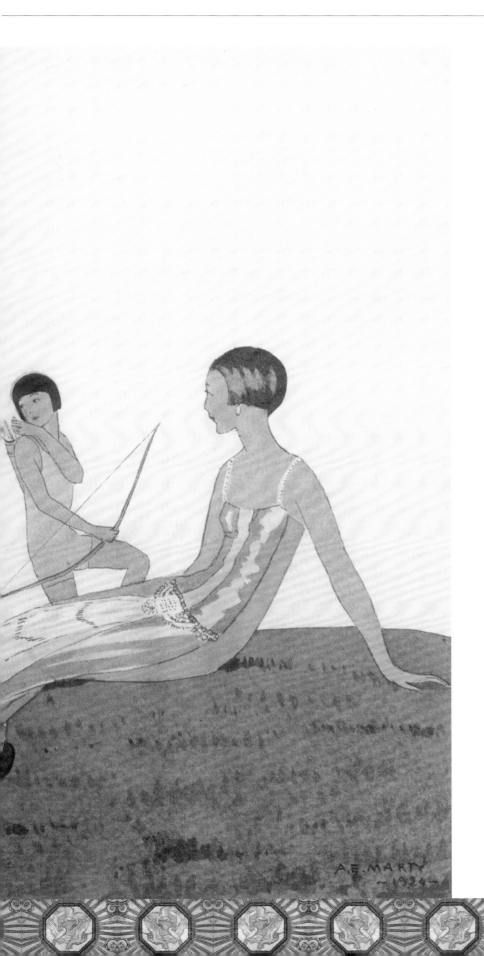

André Edouard Marty
Evening Dresses, 1924,
from *Gazette du Bon Ton*
© Estate of André Edouard Marty/
Mary Evans Picture Library

MEDIUM: Pochoir print

RELATED WORKS: Sandro Botticelli
(*c.* 1444/5–1510), *The Birth of Venus*, *c.* 1485

André Edouard Marty
French Art Deco Wedding, 1930,
from *Harper's Bazaar*
© Estate of André Edouard Marty/
Mary Evans Picture Library

MEDIUM: Pochoir print

RELATED WORKS: Unknown artist,
Feminine Elegance, 1924, from *Art, Goût, Beauté*

Unknown artist
Smart Party Guests (designs by
Paul Poiret et al.), 1926,
from *Art, Goût, Beauté*
© Mary Evans Picture Library

MEDIUM: Pochoir print

RELATED WORKS: Jeanne Paquin
(1869–1936), *Chimère* evening gown, 1925

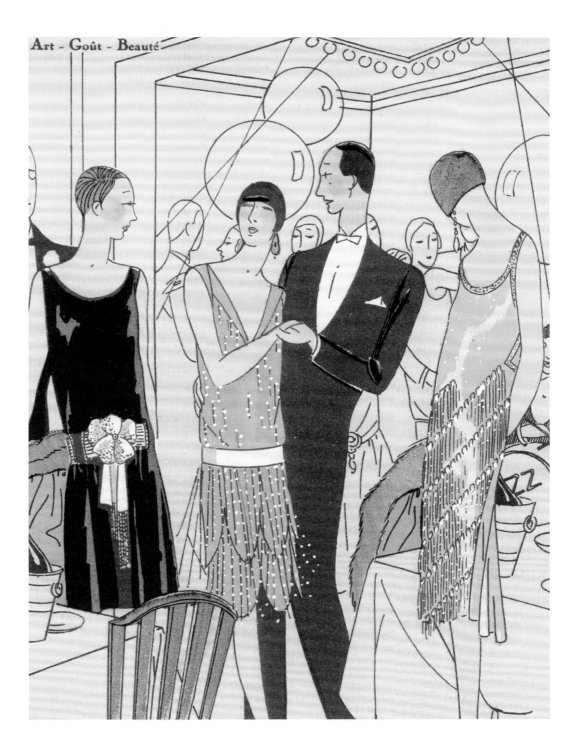

Bouraine (1886–1948) created *Harlequin*, 1925 (*see* page 34) – a female harlequin with modern hairstyle and painted fingernails is seen to be dancing, perhaps to the Jazz music of the new era. The beauty of Jean Dunand's (1877–1942) craftsmanship is visible in *A Grand and Fine Lacquered Wood Panel*, *c.* 1925–29 (*see* page 40), depicting fawns in an Art Deco forest of flowers, swirling mist and tall trees. Such objects, although not cheap, were the type of piece that would be purchased to create an Art Deco look in the home. They would not lose value, going on to become collector's items. Dunand's craftwork was perennially in demand; *La Moisson (The Harvest)*, *c.* 1935 (*see* page 42), executed ten years after the *Exposition*, maintains the quality of his earlier work. Moreover, the pictorial design of this work was to influence commercial illustrators.

Emile-Jacques Ruhlmann

Neither craftsman's work would have been likely to find a place in one of Le Corbusier's all-white houses with flat roof, free interior plan, pilotis (supporting columns), ribbon windows and roof garden. In contrast to Le Corbusier's Esprit-Nouveau house and furnishings, the richly veneered furniture of the French designer Emile-Jacques Ruhlmann (1879–1933) was considered by many visitors to be the highlight of the 1925 *Exposition*. His furniture used rare woods such as Brazilian rosewood, Macassar ebony and the exotic amboyna burl, the three often synthesized in one piece. Mother-of-pearl and ivory inlays used for decorative detail were a design throw-back to the eighteenth century. Using just a touch of classicism, Ruhlmann created modern pieces without historicism, which is exactly what the *Exposition* requested. On style crazes, such as Art Deco, his view was that only the very rich could afford to be fashionable, and he catered for them.

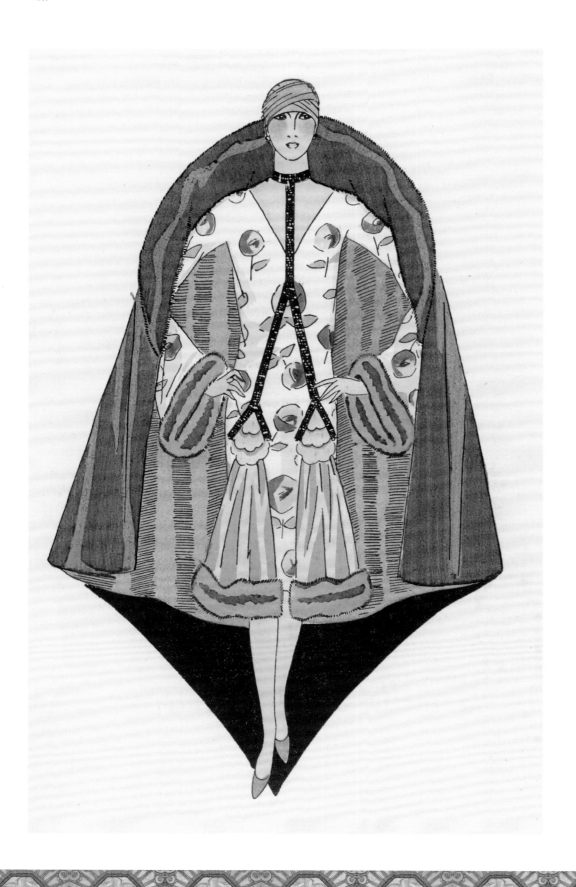

Department Stores — Mass Market for Art Deco

Four of the principal department stores in France built Art Deco pavilions at the *Exposition*: Bon Marché, Grande Magasins du Printemps, Galleries Lafayette and Grande Magasins du Louvre. The main area of promotion for the 1925 exhibition was luxury goods, and many manufacturers made a point of not bringing their mass-produced objects such as carpets, rugs, glassware, lighting and cabinets. The department stores, however, whilst showing objects created by world-class craftsmanship and representing the industrial manufacture of luxury goods, chose to appeal to the mass market too. The ordinary visitor to the exhbition could afford some of the wares exhibited but they would need to go to the stores to purchase them. Each of the stores had their own design studios to capitalize on the decorative arts and stay ahead of, or in line with, the decorative art collectives in Germany and Austria. The Printemps group opened the Primavera studio in 1912 with two *artistes-décorateurs*, followed by graphic designers and architects, growing to a staff of 20 by 1921.

Department-store Policy: Studio Design and Machine Aesthetic

Other major stores followed Printemps to create their own ateliers, employing *artistes-décorateurs*, and commercial illustrators for publicity. By the time of the *Exposition* principal department store groups controlled their own-label design, one offering over nine thousand objects in its design collection, which through advertising had the capability to influence popular taste. At the *Exposition* it was their goods that were affordable to the masses. Some *artistes-décorateurs* expressed concern that mass production would mean a loss of quality to quantity, but strict controls on design and production countered the argument, and it was good business. Beautiful objects such as a silvered bronze clock (*see* page 41) by Edgar Brandt were difficult to produce,

with intricate metalwork details – although timepieces could be reproduced in cheaper metals; but the decorative style of the lacquered panel, such as *Panneau de Laque d'Or Gravé* (*see* pages 38–39) by Jean Dunand (1877–1942), could be copied using machine tools and cheaper materials.

Art Deco Defines the Age of the Machine

The 1925 *Exposition* had confirmed public enthusiasm for the Art Deco style, known too as *Art Moderne* and *Jazz Moderne*, and it would maintain high popularity until the early years of the Second World War. The machine aesthetic of the *Expo* coincided with increased public interest in luxury transport, particularly the sports car, the aeroplane and transatlantic ocean liner steamships. *Self Portrait (Tamara in the Green Bugatti)*, 1925 (*see* page 82), by Polish-born artist Tamara de Lempicka (1898–1980) and commissioned for the front cover of a German fashion journal, captures the mood for speed. The symbolism of an image of a beautiful woman in control of a fast sports car, enjoying success and freedom in a machine-motivated world was a revelation; Lempicka used the sexy car as a metaphor for women's emancipation. A Dutch lithograph poster by Willem Frederick Ten Broek (1905–93) advertising the Holland-America line, 1936 (*see* page 70), captures the vast size of the steamship in comparison with an abstract sailing boat in front of it. The bold colours, crisp, clean lines and sharp angles of the design are the culmination of the streamlining trend of the

Unknown artist
Poiret Evening Dress, 1926,
from *Art, Goût, Beauté*
© Mary Evans Picture Library

MEDIUM: Pochoir print

RELATED WORKS: Georges Lepape,
Sorbet, 1912, from *Art, Goût, Beauté*

Erté
Cover of *Harper's Bazaar*,
April 1933
Courtesy of Mary Evans Picture Library/
National Magazine Company/© Sevenarts Ltd

MEDIUM: Unknown

RELATED WORKS: Erté, First cover of
Harper's Bazaar, January 1915

Art Deco style and all help to emphasize the thrusting power of the ship and the concept of ploughing full steam ahead into the future of travel and technology.

Art Deco Women – Modernism and Nudity

Lempicka's earlier painting *Perspective*, 1923 (*see* page 45), which uses the geometry of the Art Deco style, is significant in its continuation of a Cubist-inspired interpretation, similar to the work of Picasso and the Greek-born Italian artist Giorgio de' Chirico (1888–1978). The disconcerting portrait of two naked, muscular women with heavily painted faces, sitting and lying in close proximity, highlights the growing acceptance of lesbianism and counteracts the feminine style of women promoted in *Gazette du Bon Ton*, such as *Le Pouf, Robe du Soir*, 1924 (*see* page 53), which shows a floor length floral Paul Poiret evening dress, illustrated by Jean Bernier (active 1910–25) and Léon Bakst. In contrast Lempicka creates a shadowy landscape where the spectator enters the space of the female couple. She uses de' Chirico's technique of blurring the edges between ancient and modern, real and unreal, internal and external spaces, using classicism to recreate the modern world. Her portrait of *Andromeda*, 1928–29 (*see* page 47), in the style of the sensuous nude portraits by Jean-Auguste-Dominique Ingres (1780–1867), uses the city backdrop to emphasize the female still chained to the role of naked beauty. *Les Perruches* (*The Parakeets* or *The Parrots*), 1925 (*see* page 52), by Jean Dupas (1882–1964) compares the roles of women, from chattering birds to sultry Eves. It is very reminiscent of Pablo Picasso's equally suggestive *Les Demoiselles d'Avignon*, 1907, and the paintings of Paul Delvaux (1897–1994).

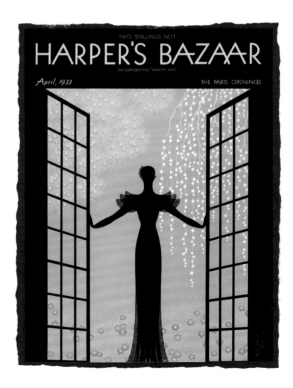

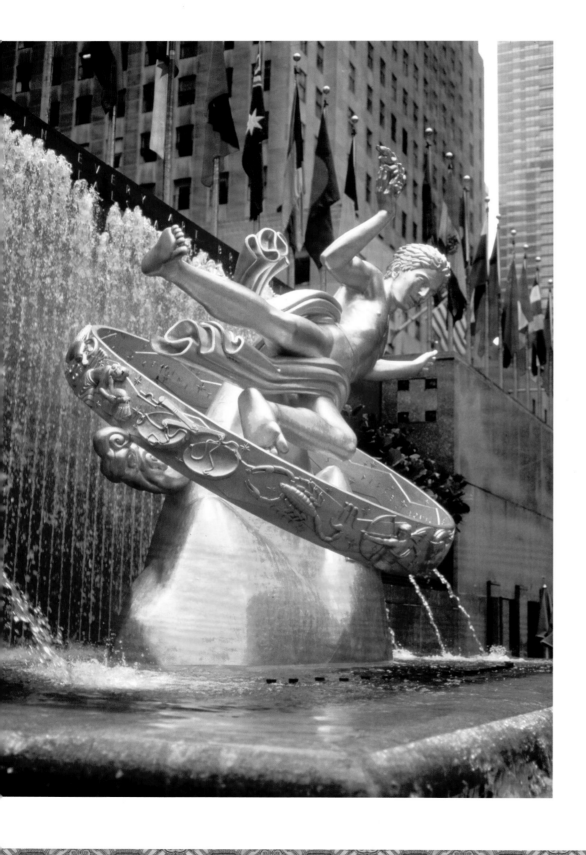

Illustrating Art Deco Women: Daywear and Social Gatherings

In contrast to Lempicka's challenging women, the fashion brochures and magazines from 1909–30 focus on the socialite lifestyle of the well-dressed woman. The nineteenth century in Europe had been steeped in the formal requirements of dress code. For women invited to the homes of the aristocracy this meant an expected change of dress at least three times, perhaps four, in a day. One can see in *Feminine Elegance*, 1924 (*see* pages 54–55), an illustration from the magazine *Art, Goût, Beauté* ('Art, Taste, Beauty'), the French high-fashion daywear designed to fit the social rigours of tea parties at home with friends, family and dogs in attendance. A group of women wearing dresses designed by Patou, Poiret, Premet, Doeuillet and others, mingle in a stylized room complete with classical columns; each dress carries the mark of Art Deco in its geometric shape or pattern and the flat two-dimensional design of the image highlights its modernity.

Painting Arlette Boucard

Lempicka's *Portrait of Madame Boucard*, 1928 (*see* pages 48–49), is one of three portraits she painted of Arlette Boucard. It depicts the reality of a socialite female living through the 1920s.

Paul Manship
Prometheus Fountain,
Rockefeller Center, 1934

© Estate of Paul Manship/2004 Charles Walker/Topham Picturepoint

MEDIUM: Cast bronze with 24kt gold leaf

RELATED WORKS: Lee Lawrie, *Atlas Sculpture*, Rockefeller Center, 1932–34

Lee Lawrie
Wisdom, **Entrance portal to Raymond Hood's RCA Building, Rockefeller Center, 1932–40**

© Estate of Lee Lawrie/akg-images/Günter Lachmuth

MEDIUM: Gilt bronze and stone relief

RELATED WORKS: W. Blake (1757–1827) *Urizen as the Creator of the Material World*, 1794

She stares out confidently to the spectator, her short hair worn in the fashionable wave style. Her clothes are timeless yet contemporary. Behind her a Cubist-style sea harbour of ocean liners partially hides a small town on the hill. Lempicka has illustrated the new woman of the Art Deco era; independent, emancipated, confident. Lempicka's pose for her is reminiscent of *Olympia*, 1863–65, by the painter Edouard Manet (1832–83). Couturiers were quick to create stunning high-fashion designs for clientele such as Madame Boucard. To be the designer of the clothes worn by a society gathering of the Parisian elite was the best type of self-promotion a designer could wish for. In particular it is designers such as Worth, Patou, Poiret and Paquin that were instrumental in promoting the new look of shorter-length skirts and slim-fitting clothes without a stiff corset or prewar bustle. The new freedom of travel by car, plane and ocean liner demanded clothes that would fit the modern lifestyle. French couturiers obliged.

Illustrating Art Deco Women: Evening Wear and Party Frocks

Whilst *The Dancer*, c. 1920s (*see* page 51), by Raphaël Delorme, combines an exotic narrative of naked African musician, a statue of the ancient Greek poetess Lesbia and a swirling female dancer and onlooker – perhaps to hint at lesbian activities on the party scene – the regular two-dimensional graphics of *Smart Party Guests*, 1926 (*see* page 59), an illustration from the November 1926 edition of *Art, Goût, Beauté*, exudes Art Deco modernity in its execution. The socialites of the *Jazz Moderne* world are depicted in conversation at an event which calls for 'smart' party wear. The rules of etiquette on what to wear were being confirmed and rewritten by the couturiers who designed the fashion. The influence of the 'Roaring Twenties', the Charleston dance craze and flapper style had seeped into the elegance of the evening frocks. It is noticeable in the majority of fashion illustrations that the man is assigned a low-profile role, as here, always in smart but plain evening wear, usually white-tie evening dress.

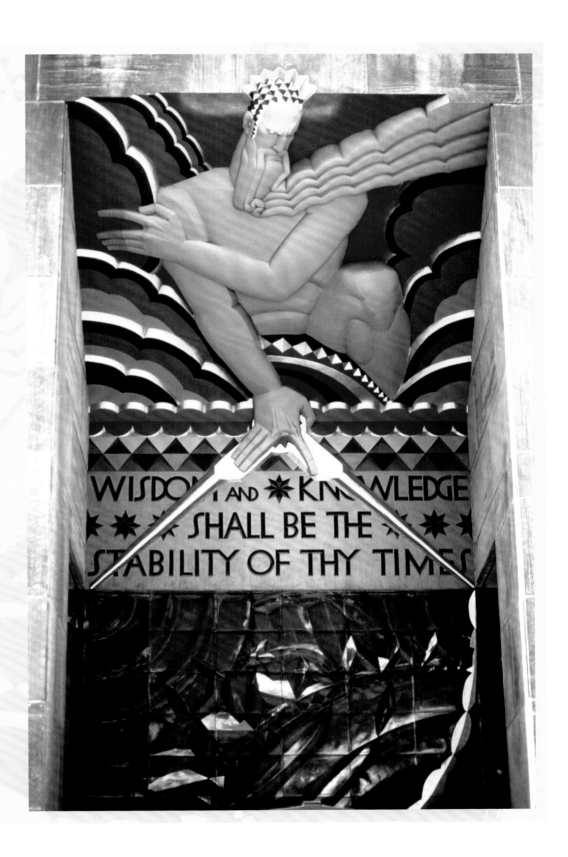

Lee Lawrie
Sound, above the left entrance of
**Raymond Hood's RCA Building,
Rockefeller Center, 1932–40**
© Estate of Lee Lawrie/akg-images/Robert O'Dea

MEDIUM: Gilt bronze and stone relief

RELATED WORKS:
Jean Broome-Norton (1911–2002),
Abundance, 1934

Lee Lawrie
Light, above the right entrance of
**Raymond Hood's RCA Building,
Rockefeller Center, 1932–40**
© Estate of Lee Lawrie/akg-images/Robert O'Dea

MEDIUM: Gilt bronze and stone relief

RELATED WORKS:
René Lalique, *The Spirit of the Wind*,
car mascot, 1928

Avant-garde Mythology and Reality

Evening Dresses, 1924 (*see* pages 56–57), a hand-coloured fashion
plate by André Marty for *Gazette du Bon Ton*, illustrates a fur-
trimmed evening coat and three evening dresses by Poiret.
However, Marty takes the party outdoors into a mythological,
pastoral landscape, with the four women evoking Venus and

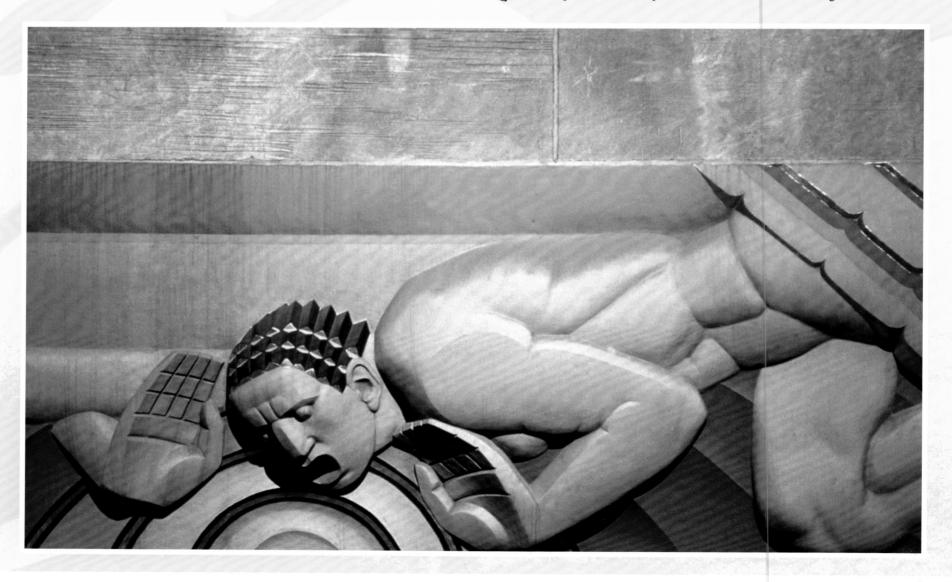

the Three Graces in modern dress. Art Deco-style 1920s hair bobs are evident. The blue and gold dress inspired by ancient Egypt capitalizes on the 1922 discovery of the tomb of Tutankhamen in Luxor. In contrast, Lempicka's sultry woman in *La Musicienne*, 1929 (*see* page 50), is portrayed in evening dress against a city backdrop. There is unease in the depiction; the fabric of her deep blue-purple dress rises like an angel's wing as it catches the wind and she plays a stringed instrument. The modernity of Lempicka's painting is striking. She too, like Marty, captures the Art Deco movement's fusion of classical and modern.

Edouard Bénédictus (*overleaf left*)
Book Plate 9 (detail), from *Relais*, 1930
© V&A Images, Victoria and Albert Museum

MEDIUM: Pochoir print

RELATED WORKS: Charles Rennie Mackintosh (1868–1928), *Basket of Flowers*, 1910

Edouard Bénédictus (*overleaf right*)
Book Plate 1 (detail), from *Relais*, 1930
© V&A Images, Victoria and Albert Museum

MEDIUM: Pochoir print

RELATED WORKS: Henri Matisse (1869–1954), *The Goldfish*, 1912

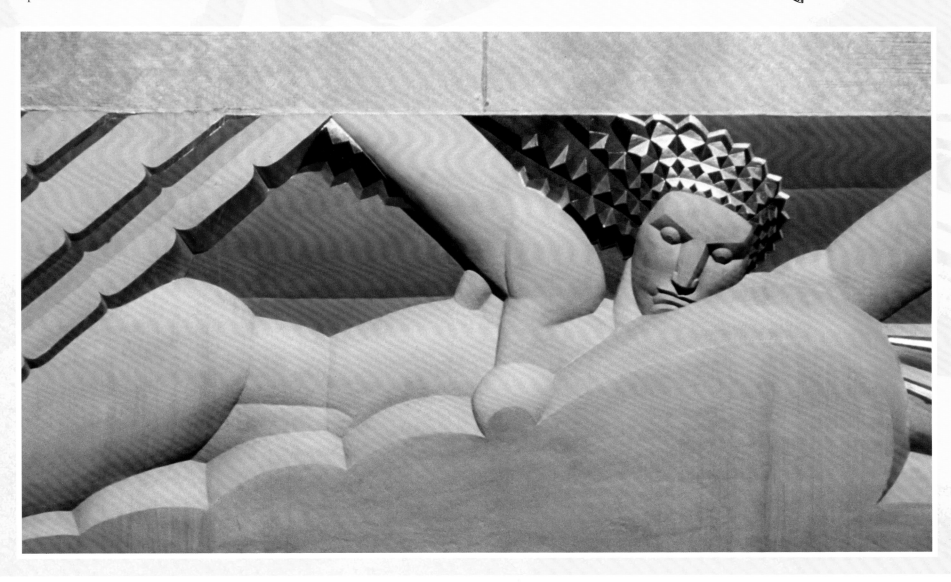

New York, New York
— American Art Deco

American interest in the French Art Deco style gained
momentum following the 1925 *Exposition*. The style, so fitting for
the Roaring Twenties and the Jazz Age, epitomized the socialite
embracement of the new. The movement spread to the United
States through a variety of design forms. Advertisers used the
Art Deco style as a marketing tool to repackage goods, to create
new appeal to consumers. Sharp, geometric design and bright
colour gave an impression of modernity to ordinary brands.
Alongside 'streamlining', American Art Deco motivated the
country's designers and the public, particularly after the Wall
Street Crash of 1929 and the ensuing Great Depression years.
The passion for Art Deco design spread from mass-produced
objects to the architecture and sculpture of the American city.

Chrysler Building,
New York, 1928–30

The rise in height of the American skyscraper reached dizzying
proportions by the beginning of the 1930s. Competition to
build the tallest skyscraper led to diverse tricks to add even
greater height to monumentally tall buildings – one being the
use of additional spires. Designed by architect William van Allen
(1883–1954), the Chrysler building was built from 1928 to 1930.

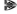

Tamara de Lempicka
New York, c. 1930–35

Courtesy of Private Collection/Christie's Images/
The Bridgeman Art Library/© ADAGP, Paris
and DACS, London

MEDIUM: Oil on canvas

RELATED WORKS: Tamara de Lempicka,
Portrait of Mrs Alan Bott, 1930

Albert Staehle
Poster for the *New York
***World's Fair*, 1939**

© Estate of Albert Staehle/Christie's Images Ltd

MEDIUM: Lithograph

RELATED WORKS: John Atherton,
Poster for the *New York World's Fair*, 1939

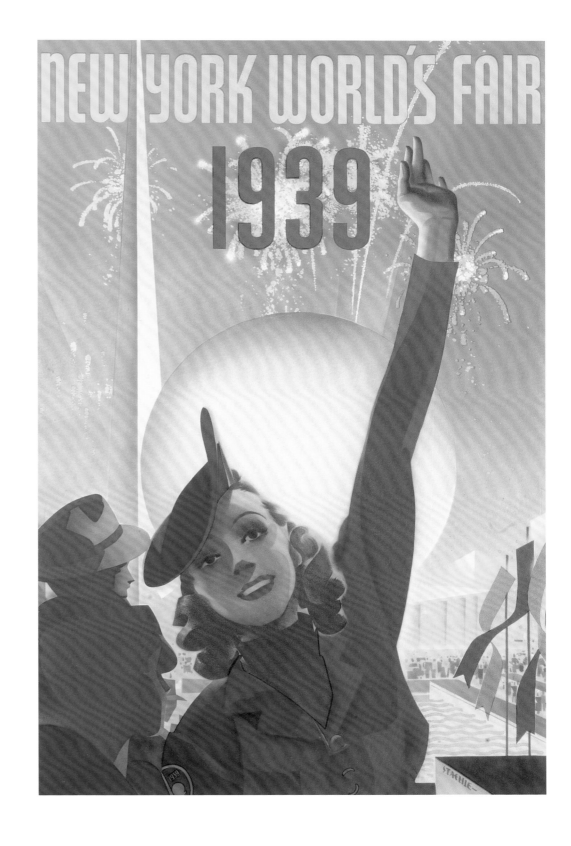

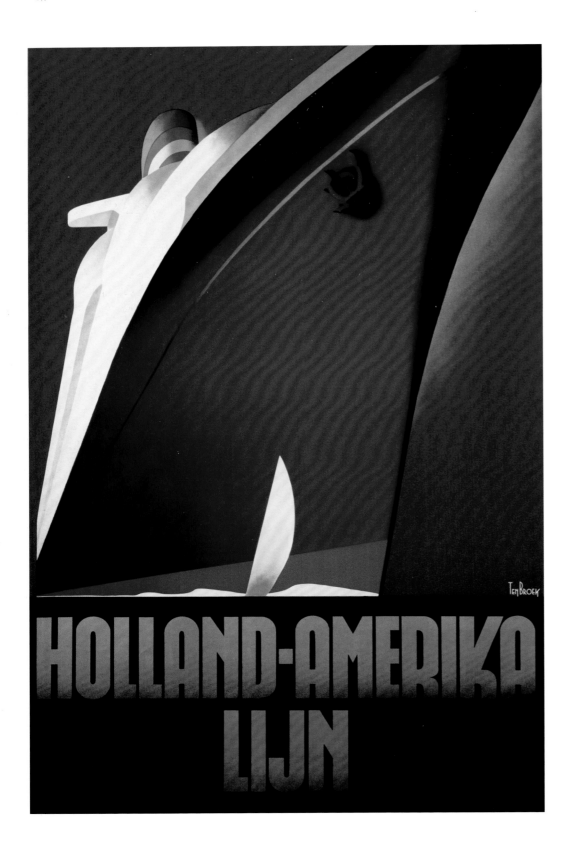

HOLLAND-AMERIKA LIJN

At 319 m (1,047 ft), it was the world's tallest building until overtaken by the Empire State building in 1931. However, the Chrysler building, as an icon of the Art Deco era, remains one of the most admired, richly decorated skyscrapers in the world. Its shiny metallic coat, a reference to Chrysler cars, is complete with pinnacle, underneath a spire of geometric sunbursts. The building is pure Art Deco and confirms American Art Deco as an art form. Paintings from the era capture the modernity of high-rise living – Tamara de Lempicka's Art Deco *New York*, c. 1930–35 (*see* page 68), illustrates the stepped-back skyscrapers of the Manhattan skyline, anonymous creations of stone, glass and metal enveloped by a densely polluted sky.

The Rockefeller Center, New York, 1932–40

In New York City Raymond Hood (1881–1934), the senior architect of the new Rockefeller Center (1932–40), planned a complex of 19 buildings in midtown Manhattan. The centrepiece block, designed by Hood, was the 70-floor skyscraper of the RCA building (now General Electric building). Hood commissioned Art Deco sculpture and architectural reliefs to adorn and enliven the solemnity of the austere limestone facades, with the sculpture programme planned by Hartley Burr Alexander (1873–1939). The sculptor Lee Lawrie (1877–1963), a German émigré and one of the foremost architectural sculptors of his generation, created twelve pieces – including an Art Deco sculpture of the mythical *Atlas*, 1934, for the Fifth Avenue entrance. For the portal above the entrance to the RCA building Lawrie produced the allegorical figure of *Wisdom*, 1934 (*see* page 63). Based on a watercolour,

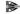

Willem Frederick Ten Broek
Poster for *Holland Amerika Lijn*, **1936**
© Estate of Willem Frederick Ten Broek/Christie's Images Ltd

MEDIUM: Lithograph

RELATED WORKS: Andrew Johnson, Poster for *Orient Cruises*, 1930s

Leslie Ragan
Poster for the *New York Central System*, 1951

© Estate of Leslie Ragan/Christie's Images Ltd

MEDIUM: Lithograph

RELATED WORKS: A.M. Cassandre, Poster for the *Nord Express*, 1927

Urizen as the Creator of the Material World, 1794, by the English artist William Blake (1757–1827), the imagery is Blake but the decorative elements are pure Art Deco in form, from the cast-glass panes, to the metallic details of the relief. So too in *Sound* and *Light*, 1932–40 (*see* pages 64 and 65), above the left and right entrances to the RCA building, both Art Deco in style and form. Paul Manship (1885–1966) continued the Art Deco theme in the gilded bronze centre-piece fountain portraying the Greek Titan *Prometheus*, 1934 (*see* page 62), bringing fire to the world. It dominates the sunken plaza in front of the Rockefeller Center.

Harper's Bazaar, New York

The Art Deco style crossed the Atlantic not only via the interior design of cruise liners, but in many ways through the output of the commercial illustrators, the graphic artists whose work was available through publications in the United States. French Art Deco had arrived in the form of advertisements and editorial in fashion magazines such as *Harper's Bazaar*. Its October 1930 edition contained Marty's illustration *French Art Deco Wedding* (*see* page 58). The illustration identifies bridesmaids and escorts leaving the church at a sophisticated Art Deco wedding in France. The bridesmaids wear elegant gowns designed by Martial et Armand. The cover of the April 1933 *Harper's Bazaar* by Erté (*see* page 61), one of many he created under a lucrative contract with the magazine, shows the silhouette of an elegant woman in long evening dress opening French windows onto a ravishing garden in full bloom. Through fashion journalism in the United States the Parisian world of couture and the Art Deco style found a new audience, from big business to Hollywood.

On The Move Along The Water Level Route

NEW YORK CENTRAL SYSTEM

CALENDAR FOR 1951

1826—125th Anniversary of one of America's Great Railroads—1951

Typography, Books and Advertising

Commercial illustrators and creators of poster art had risen in celebrity following Alphonse Mucha's sensational overnight rise to fame creating theatre posters and advertisements for the French actress Sarah Bernhardt (1844–1923) in Paris from 1895 to 1903. Robert Bonfils, Cassandre, Paul Colin (1892–1985), Albert Staehle (1899–1974) and Leslie Ragan (1897–1972) are a few of the names synonymous with Art Deco typography and innovative poster advertising. Cassandre was to go on to launch his own advertising agency, Alliance Graphique, and to create new typefaces, such as *Bifur* in 1929, the sans serif *Acier Noir* in 1935 and *Peignot* in 1937. From 1914 to 1928 the demand for graphic design for mass-production commodities had doubled. New innovations in print technique revitalized the industry.

Bold New World of Art Deco

From Robert Bonfils's poster for the Paris Exposition in 1925 (*see* page 32) to Albert Staehle's poster for the 1939 New York World's Fair (*see* page 69), the style was characterized by the bold lettering and many new typefaces that illustrators developed. The typography process had been studied closely in the nineteenth century by William Morris and the Arts and Crafts guilds, and was taught at the Bauhaus – located in Weimar from 1919 to 1925, Dessau from 1925 to 1932 and finally in Berlin from 1925 to 1933, before being forcibly closed by the Nazi regime. The creative output of the many Bauhaus Masters, including

Jean Dupas
Angels of Peace, 1948
© Estate of Jean Dupas/Private Collection/
The Bridgeman Art Library

MEDIUM: Oil on canvas or card

RELATED WORKS: Pablo Picasso
(1881–1973), *Dove of Peace*, 1949

Walter Gropius, Hannes Meyer (1889–1954) and Ludwig Mies van der Rohe, promoted graphic design – typography and illustration – as a worthy decorative art. The competitive nature of Europe created modernity in advertising; French modern graphics had led the way forward. Two works, *Book Plate 1* and *Book Plate 9* both from *Relais*, 1930 (*see* pages 66 and 67), by the French illustrator Edouard Bénédictus are timeless in their modernity. The book was a posthumous appreciation of his work in an eclectic mix of various designs. An appreciation written by Yvanhoé Rambosson considered him to be an innovator fulfilling the 'potential of the mechanical production'.

New York World's Fair, 1939

The World's Fair held in New York in 1939 was an opportunity for the city to revive itself after the Great Depression years (1929–38). The prized poster for the fair (*see* page 69) by renowned American illustrator Albert Staehle, shows the Deco-style monumental white buildings of the fair, the *Trylon* and *Perisphere*, set against a colourful background of fireworks lighting up the sky. A young woman, an official of the fair, with stylish uniform and jaunty hat, leans forward into the picture frame with arm raised towards the sky, to greet the visitor and the new era. The typography of Staehle's poster is consistent with the advances made in the United States in this field. Since the 1925 *Exposition* in Paris, print foundries with the latest technology had been set up in the United States to create stronger typefaces for more effective poster advertising campaigns.

Art Deco Gracefully Fades

The Deco style with pared down classicism, sharp lines and use of geometric contrasts continued to remain popular long after the craze for Art Deco faded in a Europe living through the years of the Second World War. In the United States the iconography of the style would re-emerge from time to time, primarily in poster art to evoke the excitement of travel by steamship or aeroplane. The poster celebrating the 125th anniversary of the New York

Central System, 1951 (*see* page 71), by Leslie Ragan, looked back to that exciting, innovative period. Ragan is recognized for his particular niche: the locomotive in the American landscape.

His paintings of railroad trains all mythologize speed in the age of steam. The anniversary poster, for one of the United States's pioneering railroads, harks back to the highpoint in the American

Art Deco era to reproduce the 'streamline' train with Deco chevrons, a marketing tool to encourage consumer spending on travel and other commodities. To the right of the image an industrial factory is a landmark en route across the United States. The poster sums up an era. It may reflect the opulent, luxurious lifestyle of the rich but for the masses its popularity in the United States symbolized the Roaring Twenties to the Thirties' Jazz Age; a modern life and an opportunity to embrace the future.

Art Deco Revivals

Postwar France took time to come to terms with its losses after 1945. Jean Dupas' *Angels of Peace*, 1948 (*see* page 73), captures the mood of France – a dove of Peace is held gently in the palm of an angel's hand. The soft colours and side profiles of the angels are in remarkable contrast to Dupas' earlier work *Les Perruches* (*The Parakeets* or *The Parrots*), 1925 (*see* page 52), which reveals the use of cubism and classicism to evoke the heady days of plenty. However, Dupas continued to use Art Deco techniques in the clean strong lines and use of colour. In Paris the once-vibrant art and design fraternity had moved on or dissipated when France was occupied by enemy forces. One of the few to stay was the Spanish artist Pablo Picasso, one of the unwitting instigators of the Art Deco style that rose out of the early twentieth-century art and craft movements. Many of Europe's finest graphic artists, architects and painters had moved to the United States, to set up studios there. The New York Ashcan School was to take hold from 1939 onwards.

High Points of Art Deco

To recall the exuberance of the Art Deco era one can look to the architecture of Chicago and New York of the 1920s and 1930s, particularly New York's Art Deco Chrysler building. In Europe and the United States the 1980s Post Modern era found architects and designers using the geometric classicism and recognizable emblems of the Art Deco period to create new forms, but it has been difficult to achieve. The *Zeitgeist* of the era needs to be present and it has faded, much like Art Nouveau faded as a movement and style. To recall the high points of Art Deco one should look to Erté's colourful sketches such as *Feather Gown*, 1985 (*see* right), to recognize the Deco style of the Empire-line in the bejewelled bustier top with a gown of vibrantly colourful red, orange and yellow pheasant-eye feathers. His design captures the exoticism of the Ballets Russes mixed with Orientalism and Muthesius' interest in the designs of Charles Rennie Mackintosh. The 1960s Art Deco revival in England was evident in fashion, interior design and the decorative arts. The fashion for multi-coloured shorter dresses was reminiscent of the fabulous 'flapper' fashion dresses of the Twenties, Paul Poiret's evening dresses being prominent examples (*see* 1926 illustration on page 60). The difference in the 1960s was the cost of clothes, such as those designed by fashion illustrator Barbara Hulanicki for her Biba fashion shop in London – the clothes were affordable in order to capture the youth market.

Erté
Feather Gown, 1985

© Sevenarts Ltd

MEDIUM: Serigraph

RELATED WORKS: E. Serine (dates unknown), Various fashion plates, *c.* 1914

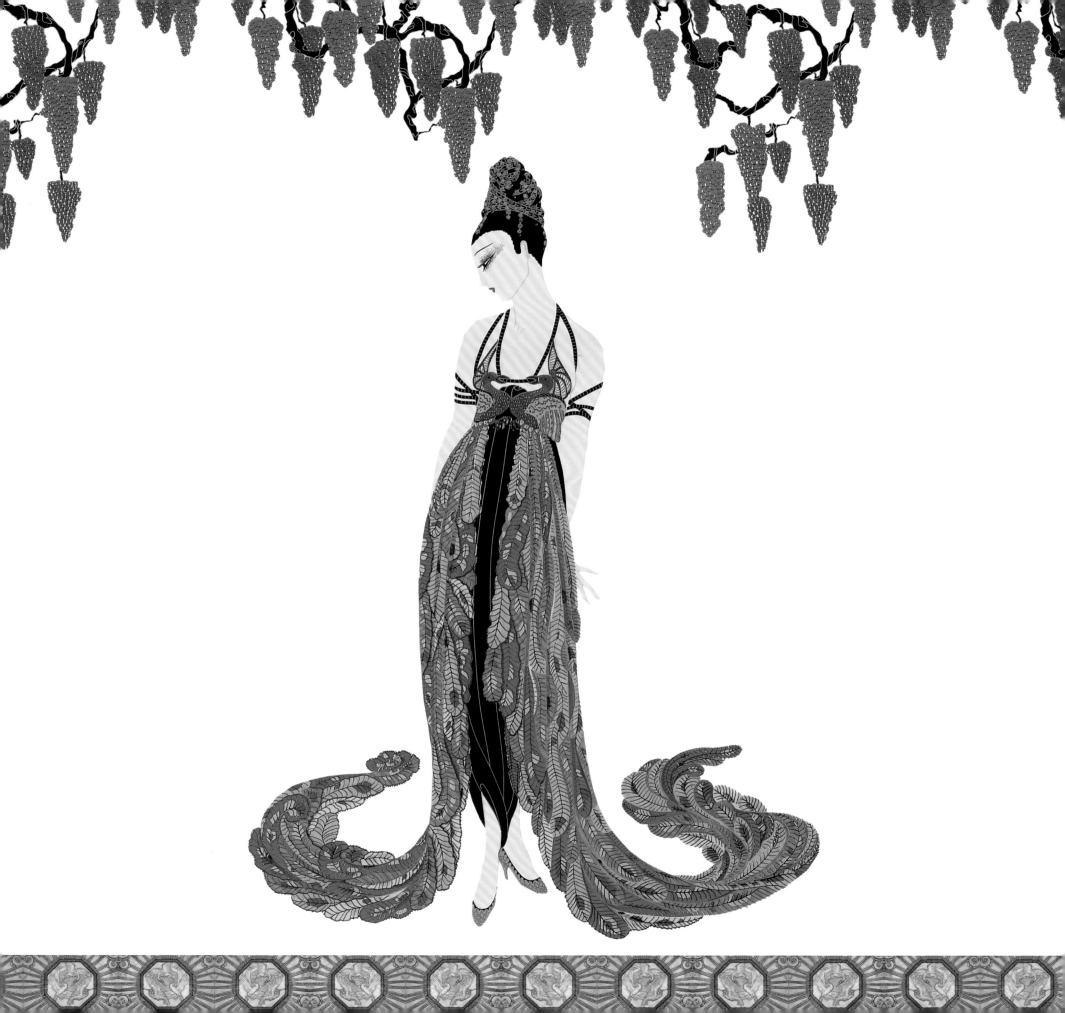

SECTION TWO:

FASHION

TAMARA DE LEMPICKA
(1898–1990)

Early Life

Tamara de Lempicka was born into a privileged society in Warsaw at the height of the so-called *Belle Époque* in 1898, a time when the first fruits of European *modernisme* were manifest. Her father was a lawyer and both he and her mother came from *haute-bourgeois* and educated families. From an early age she was marked out as an unconventional child who preferred the company of her grandmother during school holidays. During one vacation she was taken to Italy where she discovered the paintings of the Renaissance masters, an influence that was to remain with her throughout her career. Although she painted in a modern idiom, *The Orange Turban*, 1935 (*see* left), clearly demonstrates her homage to Raphael (1483–1520). At the outbreak of the First World War, Tamara was living with her aunt in St Petersburg where she discovered contemporary Russian academic painters such as Boris Grigoriev (1886–1939). Her painting *The Green Turban*, 1930 (*see* right), uses a similar palette and forms as the Russian artist. It was while in Russia that Tamara met and married her first husband Count Tadeusz de Lempicki in 1916. The following year she was forced to flee Russia following the Bolshevik Revolution and the arrest of her husband by the Cheka, Lenin's secret police. After only a short while, Tadeusz was released and joined Tamara in Copenhagen before they both emigrated to Paris, where she had decided to settle and become an artist. Her first tutor was

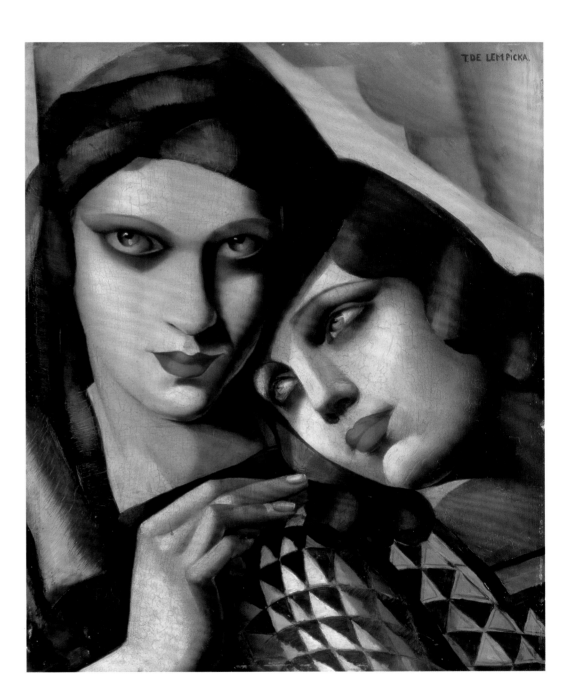

Tamara de Lempicka
The Orange Turban, 1935

Courtesy of Musée des Beaux-Arts Andre Malraux, Le Havre, France, Giraudon/The Bridgeman Art Library/© ADAGP, Paris and DACS, London

MEDIUM: Oil on canvas

RELATED WORKS: Raphael (1483–1520), *Portrait of a Woman*, 1512

Tamara de Lempicka
The Green Turban, 1930

Courtesy of Private Collection/The Bridgeman Art Library/© ADAGP, Paris and DACS, London

MEDIUM: Oil on panel

RELATED WORKS: Pablo Picasso (1881–1973), *Three Women at the Spring*, 1922

Maurice Denis (1870–1943), a Symbolist artist who taught her the decorative qualities of design in painting. However, it was her subsequent lessons with the Cubist painter André Lhote (1885–1962) that exerted the greatest influence, through introductions to his contemporaries Pablo Picasso (1881–1973)

and Fernand Léger (1881–1955). It is probably the latter whose female forms are most reflected in Tamara's nudes, erotic studies and female portraits, such as *Young Girl in Green* (or *Young Lady with Gloves*), 1927–30 (*see* right).

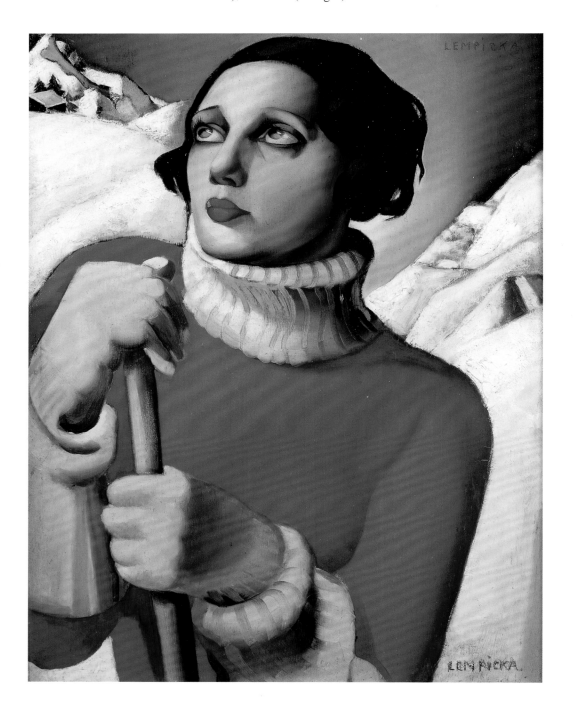

Tamara de Lempicka
St Moritz, 1929

Courtesy of Musée des Beaux-Arts, Orleans, France, Giraudon/The Bridgeman Art Library/© ADAGP, Paris and DACS, London

MEDIUM: Oil on wood

RELATED WORKS: Emil Cardinaux (1877–1936), Skiing posters, 1930s

Tamara de Lempicka
Young Girl in Green
(Young Lady with Gloves), 1927–30

Courtesy of Musée National d'Art Moderne, Centre Pompidou, Paris, France/The Bridgeman Art Library/© ADAGP, Paris and DACS, London

MEDIUM: Oil on canvas

RELATED WORKS: Fernand Léger (1881–1955), *Three Women*, 1921

The Career Woman

The painting *Self-Portrait (Tamara in the Green Bugatti)*, 1925 (*see* page 82), appears to us today as iconic of its era, and so it was in its own day, symbolizing the newly emancipated woman of the 1920s. The German fashion magazine *Die Dame* commissioned the painting for its front cover, one of several that Tamara was to undertake. This cool image, suggesting the empowerment of women in a new age, made her an overnight success. Although Tamara never owned a Bugatti, she socialized with many aristocratic and wealthy people who probably did, associations that ultimately led to a number of commissions to paint the rich and famous in the interwar years. Among these patrons was Baron Kuffner, whom she painted in 1928 and who was to become her second husband five years later. Many of Tamara's introductions to high Parisian society were through her acceptance at the salons of the wealthy and influential socialite Natalie Barney who encouraged the arts, particularly literature, and counted among her friends F. Scott Fitzgerald (1896–1940), Ernest Hemingway (1899–1961) and T.S. Eliot (1888–1965), as well as Isadora Duncan (1878–1927) and Peggy Guggenheim (1898–1979). Her commissions were not confined to Paris either; in 1929 she travelled to New York for the first of her many American commissions. The self portrait in a green Bugatti was for the wealthy industrialist Rufus T. Bush.

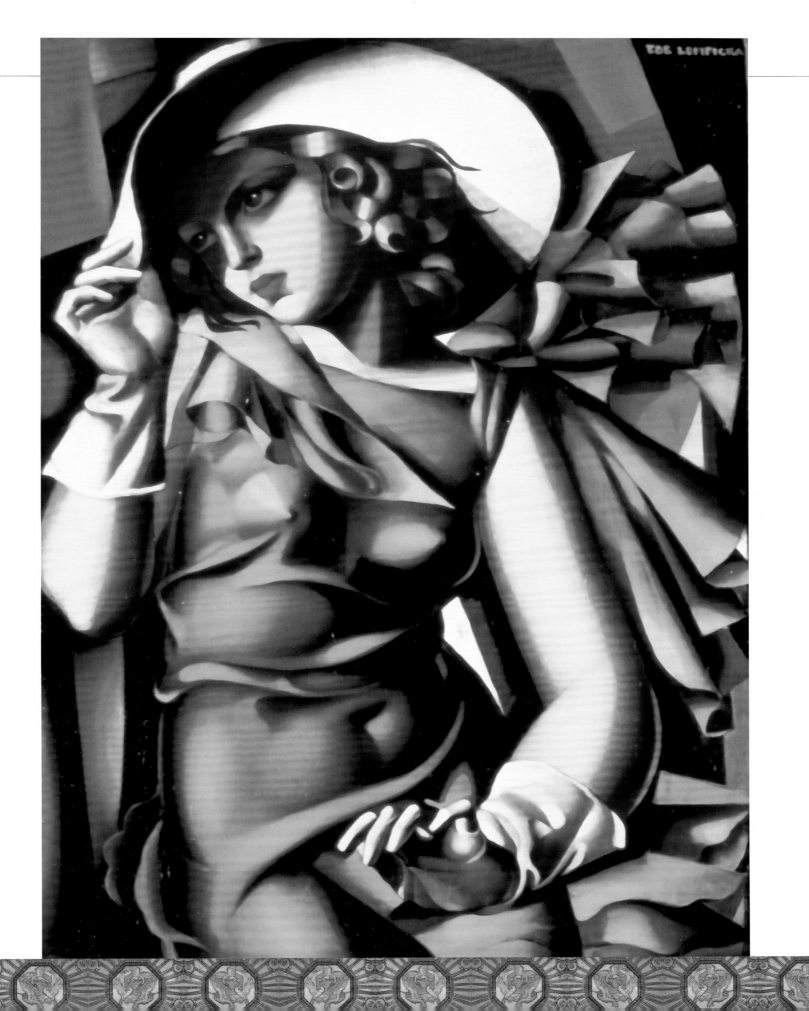

From Parvenue to Aristocrat

Tamara built on her connections establishing a formidable reputation in Parisian society for her stylized portraits that had found an enthusiastic audience. She showed her work at the fashionable art dealers such as Gallerie Colette Weil as well as the Salons, and was awarded prizes in Paris, New York and even in Warsaw. In 1932 her painting *Young Girl in Green* was purchased at 8,000 francs by the Musée du Luxembourg in Paris for their permanent collection. Apart from the portraits, she often painted erotic images of singularly posed women, groups and couples, as well as the *haute-bourgeoisie* at leisure. The painting *St Moritz* is an example of the latter, which was painted in 1929. In the previous year, St Moritz hosted the Winter Olympic Games and has remained a firm favourite with the affluent ever since. Tamara's marriage to the wealthy and titled Baron Raoul Kuffner in 1933 enabled her to be more selective about the commissions she accepted. She was now free to concentrate on only those paintings that excited and inspired her.

Kizette

Kizette de Lempicka, Tamara's daughter from her first marriage to Tadeusz was born in 1916. The artist often sought to distance herself from her daughter, sometimes not even telling her friends of her existence. The painting *Kizette en Rose*, 1926 (*see* right), is one of many portraits that Tamara painted of her daughter, some of which, such as *Girl on a Balcony*, 1927, do not name the sitter.

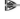

Tamara de Lempicka
Self-Portrait (Tamara in the Green Bugatti), 1925

Courtesy of Private Collection, Paris/akg-images/ © ADAGP, Paris and DACS, London

MEDIUM: Oil on wood

RELATED WORKS: J.A.D. Ingres (1780–1867), *Madame Panchoucke*, 1811

Tamara de Lempicka
Kizette en Rose, 1926

Courtesy of Musée des Beaux-Arts, Nantes, France, Giraudon/The Bridgeman Art Library/ © ADAGP, Paris and DACS, London

MEDIUM: Oil on canvas

RELATED WORKS: Tamara de Lempicka, *Girl on a Balcony*, 1927

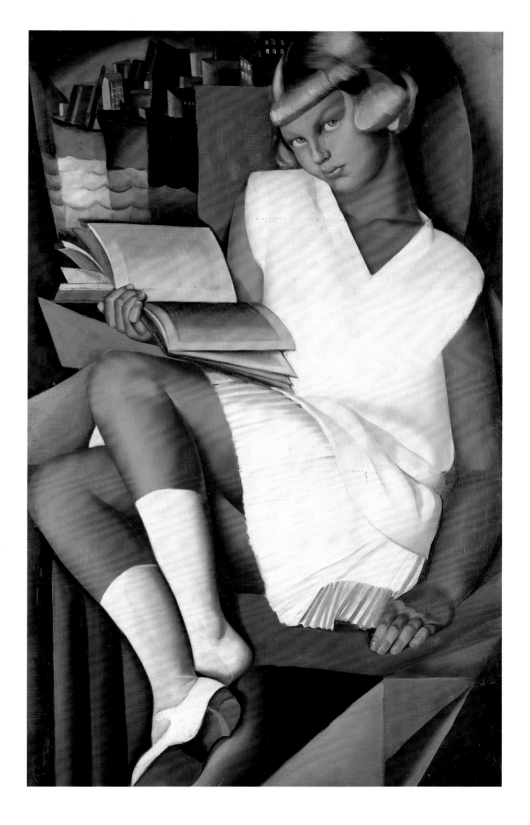

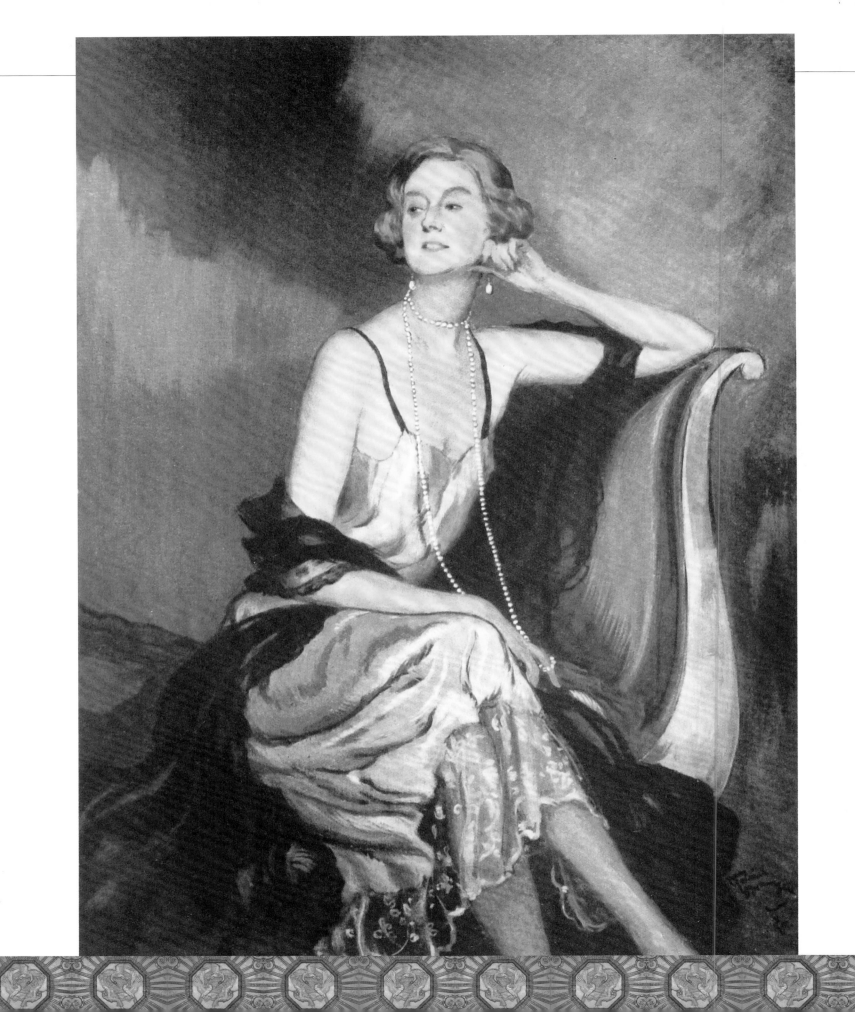

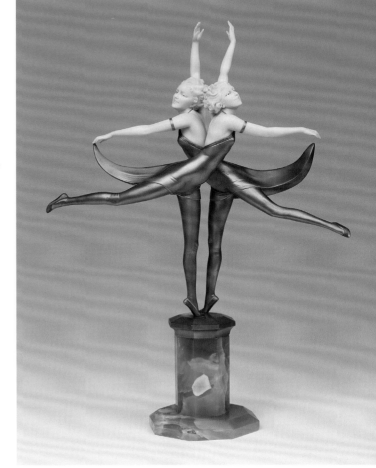

Nevertheless, Kizette has given us the best insight into her mother's character through her biography published in 1987. She portrays her mother as single-minded and determined to exploit her painting for commercial gain. Tamara realized that her work needed to stand out from her contemporaries in Paris in order to achieve prominence in both dealer's galleries and at the various Salons where she also exhibited. To this end she quite deliberately painted 'cleanly' as opposed to other artists that she saw as 'dirty' in their painting methods. She also saw that art in the 1920s had become banal and needed a new style more appropriate to the era. Tamara recognized that the Art Deco style owed much to the classical forms of a previous age, forms that she had reinvented having studied and greatly admired the nineteenth-century French classical artist Jean-Auguste-Dominique Ingres (1780–1867).

'The Baroness with the Brush'. The postwar years saw her return to Europe, but as a peripatetic. Following the death of her husband in 1961 and with her reputation assured, Tamara spent the last 20 years of her life continually on the move between Europe, Texas, where Kizette was living with her own family, and Mexico where she eventually retired and died. Although in her later paintings she played with some alternative ideas including abstraction, her work never lost the Art Deco style.

JEAN-GABRIEL DOMERGUE
(1889–1962)

The United States Beckons

Some time in 1938, Tamara persuaded her husband that it was not in their interest to stay in Europe with an impending war looming. He subsequently sold many of his assets and they both relocated to the United States. Tamara took some of her favourite paintings with her, including *La Musicienne*, 1929 (*see* page 50), and had arranged an exhibition of her work at the Paul Reinhardt Gallery in New York. The couple subsequently moved to Beverly Hills in California, where Tamara lost no time in establishing herself within Hollywood's high society. 1942 saw the USA's entry into the Second World War and not long after Tamara's move to New York, where she showed her work at the exclusive Julien Levy Gallery, being dubbed by the press

A Change in Style

Born in Bordeaux, French artist Jean-Gabriel Domergue was one of a talented group of artists from the region. On viewing a range of Domergue's work one can see a marked contrast between his political sketches created during the First World War and his popular postwar frothy portraits of Society women. His macabre war drawings, such as *Les Atrocités Allemandes* ('The German Atrocities'; published in the *Red Book of German Atrocities*), 1915, in the style of drawings from the Franco-Prussian war of 1870, capture the intensity of his feeling relating to the horrors of war in France. His image of a helpless, abused woman bears no resemblance to his many paintings that followed,

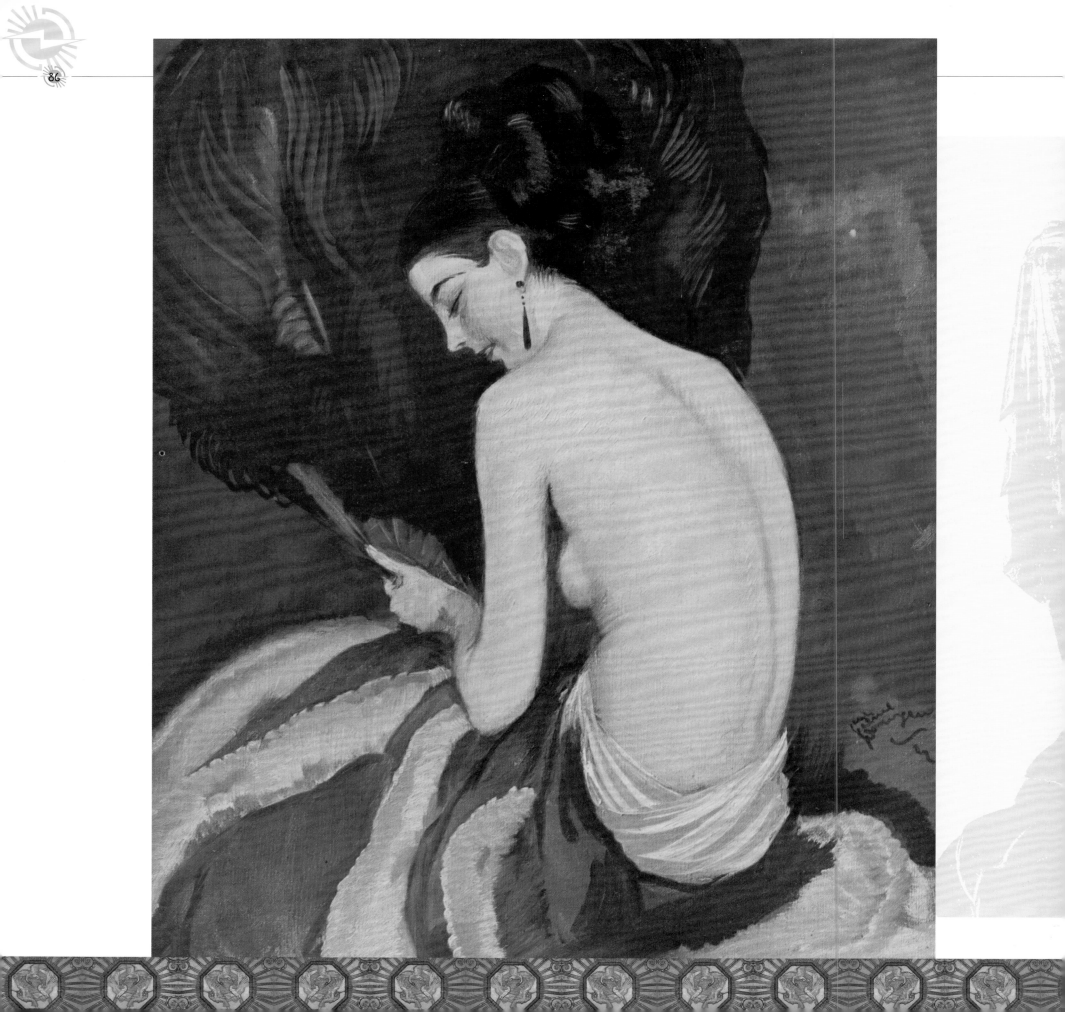

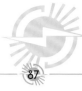

which capture the light-hearted gaiety of life in the 1920s.
His posters for theatre productions and promotions of seaside
vacations show his preference for focusing on one central figure.
He is noted less for these works than for his portraits of
glamorous, often nude, women. His output varied from fashion
illustrations painted on decorative fans to nude portraits; his
portrayal of socialites as smart, sexy, sassy and sometimes lesbian
women focused on the coquettish aspect of the female in contrast
to Tamara de Lempicka's sultry, emancipated depictions. Both
artists capture the modernity of the 1920s and 1930s, however.

Capturing the Gay Modern Life

Lempicka's languorous females were in the minority, and popular
taste chose the more light-weight gaiety of the female muse: the
two lively, young women in the sculpture *Butterfly Dancers, c.* 1920
(*see* page 85), produced in ivory, painted bronze and onyx, is the
work of the German Art Deco sculptor Professor Otto Poertzel
(1876–1963). These dancing figures show the same elegance
and style as Domergue's two-dimensional women. In postwar
France Domergue became part of a coterie of illustrators, *artistes-
décorateurs* and painters from Bordeaux who were commissioned
by the new aristocracy, including many socialites, to 'capture'
them on canvas. His painting *Portrait of Mrs Heathcote*, 1927
(*see* page 84), lends itself to the Beaux-Arts style of the

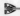

Jean-Gabriel Domergue
*With her Mammoth Fan: A Dark
Beauty of Today,* 1924
Courtesy of Illustrated London News/
Mary Evans Picture Library/© DACS

MEDIUM: Unknown

RELATED WORKS: Edgar Degas
(1834–1917), *Woman Drying Herself,* 1906
and *After the Bath,* 1910–11; Mary Cassatt
(1844–1926), *The Bath,* 1890–91

Marcel-André Bouraine
Danseuse, c. 1928
© Estate of Marcel-André Bouraine/
Christie's Images Ltd

MEDIUM: Glass

RELATED WORKS: René Lalique,
Ondine Refermée bowl, 1921

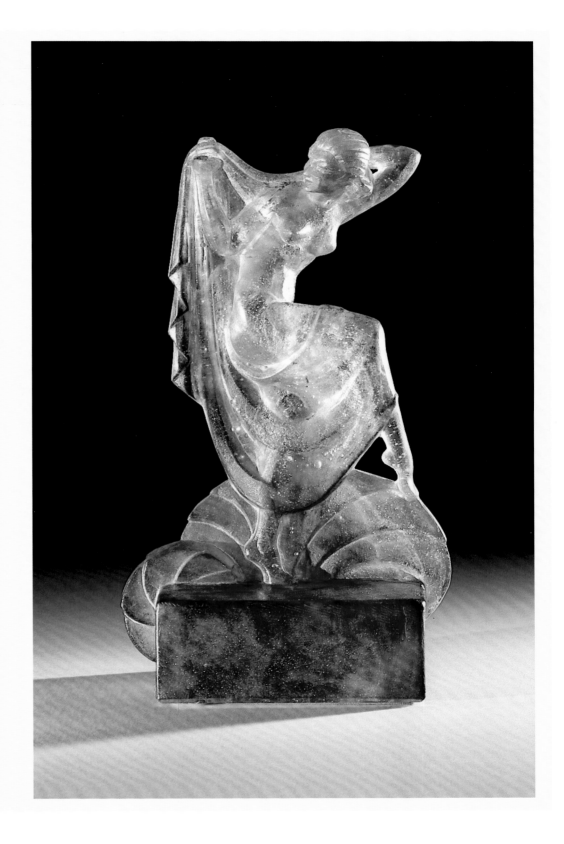

eighteenth-century society portraits created by Sir Joshua Reynolds (1723–92), combined with the modernity of Art Deco dress and abstraction. In the portrait Domergue captures the refined elegance, sophistication and restrained stylishness of the mature lady. He uses the techniques of the graphic illustrator to highlight small details and draw attention to the image as a whole. This is evident in the detail of her silk evening dress, notably fashionable in its loose, slim fit. The length is accentuated by the extra long string of pearls she wears entwined around her throat, which are left to dangle close by her right hand. They are an expensive accessory, which denotes high-fashion attention to the 'Roaring Twenties' style. She leans back with an elbow resting on the top of the fashionable Directoire-style chair. Her hand touches her face, highlighting her fine skin and neatly bobbed red hair in the latest shingle style. Domergue creates an abstract background to focus attention on the exquisite *objet d'art*: Mrs Heathcote.

A Painter of Beautiful Women

The beauty of the body was a continuing theme that informed Domergue's work; it led to his series of paintings depicting the beauty of the female back. Portraits of models, such as the elegantly coiffured bare-backed girl in *With Her Mammoth Fan: A Dark Beauty of Today*, 1924 (*see* page 86), links his style to the Impressionist works of Edgar Degas (1834–1917) and Mary Cassatt (1844–1926). Domergue's series uses the fashionable imagery of young women, with his models in a variety of poses, naked, or swirled in diaphanous fabrics, always drawing attention to the body. This fluid depiction of women is echoed in *Danseuse*, c. 1928 (*see* page 87), an exquisite sculpture in frosted pink glass created by Marcel-André Bouraine (1886–1948),

Jean-Gabriel Domergue
Portrait of Madame O'Deril, 1930

Courtesy of Private Collection, Bonhams, London, UK/The Bridgeman Art Library/© DACS

MEDIUM: Oil on canvas

RELATED WORKS: Sir Joshua Reynolds (1723–92), *Portrait of Mrs John Musters*, 1782

René Lalique
Bacchantes vase, 1932

Courtesy of Christie's Images Ltd/
© ADAGP, Paris and DACS. London

MEDIUM: Glass

RELATED WORKS: Henri Matisse (1869–1954), *Dance*, 1909

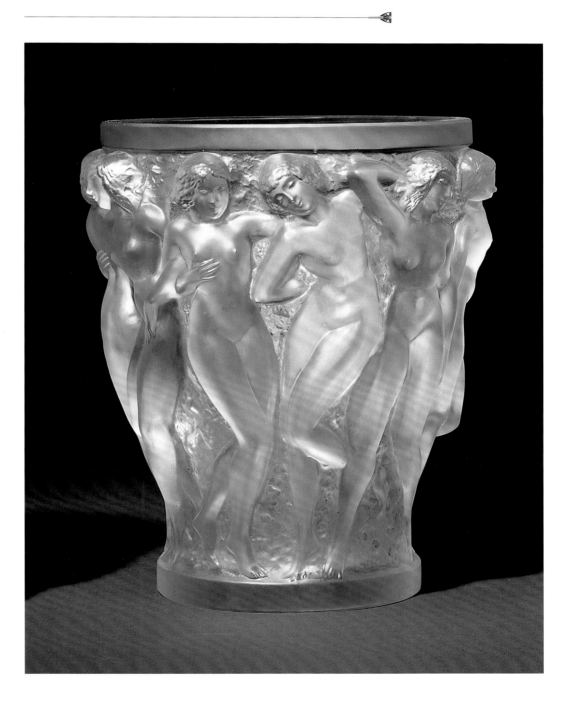

which evokes the freedom of the Twenties through new classical dance forms, popularized in France by the American, Isadora Duncan. Rejecting ballet for her own style of free movement she was considered one of the founders of modern dance. Her performances in bare feet, usually wearing a faux-Grecian tunic, and wrapped in flowing scarves, attracted attention to her and her dance improvisations. The new freedoms for women were exemplified in low-cut dresses, a sexier reflection of modern times.

Revealing Portraits

Domergue enjoyed and specialized in painting long-necked, long-legged, beautiful women. The Parisian society woman appealed to his ability to capture the essence of her sophistication, confidence and modernity. Domergue's contemporary, half-length *Portrait of Madame O'Deril*, 1930 (*see* page 88), reveals the vast changes to the lifestyle of women; her state of undress represents the 1930s Art Deco culture of enjoying life – to dress sexily, to party, to dance, to vamp it up. In her portrait, Madame O'Deril, face made up and hair elegantly styled in the high-fashion shingle, looks up and out across the picture frame. She has the confidence and style of a Hollywood star, flaunting her beauty whilst choosing to ignore the spectator. The pose accentuates her long, swan-like neck, a socialite's natural accessory. Her jewellery has been removed and a shoulder strap of her dress hangs down on her arm, which accentuates her iridescent flawless skin and cleavage whilst the indiscriminate background pushes her forward. Portrayed as an attractive, modern-day emancipated woman, the oil painting perhaps captures the *joie de vivre* of the period far more than a photograph could.

Stylish, Nonchalant Beauty

The culture of desire for beautiful objects, particularly using the female form, kept the luxury and commercial decorative-arts markets busy throughout the Art Nouveau and Art Deco periods.

René Lalique (1860–1945) adapted his glassware to fit both styles, and his machine-made products (which had the look of handmade) widely varied in their decoration, from abstract to figurative. The nude or near-naked decorative image of females appeared on many *objets d'art*. The dancing women on Lalique's *Bacchantes* vase, 1932 (*see* page 89), each with an individual pose, shows the continuing interest in the classical nude form. As we have seen, Domergue too was equally comfortable with nudity, painting the emergent sassy and nonchalant beauties; he was willing to risk reputation for a contemporary portrayal of their 1930s lifestyle. The stylish painting *Woman with Greyhounds (La Femme aux Levriers)*, 1930 (*see* right), captures the excitement of the life of the emancipated woman. Sitting in a relaxed pose on a wide and sumptuous wrought-iron bed, she leans back against the bedstead. Her large hounds loll against her, comfortable in her presence and her evening dress in stylish black and white mirrors the colour of the fur of her pets. Her couture dress is worn almost off-shoulder to reveal her long, graceful neck and flawless décolletage. The woman is confident in her nudity, and relaxed in the intimate surroundings. She is aware of the spectator without engaging his gaze. Domergue manages to capture the essence of the women of the era in this risqué exposure.

Poiret, Chanel, Worth, Patou – Perfumed Days

Perfume was an essential accessory for the elite clients of the French couture houses. Domergue's *La Garçonne*, 1925 (*see* page 92), depicts 'la garçonne', a term coined to describe a woman with a short, cropped, urchin-style haircut, who is possibly

Jean-Gabriel Domergue
Woman with Greyhounds, 1930
Courtesy of Musée d'Art Moderne de la Ville de Paris, Paris, France, Lauros, Giraudon/ The Bridgeman Art Library/© DACS

MEDIUM: Oil on canvas

RELATED WORKS: Professor Otto Poertzel, *The Aristocrats*, 1920s

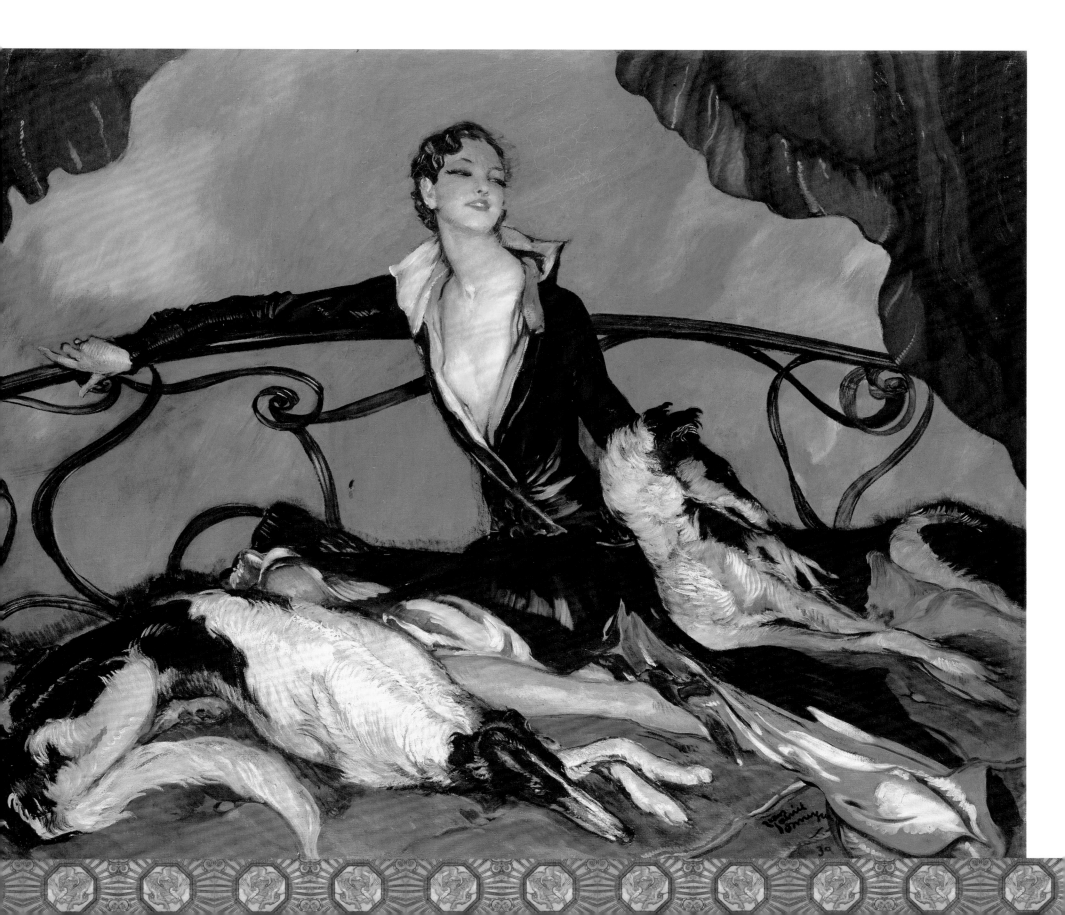

of ambiguous sexuality. She closes her eyes to apply a fine mist of perfume to her plunging neckline. Who is she getting ready to meet? Domergue paints a snapshot of the young woman's lifestyle. The vogue for urchin haircuts coincided with a much more relaxed acceptance of the lesbian woman in society. Is that what Domergue is hinting at in *La Garçonne*? The painting, framed like an instant photograph, highlights the modern, light-filled interior of the elegant dressing room: the fashionable mirror, and the black, close-fitting, low-cut dress that she wears. Her hair, make-up, couture dress and scarf all point to the life of a young socialite getting ready to party.

Scent of a Woman

The couturier Paul Poiret (1879–1944) is considered the first to have tied in a brand-name perfume to couture. In 1911 he set up a company, *Parfums de Rosine*, for his elder daughter, Rosine. (For his younger daughter, Martine, he set up *Les Ateliers de Martine*, a decorative arts workshop). Different perfumes were created by Rosine's company to coincide with Poiret's collections. The concept spread and eventually the majority of principal fashion houses had perfumes created for them. In 1921 the perfume maker Ernest Beaux (1881–1961) created *Chanel No. 5* for the couturier Coco Chanel (1883–1971). The House of Worth produced its classic perfume *Je Reviens* in 1932 and Jean Patou (1887–1936) had huge success with *Joy* in 1935. The bottles and packaging from the era show the influence of Art Deco on the styling of the companies' products – some of the most famous brands, such as Chanel, kept to the original design style associated with the luxury and opulence of the era. With the growth of the film industry in Hollywood the culture of celebrity spread and endorsements of products, particularly

Jean-Gabriel Domergue

La Garçonne, 1925

Courtesy of The Art Archive/Private Collection/Gianni Dagli Orti/© DACS

MEDIUM: Oil on canvas

RELATED WORKS: Paul Iribe (1883–1935), *Quelles Perles*, Advertisement for Suclier et Cie., Paris, 1912

fashion and perfume, became an accepted practice. For Domergue the cult of beauty and the never-ending opportunities to paint socialites, make his portraits a social history of the Art Deco period of the 1920s–1930s in France, particularly the capital city.

ERTÉ (1892–1990)

A Familiar Figure

It is hard to imagine any book on Art Deco that does not include the evocative work of Erté. Due to his long and continually prolific career (right up until his death in 1990), his designs, which so epitomize the era, are still familiar to many – his hallmark being the extravagance and exoticism of the costumes bathing his sinuous and lyrical figures. At the time, his name was synonymous with the fashion-magazine covers and theatre sets of the interwar period in France, Britain and the United States. He designed for the famous – and the infamous – with clients such as Mata Hari (1876–1917), his stylized women often draped in beads and expensive jewels. He was not just a designer, but also a trend-setter *par excellence* who defined

fashion for that generation. As he said, 'I believe that feminine clothes should serve to adorn women's charm'. He was seen as the most meticulous artist of his day, and his legacy is one of attention to detail. Beyond that era, most people today are familiar with his work thanks to his extraordinary output of original prints during the 1970s and 1980s.

St Petersburg

Romain de Tirtoff (Erté) was born in St Petersburg in 1892, the same year that the Franco-Russian Pact was signed – a significant event as both countries subsequently fell in love with the other's culture. The young Romain grew up in a well-to-do upper class household, and was introduced to the *haute-bourgeoisie* while at leisure – at the theatre and ballet for example. He was immediately smitten by the colour and gaiety of this environment. At the tender age of seven, Romain was taken to the 1900 *Exposition Universelle* in Paris, which started his long love affair with the city. His mother, who had very white skin and blue-black hair, later to become his ideal of feminine beauty, accompanied him. Another early influence on the young man was his exposure to the ancient Greek vases and other similar artefacts in the Hermitage museum. From an early age Romain was able to speak fluently in French, German and English as well as his native Russian. Pre-revolutionary St Petersburg was a hive of artistic inventiveness in dance, music and painting. The theatres in St Petersburg were a particular hot spot around a group called The Nevsky Pickwickians, which included Alexandre Benois (1870–1960), the stage designer, and Sergei Diaghilev (1872–1929), the theatre impresario who founded the famous and influential Ballets Russes. A touch of the ballet is in fact evoked in Erté's *Blossom Umbrella*, 1924 (*see* right) for example.

Erté
Blossom Umbrella (detail), 1924
© Sevenarts Ltd

MEDIUM: Gouache

RELATED WORKS: Alexandre Benois (1870–1960), *Nutcracker Ballet, c.* 1910

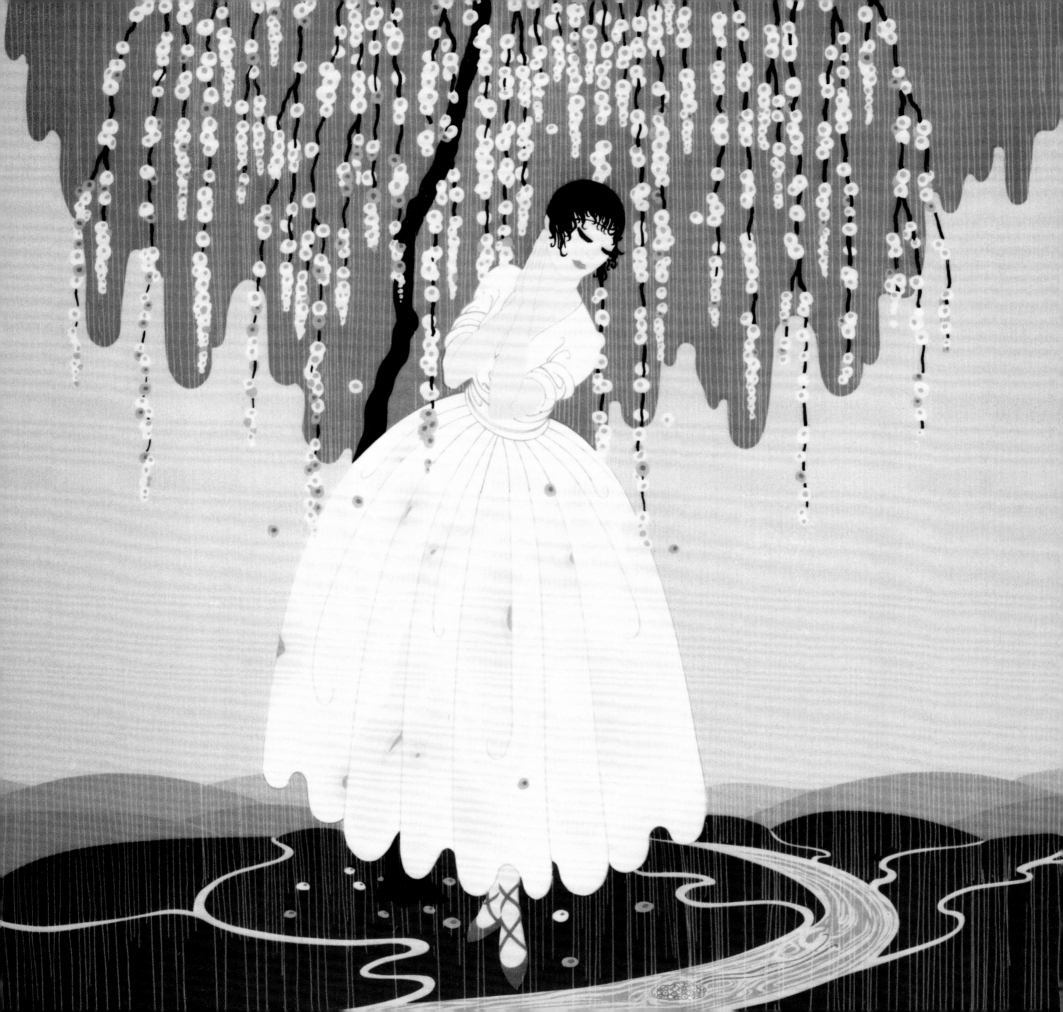

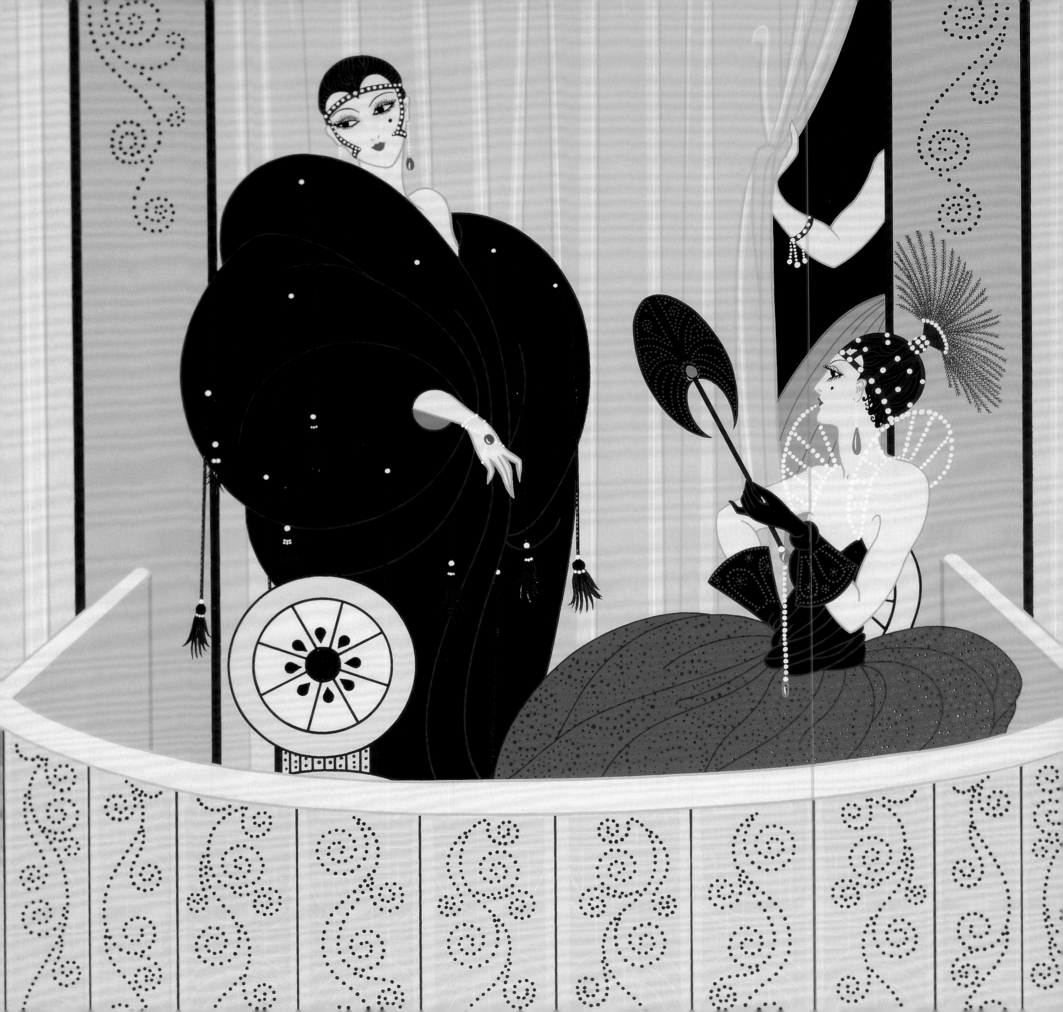

Erté
Loge de Théâtre (detail), 1912
© Sevenarts Ltd

MEDIUM: Gouache

RELATED WORKS: Jean-Paul
Laurens (1838–1921), *Le Pape*, 1870

Raymond Templier and Suzanne Belperron
**Selection of Art Deco jewellery,
1920s–1930s**
© Estate of Raymond Templier/Suzanne
Belperron/Christie's Images Ltd

MEDIUM: Various (diamond, rock
crystal, metal)

RELATED WORKS: Cartier,
Various Jewellery, 1920s–30s

To Paris

In 1911 the young Romain saw Benois' ballet production of
Le Pavillon d'Armide, which saw Anna Pavlova (1881–1931) and
the precocious Vaslav Nijinsky (1889–1950) dancing together.
It was not only theatre that provided excitement and inspiration
for this impressionable young man; he saw huge pageants in
front of the Winter Palace, and attended very colourful church
services at the Russian Orthodox cathedral of St Nicholas.
All of this provided him with a very real sense of theatrical
backdrop. The die was cast for Romain, who decided there
and then to become an artist and move to Paris, an ambition that
he fulfilled, against his father's wishes, in February 1912. He
enrolled at the Académie Julian and studied painting under the
academic painter Jean-Paul Laurens (1838–1921). This was
short-lived – Romain decided to leave and seek employment as
a dress designer. While he was waiting for this opportunity, he
frequented as many ballets as possible, including the infamous
premiere of *L'Apres-Midi d'un Faune*, choreographed (and the
main part performed) by Nijinsky. *Loge de Théâtre*, 1912 (*see*
left), is one such work that would have been inspired by these
visits, depicting the magnificently dressed in their box at the
theatre. Their fantastical costume-like clothing is accessorized
by sophisticated jewellery – luxurious jewellery in the style
of the time was to become an art form in itself, with designers
including Raymond Templier (1891–1968) and Suzanne
Belperron (1900–83) (*see* right), and Baume et Mercier.

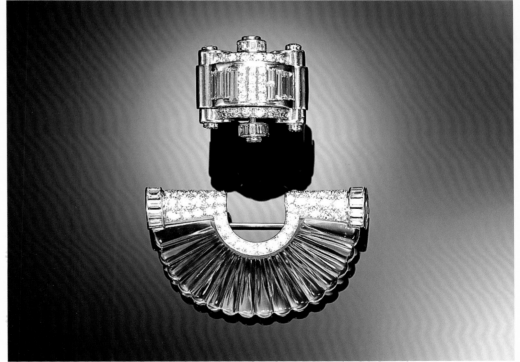

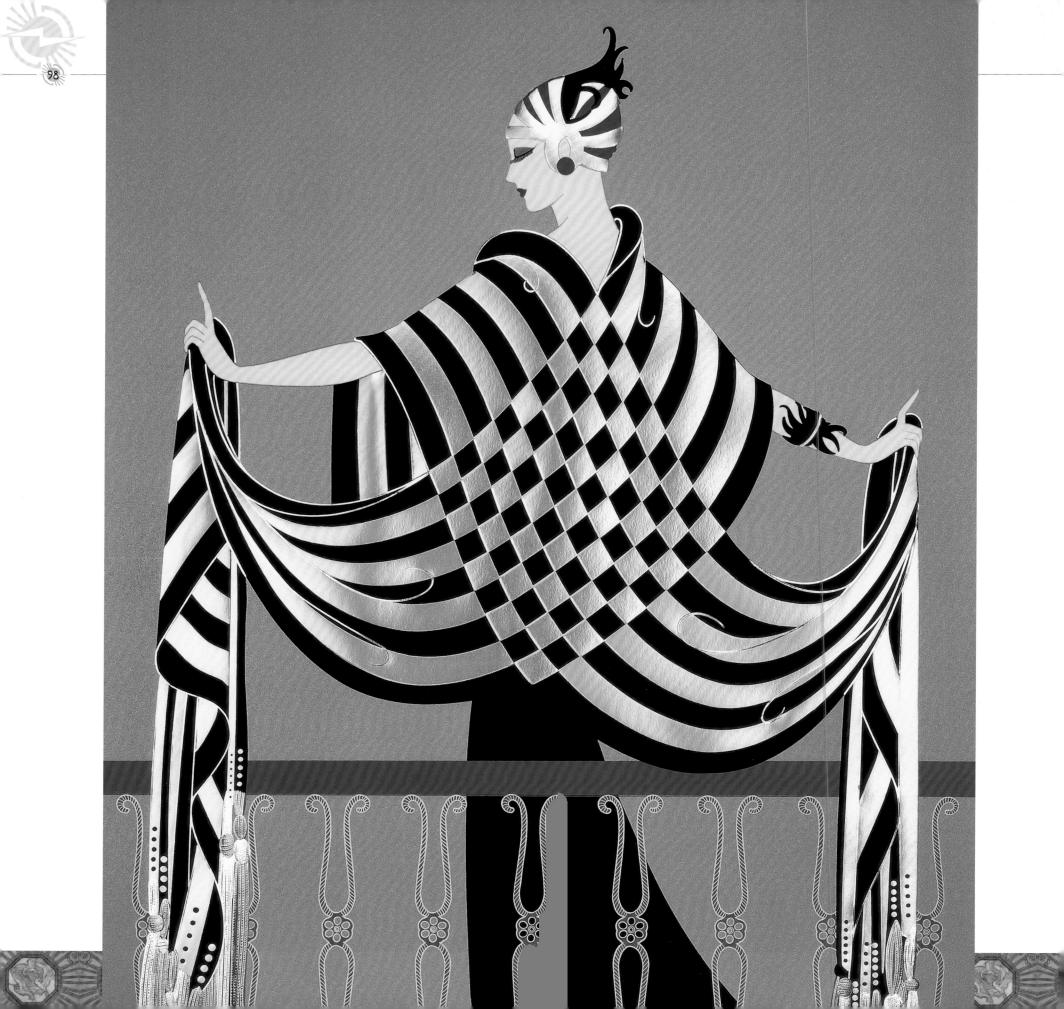

A Prodigious Talent

Romain had to wait less than a year for his first break. In early 1913 he was summoned to work with the great couturier Paul Poiret, who had seen his drawings, remaining with him until his studio closed at the outbreak of the First World War. On his appointment he adopted his pseudonym Erté, and worked as one of only two full-time designers. What attracted Poiret to this prodigious talent was the flowing curvilinear form of the extravagant gowns drawn by Erté, so reminiscent of *fin-de-siècle* Symbolism. However, Poiret himself usually signed the work produced even if executed by Erté. The first time that Erté's own name appeared commercially was for a contribution he made to the magazine *Gazette du Bon Ton* in May 1913. This period of relative affluence meant that Erté could now afford an apartment on the rue de Civry, an elegant area in western Paris. It was then too that he met a distant cousin of his, Prince Nicholas Ourousoff, who became a close friend and future business partner. During his time with Poiret, Erté designed a number of costumes for various theatrical productions, but more importantly had witnessed the workings of a couturier at first hand.

Harper's Bazaar

After his split with Poiret in 1914, Erté moved to Monte Carlo with his cousin Nicholas, and it was he who suggested that the artist send some of his designs to *Harper's Bazaar* (in fact spelt *Harper's Bazar* until 1929), the leading American fashion magazine. His first designs were published in early 1915 and by October he was being hailed by the magazine as 'a famous designer ... one of the cleverest in Paris'. He was now beginning to rival Poiret, who also contributed to *Harper's Bazaar*, establishing a reputation in his own right. By June 1916 Erté was also contributing illustrations and designs to the rival *Vogue* magazine. Having realized the potential of his prodigious talent, *Harper's Bazaar* offered Erté an exclusive 10-year contract. He was not to appear again in *Vogue* until the 1960s. What appealed to the magazines was Erté's love of colour and elegant lines for use on their front covers, thus promulgating the notion that they

were at the forefront of creative and innovative fashion. Astonishingly, Erté's designs were shown on no less than 240 *Harper's Bazaar* covers between January, 1915 and December, 1936. The magazine's owner was the media mogul William Randolph Hearst (1863–1951), an enthusiast of Erté's work.

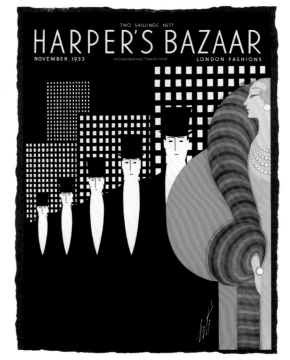

A Change of Style

After 1926, a change in editorship at *Harper's Bazaar* led to a change of style in Erté's work. It is worth remembering that his works, particularly the covers for the magazine, were not intended as dress designs but rather as more abstract notions of style and fashion. As he pointed out, 'among my creations each woman can select something suited to her, without adhering strictly to the mode'. In understanding this it is easier to relate Erté to the Art Deco style. During the 1920s he moved away from the Symbolist style of illustration to a more *moderne* idiom that was simpler in design. A later example of this is for the cover of *Harper's Bazaar*, November 1933 (*see* above). Note the monochromatic New York skyline and tuxedoed males, juxtaposed with the only colour in the image – introduced for the

Erté
The Balcony (detail), 1989
© Sevenarts Ltd

MEDIUM: Serigraph

RELATED WORKS: Erté,
Glamour, 1985

Erté
Cover of *Harper's Bazaar*,
November 1933
Courtesy of Mary Evans Picture Library/
National Magazine Company/© Sevenarts Ltd

MEDIUM: Unknown

RELATED WORKS: Tamara de
Lempicka, *New York*, c. 1930–35

elegant woman. In this we do not see a dress or coat design per se but the notion of a fashion idea. This is a chic and cool design that states the magazine's *raison d'être*, the promulgation of contemporary, fashionable taste and style.

The Folies-Bergère

Erté's knowledge and love of the theatre from a young age was to reap dividends for his career alongside his work for *Harper's*. He began designing exotic theatrical costumes similar to those shown in *The Balcony*, 1989 (*see* page 98), for artistes such as Gaby Deslys (1881–1920), a French music-hall star who had returned from the United States with her jazz band in 1917, taking Paris by storm at the beginning of the so-called 'Jazz Age'. Erté's success in Paris led to one of his most fruitful associations, with the legendary Folies-Bergère. This opportunity allowed Erté to give full vent to his extraordinary talents: he was now designing not only the costumes, but also their setting. The success of these extravaganzas may be due in part, as Erté's biographer Charles Spencer has suggested, to the fact that the artist loved to make and wear fancy dress – a contributing factor to his fertile fantasy world. Erté created elaborate stage 'curtains' that included live bodies or gigantic costumes that necessitated being worn by several people. Another device used was the suspension of models from the roof of the stage wearing enormous crinolines that extended to the floor.

New York

George White (1890–1968), the theatre impresario, having seen one of Erté's theatre productions in Paris in 1922, requested that the artist help him design sets and costumes for his own

series of *Scandals* in his native New York. *George White's Scandals* had been running on Broadway since 1911 very successfully. These revues were modelled on Florenz Zeigfeld's (1867–1932) 'Follies', which had in turn been modelled on the Folies-Bergère, and were instrumental in establishing the careers of many music hall stars such as W.C. Fields (1880–1946), Rudy Vallee (1901–86) and Ethel Merman (1908–84). It also marked the beginning of the career of George Gershwin (1898–1937), and it was his music and White's choreography that created many of the dance crazes such as The Charleston, Black Bottom and later, the Lindy Hop. These dances, popular in Europe and the United States, set the tone for the Jazz Age, an important factor in the Art Deco style. Erté provided a number of illustrations for these dances at the time and continued working for White until the Wall Street Crash of 1929.

Hollywood

In 1924 a representative of MGM Studios approached Erté to design sets for a film that Louis B. Mayer (1884–1957) was making, called *Paris*, a story about a Parisian couturier. Erté's talent had been drawn to Mayer's attention by his friend and business associate William Randolph Hearst, the owner of *Harper's*. He was thrilled with what he saw and had Erté's studio recreated in Hollywood for when he arrived to begin work. Erté, already well known in American society for his work at *Harper's*, was given a warm welcome on his arrival, the press referring to 'the importance of the costuming phase in motion picture production'. He was offered a six-month contract by Mayer to make the film, but there were problems with the script that delayed its start and eventually the artist left Hollywood without making any contribution to the film

Erté
Cover of *Harper's Bazaar*,
January 1934
Courtesy of Mary Evans Picture Library/
National Magazine Company/© Sevenarts Ltd

MEDIUM: Unknown

RELATED WORKS: A.E. Marty,
Cover of *Vogue*, January 1934

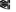

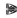

Marcel-André Bouraine

Papillon, c. 1928

© Estate of Marcel-André Bouraine/
Christie's Images Ltd

MEDIUM: Onyx

RELATED WORKS: Fayral (a.k.a. Guerbe,
c. 1892–1935), Various sculptures, 1930s

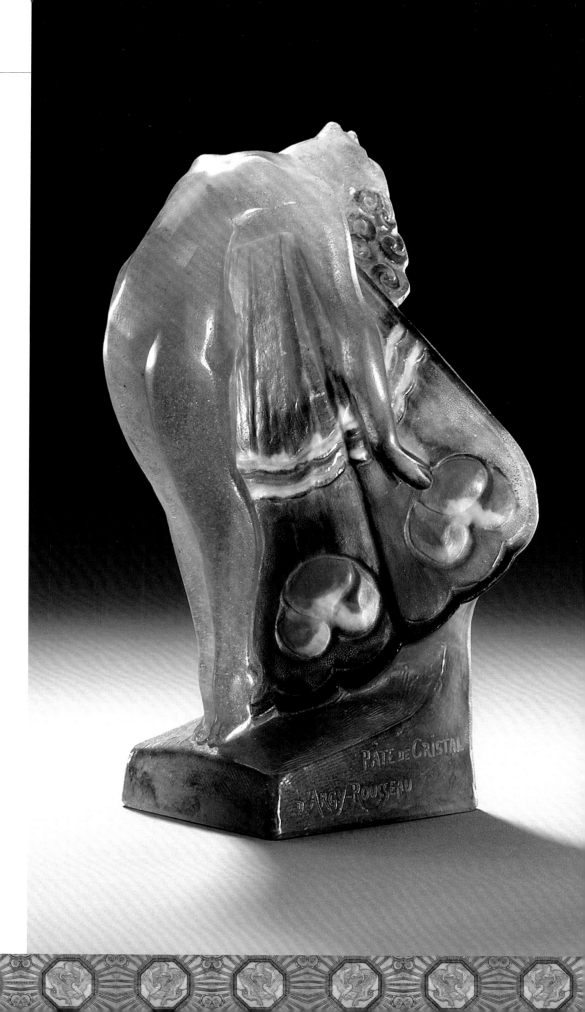

that was completed the following year. However, during the
short time he was in Hollywood he did contribute to two films
by King Vidor (1894–1982): *The Big Parade* (1925), for which
he designed a theatre set to be used at the film's premiere,
and *La Bohème* (1926), for which he designed the costume
for Lillian Gish (1893–1993).

The 1930s

Despite the depression in Europe and the United States
following the Wall Street Crash, Erté continued to design many
items during the 1930s, not just for the theatre and for ballet
productions but also jewellery and *objets d'art*. But it was the
theatre that continued to preoccupy the artist at this time. As we
have seen, even his *Harper's* covers exuded a theatrical air, such
as in January 1934's cover (*see* left), where a stylized female
profile turns her face ecstatically to the sky – the aspirational
form of which is echoed in the exquisite Art Deco sculpture,
Papillon, c. 1928 (*see* right), by Marcel-André Bouraine. Erté
provided highly exotic and even erotic designs for the theatre,
including topless costumes for the dancers at Pierre Sandrini's
club the Bal Tabarin in Montmartre, Paris. The shows were
themed – *The Planets* for instance – or were historical tableaux,
such as the story of Cleopatra. He also designed for theatres
in other parts of Europe, such as the Comico Club in Barcelona
and the Quattro Fontane in Rome. It was not, however, until
1937 that his talents were fully appreciated in London when
his designs appeared at the Saville Club and then later at The
Palladium and London Hippodrome. He was, of course, an
overnight success – although the press were unsure if Erté
was male or female.

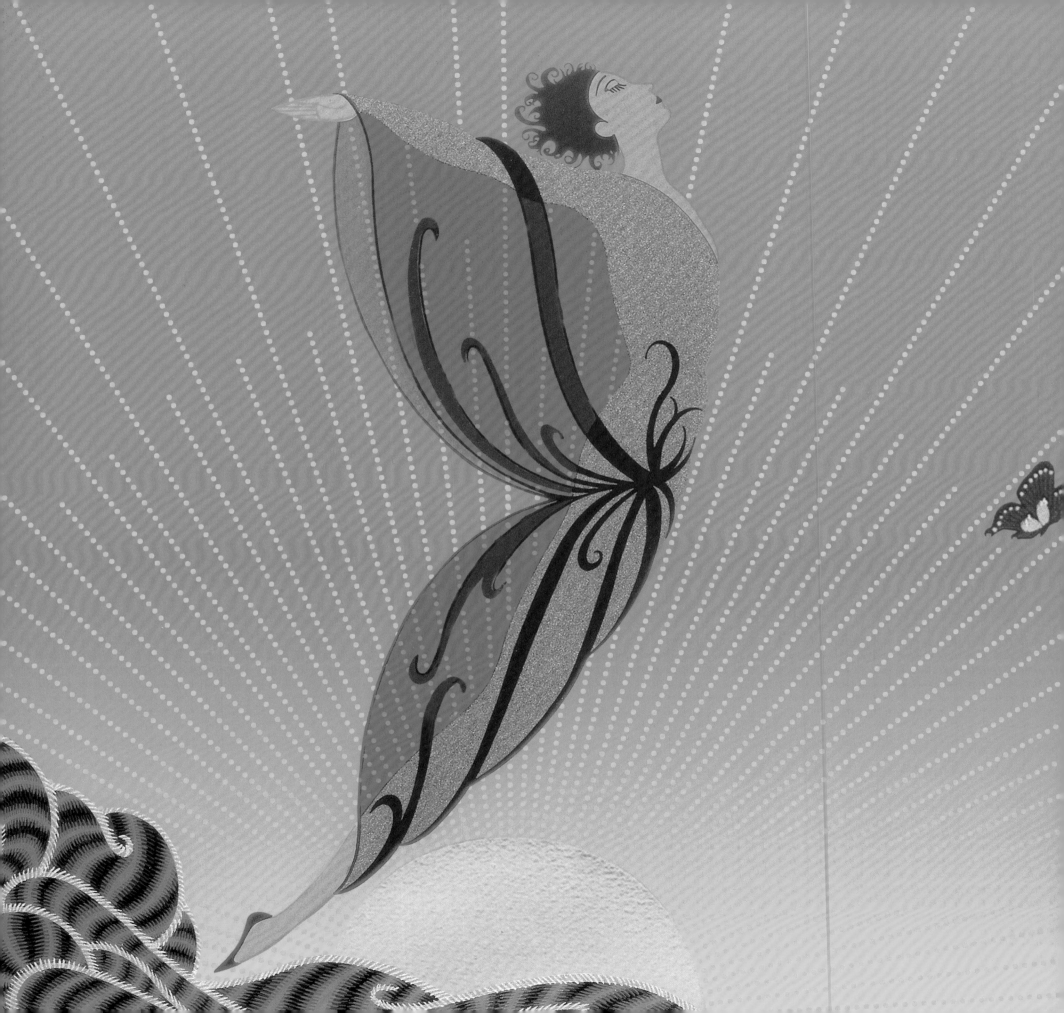

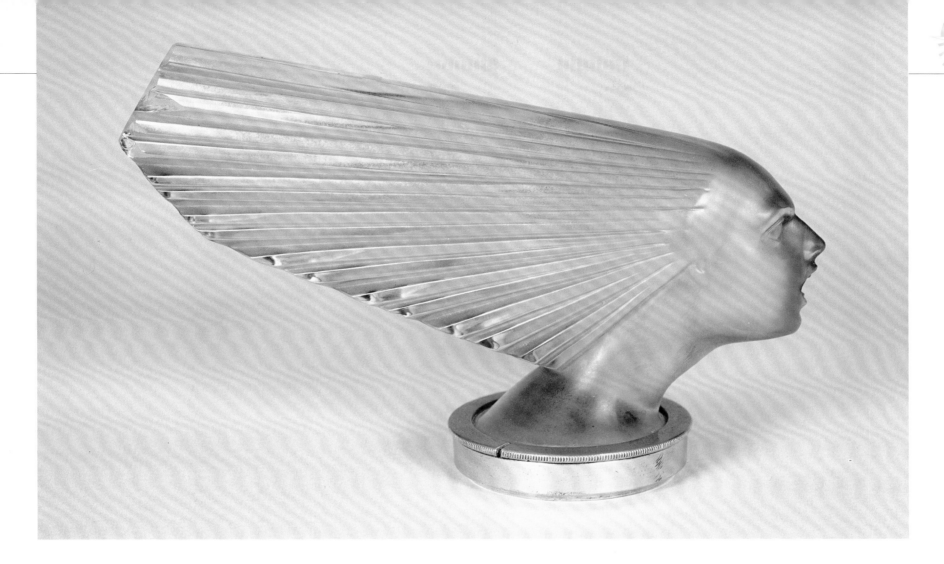

A 'Second' Career

Following the Second World War, Erté became a relatively obscure figure until the art dealer and collector Eric Estorick (1913–93) 'discovered' his huge volume of work in 1967 and felt that it would appeal to the so-called 'psychedelic generation' of the period. He was right. At a time when the decorative aspects of both Art Nouveau and Art Deco were being rediscovered by a new generation, Erté's work was exactly the stimulus needed. Although Estorick was based in London, he realized very quickly that the US was the place to show the original work. He organized an exhibition in New York that was a sensation. With the knowledge that there was an enduring market for the work, he persuaded the artist to create a new range of graphics for this audience. Estorick also organized similar exhibitions in London, Paris and Milan, again with the same degree of success. Even in the late part

of Erté's career he was still being asked to create costume designs for theatre. In 1969 he designed, for example, the costumes for Zizi Jeanmaire (b. 1924) in the revue by her husband Roland Petit (b. 1924) at the Casino de Paris, working alongside the young designer Yves St Laurent (1936–2008). One of many examples of his later work, *Sunrise*, 1984 (*see* left), continues the use of sinuous lines combined with the classic

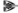

Erté
Sunrise (detail), 1984
© Sevenarts Ltd

MEDIUM: Serigraph

RELATED WORKS: Alphonse Mucha (1860–1939), *The Arts: Dance*, 1898

René Lalique
Victoire: The Spirit of the Wind,
car mascot, 1928

Courtesy of Dreweatt Neate Fine Art Auctioneers, Newbury, Berkshire, UK/The Bridgeman Art Library/© ADAGP, Paris and DACS, London

MEDIUM: Glass

RELATED WORKS: Harriet W. Frishmuth (1880–1980), *Speed*, 1925

Erté
Symphony in Black, 1983
© Sevenarts Ltd

MEDIUM: Serigraph

RELATED WORKS: E. Serine
(dates unknown), Various fashion
plates, *c.* 1914

Professor Otto Poertzel
The Aristocrats, 1920s
© Estate of Professor Otto Poertzel/
Christie's Images Ltd

MEDIUM: Bronze and ivory

RELATED WORKS: Dimitri
Chiparus, *Solo Dancer*, 1928

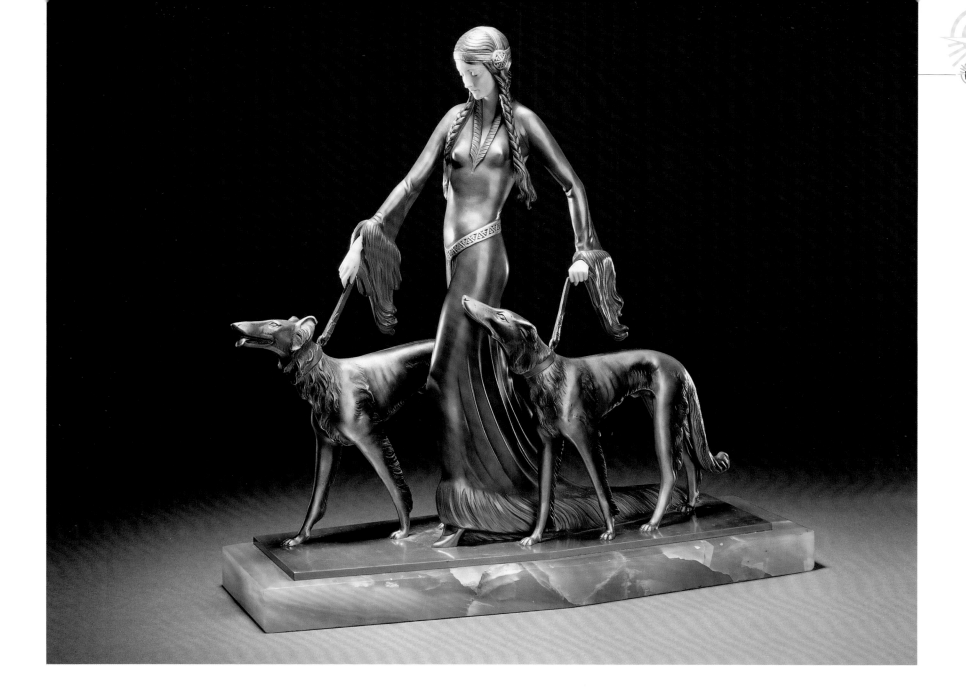

Art Deco sunburst motif – something visible even in a woman's hair in an original Art Deco car mascot, *Victoire: The Spirit of the Wind*, 1928 (*see* page 103), by René Lalique.

Erté's Legacy

Erté died in April 1990 at the age of 97. One of his best known images is *Symphony in Black*, 1983 (*see* left), an image typical of his *oeuvre*, depicting a tall very slender, curvilinear woman draped in black with a contrasting white face, her curves accentuated by the equally sinuous dog. This image has been reproduced countless times and continues to enthral subsequent generations of admirers. It epitomizes the Art Deco style because of its clean lines and its *moderne* idiom – and echoes such original works as Professor Otto Poertzel's *The Aristocrats*, 1920s (*see* above), revealing the way Art Deco style permeated all aspects of life, even down to pets – and yet has continued to be popular because of its element of fantasy and idealization (*see* the fantastical costume in *Her Secret Admirers*, 1982, page 106). During the 1980s his work, as popular as ever, was being reproduced as expensive serigraphs and lithographs signed by the

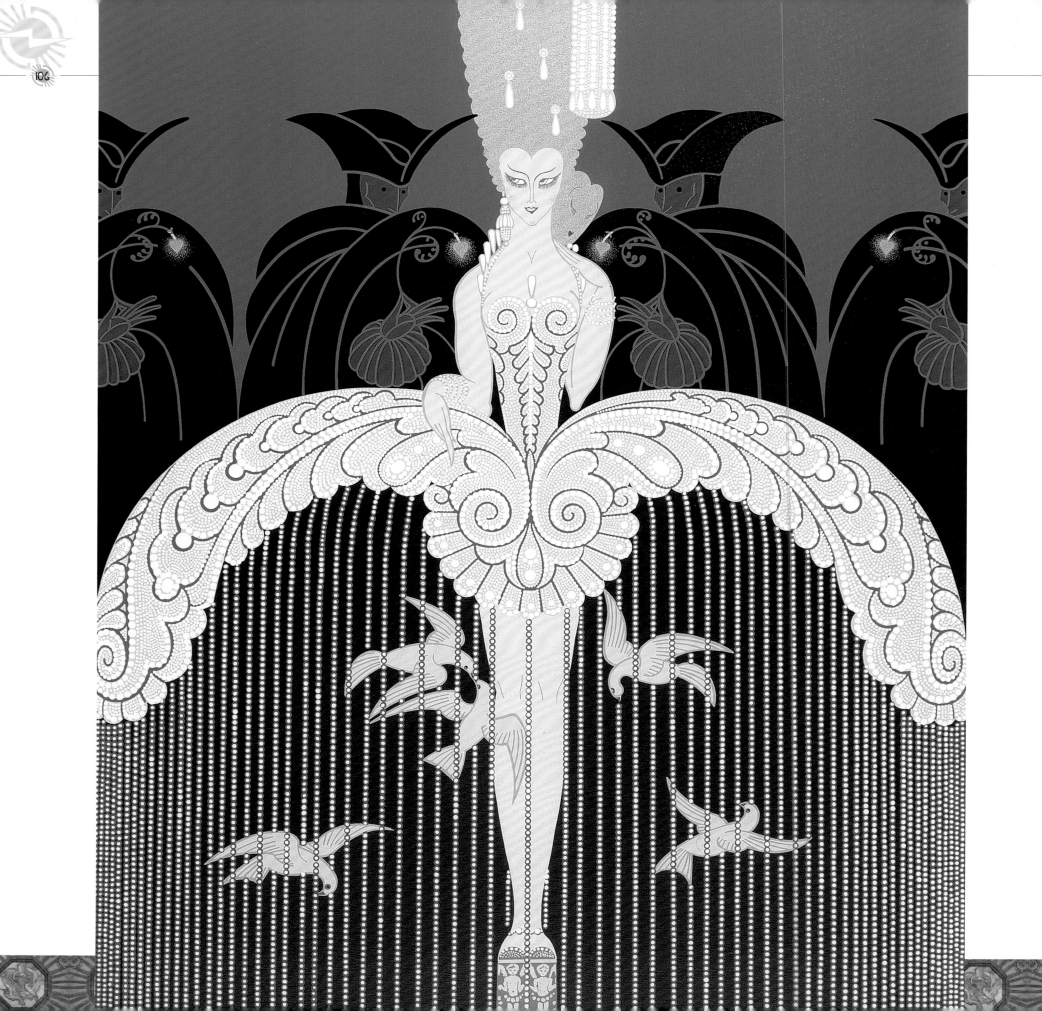

artist and issued in limited editions, which have become highly sought after. Most of his original paintings are now held in museums around the world including the Metropolitan Museum of Art in New York, The Victoria and Albert Museum in London and, perhaps the largest collection of all, in Tokyo's Museum 1999.

GEORGES BARBIER (1882–1932)

École des Beaux Arts

Georges Barbier was one of a group of artist-illustrators who graduated from the École des Beaux Arts just before the First World War. He and his contemporaries, Pierre Brissaud (1885–1964), Paul Iribe (1883–1935) and Georges Lepape (1887–1971) were, after an article in *Vogue* magazine, collectively known as the Knights of the Bracelet, due to their flamboyant dress sense and foppish gait. Barbier, like the others, was drawn to the Art Nouveau style but was moreover interested in the fashions of the late eighteenth century. In *L'Oiseau Volage* from 1914 (*see* page 108), Barbier clearly demonstrates his adherence to the late-Art Nouveau style particularly in its reliance on the use of natural forms both in the model's homage to nature and in the motifs on the dress. There is also clearly a Japanese influence both in the content and in the stylization, such as the bird cage reminiscent of a pagoda. This is a feature of both Art Nouveau and the early Art Deco style, which also used Orientalist motifs. The illustration is for a fashion journal of the period, *Modes et Manières d'Aujord'hui*, an exclusive lifestyle magazine that only ran to three hundred copies per edition. These illustrations were hand coloured with a vibrancy that was a hallmark of Art Deco fashion styling.

Fashion Magazines

Les modes (or *la mode*) refers to 'fashions' (or 'fashion'), and in the second half of the nineteenth century *Les Modes Parisiennes* was *the* fashion magazine illustrating the latest trends. This era saw a growth in fashion design and promotional magazines, most notably after Charles Frederick Worth (1825–95) showed his collection in the newly launched *Harper's Bazar* (sic) magazine, effectively endorsing Paris as the capital of fashion. By the twentieth century this method of magazine promotion was further employed to increase awareness of these trends, with important publications being *Modes et Manières d'Aujourd'hui*, *Journal des Dames at des Modes* and *Gazette du Bon Ton*. In *Les Modes* (*see* page 111), Barbier illustrates some Paul Poiret creations for a 1912 cover of *Harper's*. Again the design has echoes of Art Nouveau and there is a Japanese influence in the graphic composition, emphasizing the forms and stylizing of the gowns, one of which is dominated by an elaborate Oriental motif. Poiret demonstrates his use of the turban, a fashionable accessory of the early Art Deco period, developed by him as a method of concealing a woman's hair, something he disliked. Thus the turban and later the derivative cloche hat are both hallmarks of the early Art Deco style.

Falbalas et Fanfreluches

A series of illustrated fashion almanacs under the title *Falbalas et Fanfreluches* were produced by Barbier from 1922 until 1926. Apart from fashion they also commented on the social and artistic scene of the interwar years in Paris. Each illustration was hand coloured in watercolour and accompanied by a notation, written by the artist. These editions, known as *pochoirs*, were strictly limited to editions of 600, making them highly sought after both then and now. *Incantation*, or *Solemn Melody* (*see* page 114), is one of these illustrations from the 1923 almanac. Note the pianist who is wearing an oriental-inspired evening gown with a fur-trimmed train and split sides, both features of the early 1920s Art Deco style. Her female companion is also wearing an oriental-inspired gown that is decorated with a jewelled hip-band, a motif repeated

Erté
Her Secret Admirers (detail), 1982
© Sevenarts Ltd

MEDIUM: Serigraph

RELATED WORKS: Adolfo Hohenstein (1854–1928), Poster for *La Bohème*, 1898

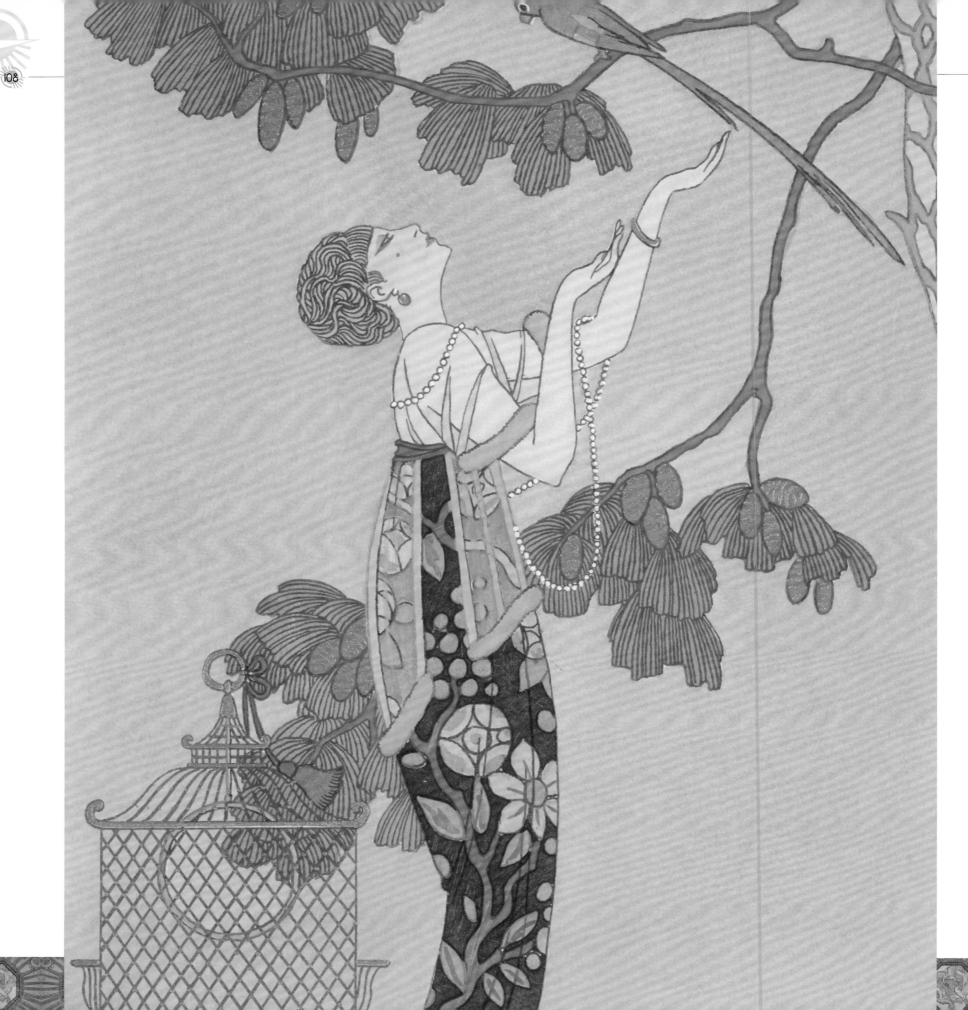

Georges Barbier
L'Oiseau Volage (detail), *c.* 1914,
from *Modes et Manières d'Aujourd'hui*
© V&A Images, Victoria and Albert Museum

MEDIUM: Gouache

RELATED WORKS: Alphonse Mucha
(1860–1939), *The Carnation*, 1898

in the tiara, halter-neck and shoe buckles. Accessories, such as Cartier jewellery (*see* page 115), are of course themselves Art Deco icons. Note also her dark, pouting 'bee sting' lips, a feature of this period. The male is dressed formerly in black tuxedo, the monochrome of him and the piano accentuating the colours worn by the women. The female piano recital and elaborate stool are features of the late eighteenth century, an era that provided Barbier with compelling motifs for use in his contemporary work.

References to the Eighteenth Century

Bonheur du Jour, a contemporary journal to *Falbalas et Fanfreluches* was more interested in the social, rather than the fashion, scene. Using *pochoir* to illustrate the journal, Barbier outlined its *raison d'être* in a text that emphasized his notion of a costume picture book similar to those used in eighteenth-century society. *Eventails* (*Fans*) (see page 112–13), which appeared in *Bonheur du Jour* in 1924, is an example in which Barbier creates an historical reference for contemporary society. The use of marbled columns in the background and a swag motif in the foreground find a resonance with eighteenth-century neoclassicism. This resonance, favoured by Barbier, suggests the comparability of eighteenth-century and contemporary societies, in social elegance, etiquette and good taste. However, the fashions are very Art Deco. The gown for the figure on the left has an Egyptian influence, inspired by the recent discovery of Tutankhamen's tomb in 1922. Ancient Egypt proved a very fertile source of inspiration for Art Deco, including hats made to resemble those worn by the pharaohs, as well as shoes, handbags and other accessories with hieroglyph motifs. The 'short bob' hairstyle and backless gowns of the other women are also contemporaneous to the Art Deco period.

Book Illustration

Barbier was also well known as a book illustrator; his designs were shown at the 1925 *Exposition des Arts Décoratifs et Industriels* in Paris. Between 1920 and 1929 he illustrated the Christmas issues for *L'Illustration* magazine. He was renowned for his interpretation of an author's work, using colour and wit in his illustrations. *Le Feu* (*The Fire*) (*see* page 116) is a plate used in the illustration of Paul Verlaine's book *Fêtes Galantes* from 1869. The book tells of the eighteenth-century Parisian, rich but idle aristocrats who have abandoned the court of the late King Louis XIV and taken small residences in the city where they can spend their time drinking and flirting. This eighteenth-century reference is again given a contemporary feel by Barbier in this *pochoir* print of 1925. The large urn and balustrade are redolent of the eighteenth century, but the style of dress and wrap are distinctly 1920s, although the dress would have seemed slightly outdated by 1925. The background of the scene is reminiscent of J.A.M. Whistler's *Nocturne in Black and Gold – The Falling Rocket*, *c.* 1875. This may well be intentional as Barbier was very much an anglophile, even adopting the pseudonym of E.W. (Edward William) Larry for his early work. The female in Barbier's illustration wields power over her lover through her languorous, winsome appeal – a very different power to that exhibited in the streamlined sculpture of a female warrior by Marcel-André Bouraine in 1925 (*see* page 117) – but both are very much Art Deco.

Chinoiserie

Continuing the theme of aristocratic indolence, Barbier also produced *La Paresse* from 1924–25 (*see* page 118). The background motifs again refer to the late eighteenth century and the fashion for *chinoiserie*, a style adopted by many European aristocrats that sought to imitate or evoke Chinese art.

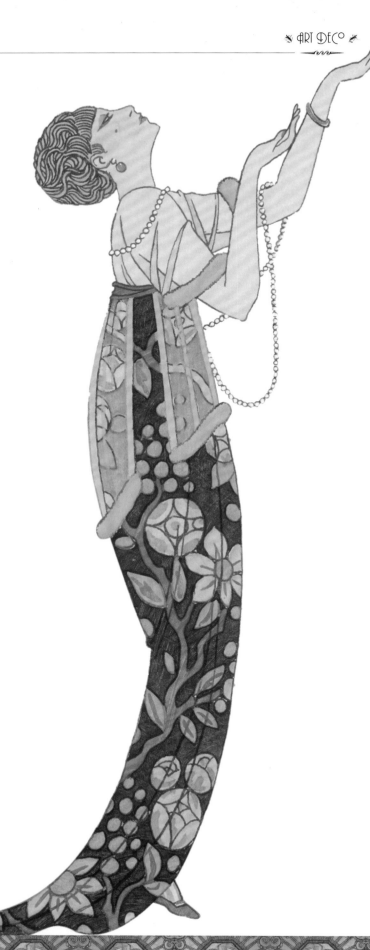

It was however usually inaccurate in its portrayals. The large porthole alludes to a ship on a voyage. The two women protagonists have possibly been smoking hashish or opium, both of which were legal substances in the 1920s. They are wearing silk pyjamas, again associated with the Chinese. In the 1920s pyjamas were not just worn at night, but by the more daring women as daywear sometimes with brocade shawls; they would often have 'Chinese' motifs painted or printed on the garment, as this illustration shows. The adoption of pyjamas as suitable attire in the 1920s has its origins in the Ballets-Russes productions in Paris from 1909, and was a style adopted by the couturier Paul Poiret. The style was taken up by women of the avant-garde as an expression of their new found freedom from convention. *La Paresse* appeared in the *Falbalas et Fanfreluches* almanac of 1925.

Gazette du Bon Ton

From 1912 until 1925, the *Gazette du Bon Ton* was arguably the most prestigious fashion journal in Paris, defining all the latest trends in *haute couture*. One of its main contributors was Barbier, who not only executed designs but also wrote essays on these trends. The *Gazette* established the tenor for elegant style and taste, and was published as a monthly journal that was both expensive to produce and for consumers to purchase. It was produced as a series of *pochoir* prints in the form of a folio rather than as a bound book and was particularly effective, as the vibrant and exciting colours of the Art Deco period were shown off to great effect by this method. Apart from *haute-couture* fashion, articles were also about high-society entertainment such as theatre, chic clubs, restaurants and travel.

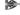

Georges Barbier
Les Modes **(detail), date unknown**
© Private Collection/The Bridgeman Art Library

MEDIUM: Lithograph

RELATED WORKS: Leon Bakst,
The Firebird, 1910

Georges Barbier *(overleaf)*
Éventails **(Fans) (detail), 1924**
© Collection Kharbine-Tapabor, Paris,
France/The Bridgeman Art Library

MEDIUM: Pochoir print

RELATED WORKS: A.E. Marty,
Worth Dance Dress, 1920

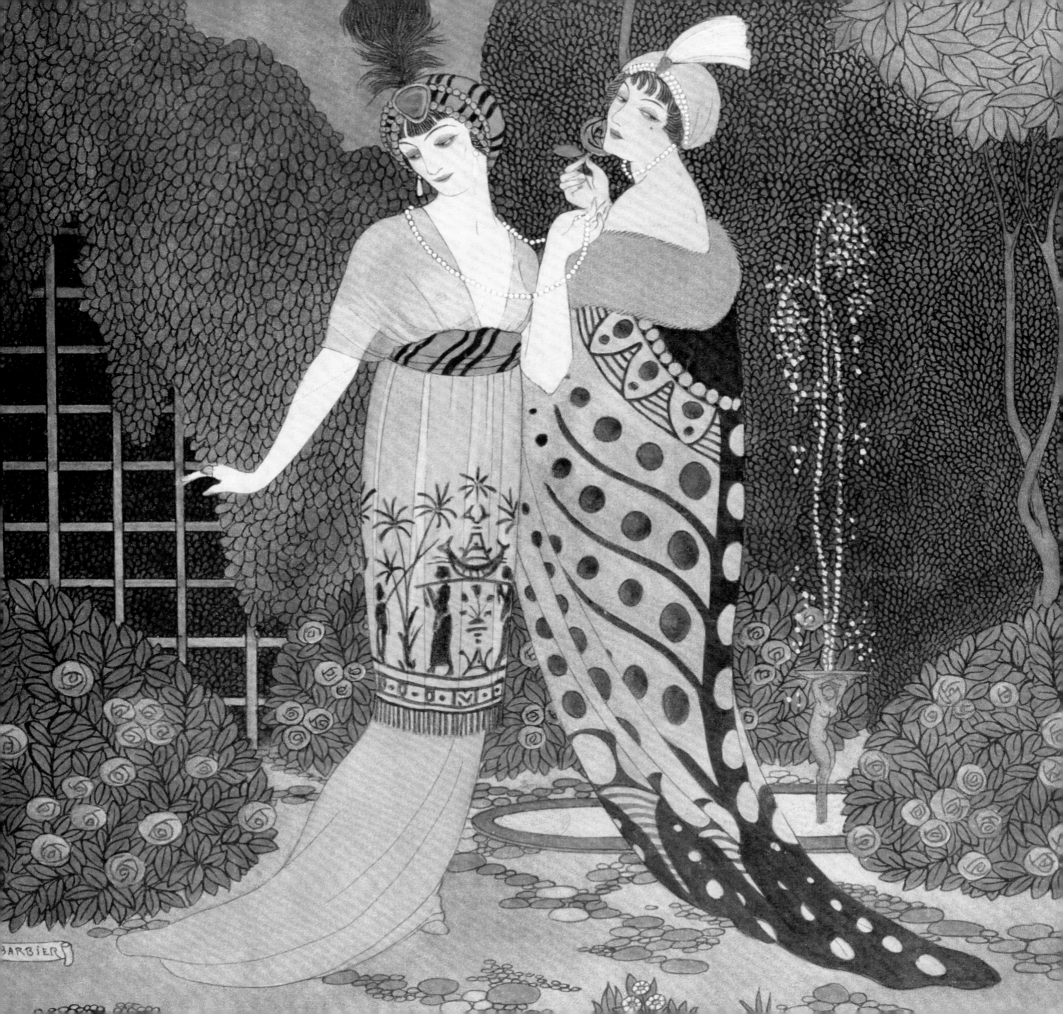

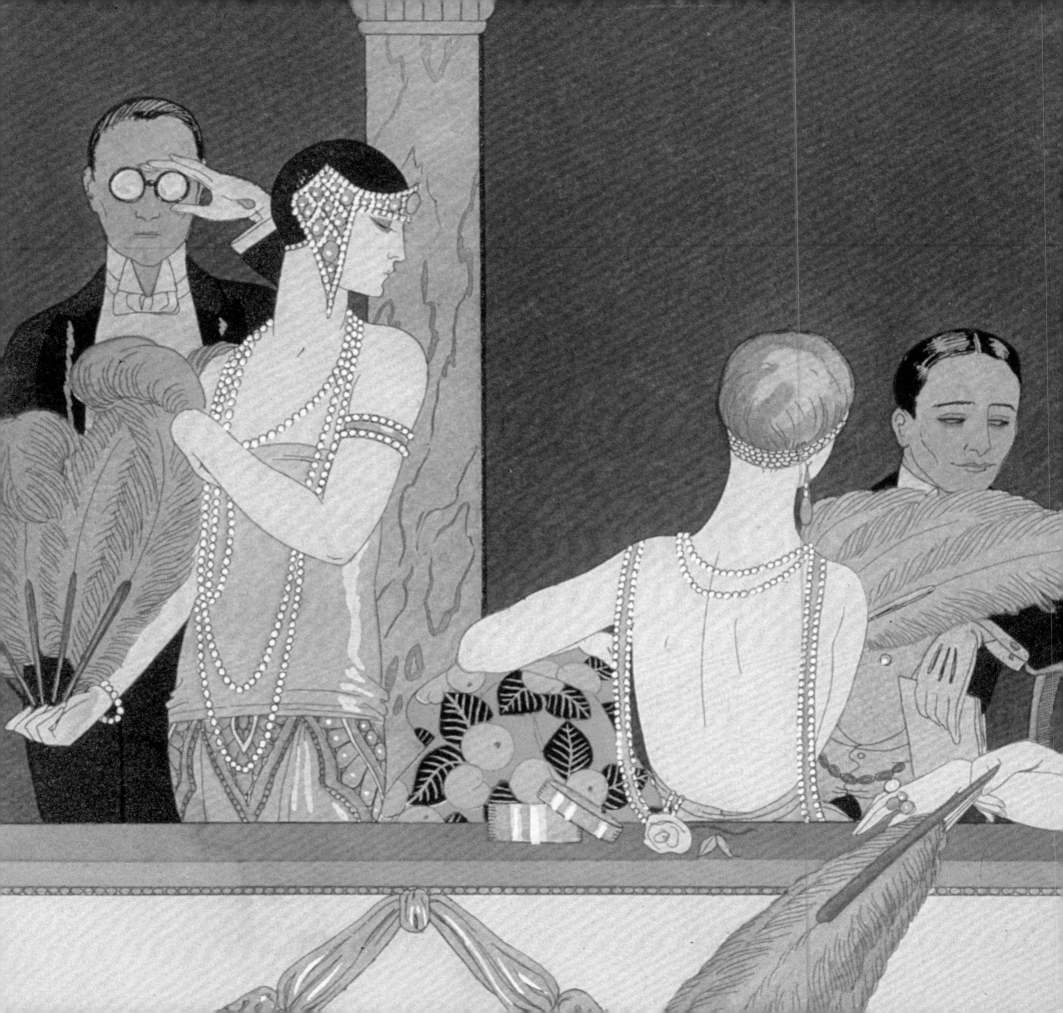

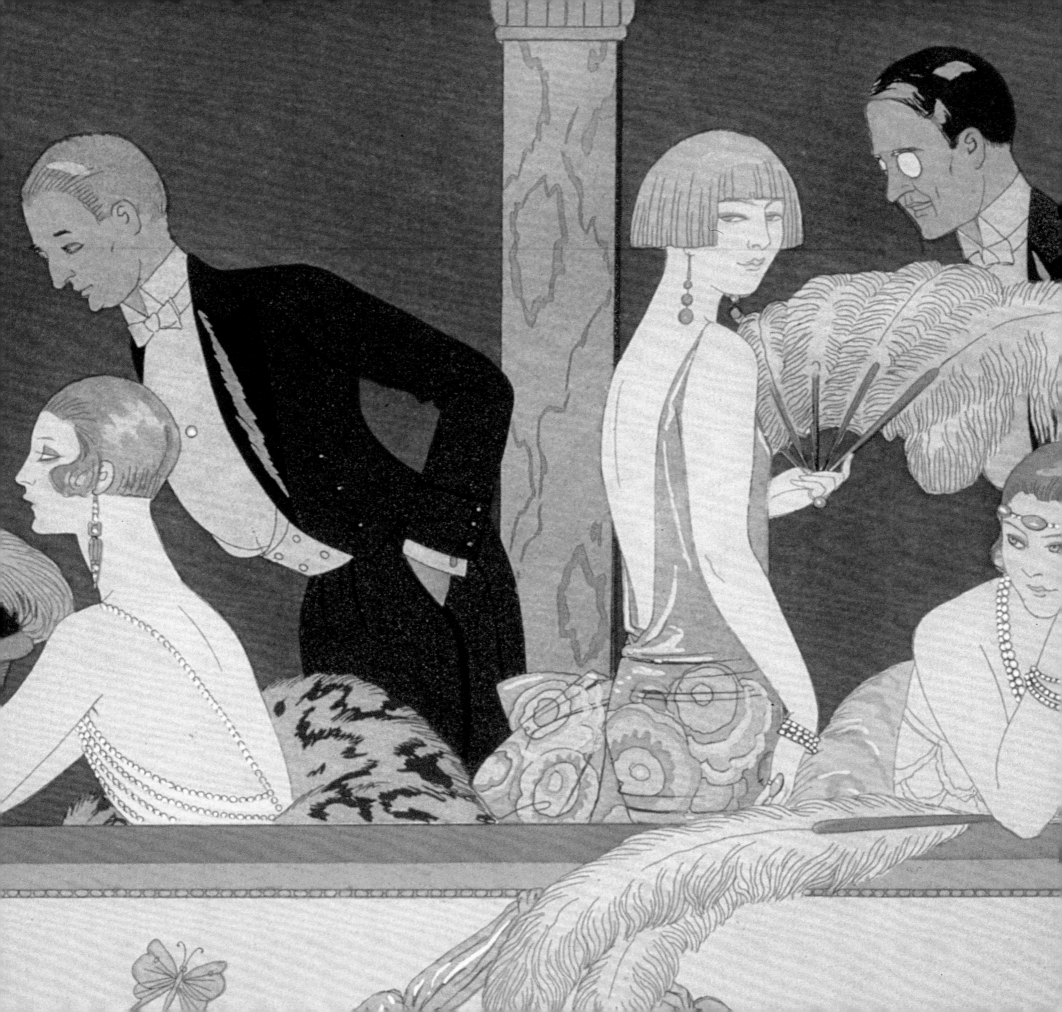

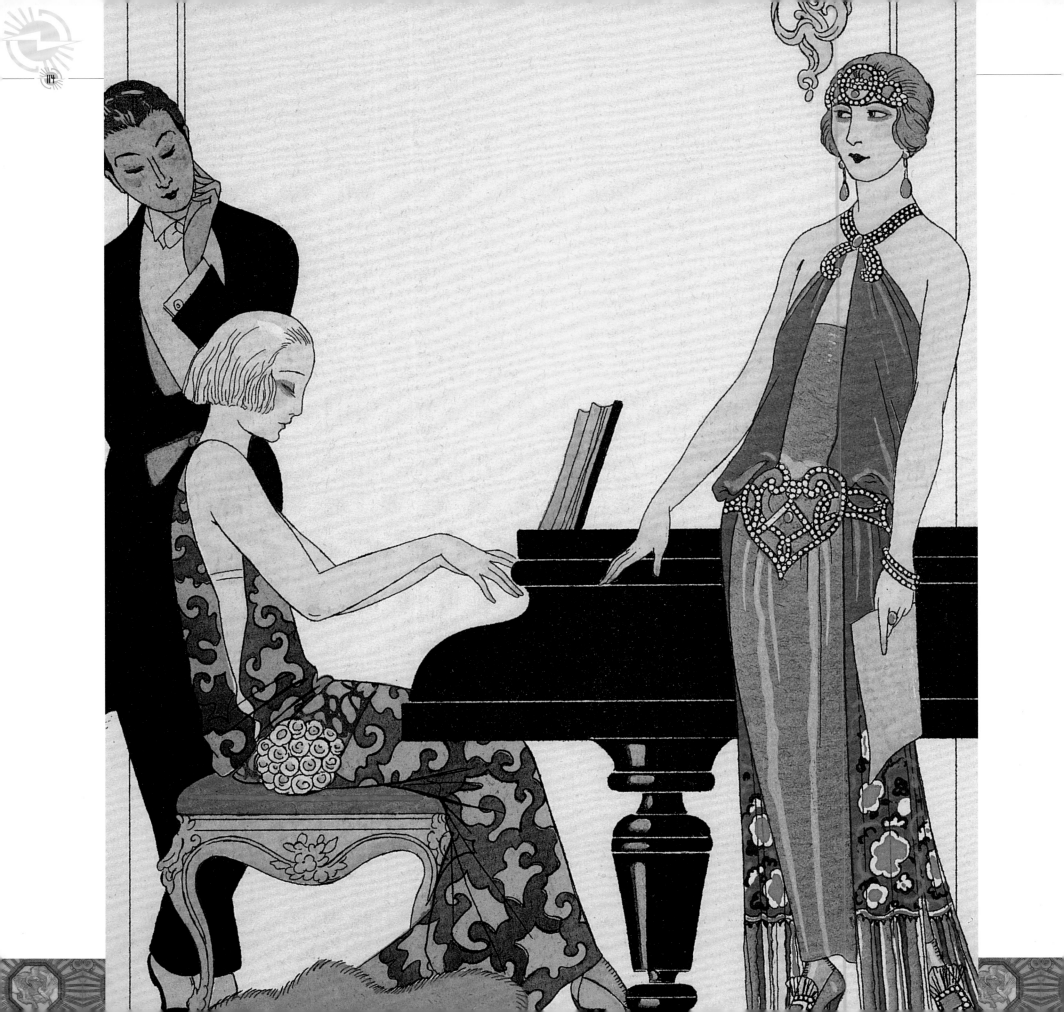

Georges Barbier
Incantation (detail), 1922–23
© Collection Archiv F. Kunst & Geschichte
Berlin/akg-images

MEDIUM: Pochoir print

RELATED WORKS: A.E. Marty,
Cover of *Vogue*, August 1926

Louis Cartier
Selection of Art Deco Jewellery, 1920s
© Christie's Images Ltd

MEDIUM: Various

RELATED WORKS:
Gerard Sandoz (1902–*c*. 1995),
Various Jewellery, 1920s

Most couturiers of note such as Jeanne Paquin (1869–1936), Poiret and Worth showed their gowns in the *Gazette* with many of the top illustrators such as Barbier employed to show them off to good effect, often in whimsical or fantastical settings.

Exoticism and African Influences

A feature of Art Deco costume is the exoticism that is found in its design and its accessories, an example being *Le Soir* (*see* page 119), painted by Barbier in 1925 and shown in the 1926 *Falbalas et Fanfreluches* almanac. The mid-calf sheath dress has a design that reflects those of the numerous bangles the model wears on her arms, which have a distinctly African feel to them. At the time of this picture, France had many colonial territories, mainly in West Africa, many of which were lost after the end of the Second World War. France was proud of its colonies and held a number of exhibitions to celebrate this fact, the largest of which were in 1906 and 1931. French avant-garde artists such as Pablo Picasso and Henri Matisse (1869–1954) had collected many African artefacts and used them as inspiration for their paintings and sculptures. The black lacquered Japanese screen in the background adds another exotic dimension to the work.

Leisure Wear

After a vacation on the French Riviera during the 1920s, the fashion designer Gabrielle 'Coco' Chanel had, against convention, acquired a suntan. This break with tradition sparked a new fad of tanning, particularly among the upper classes, at resorts such as Nice and Biarritz. Until then, suntans were associated with people who worked outside and were therefore considered vulgar. After association with the fashionable Chanel, tanning was considered desirable, a reflection of the wealth of the leisured classes, who also wished to play sports such as tennis. Women wanted to enjoy the same freedom to play as men and so Chanel's

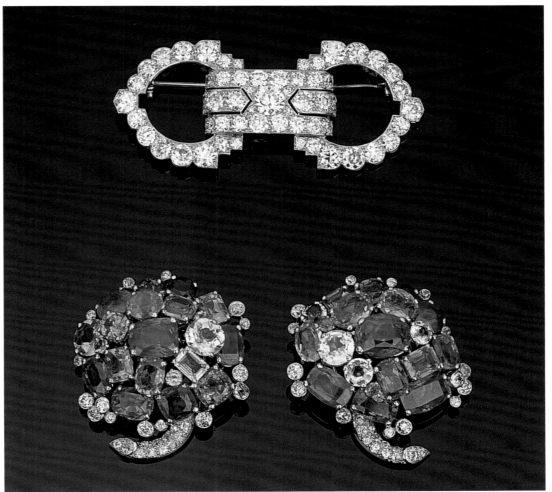

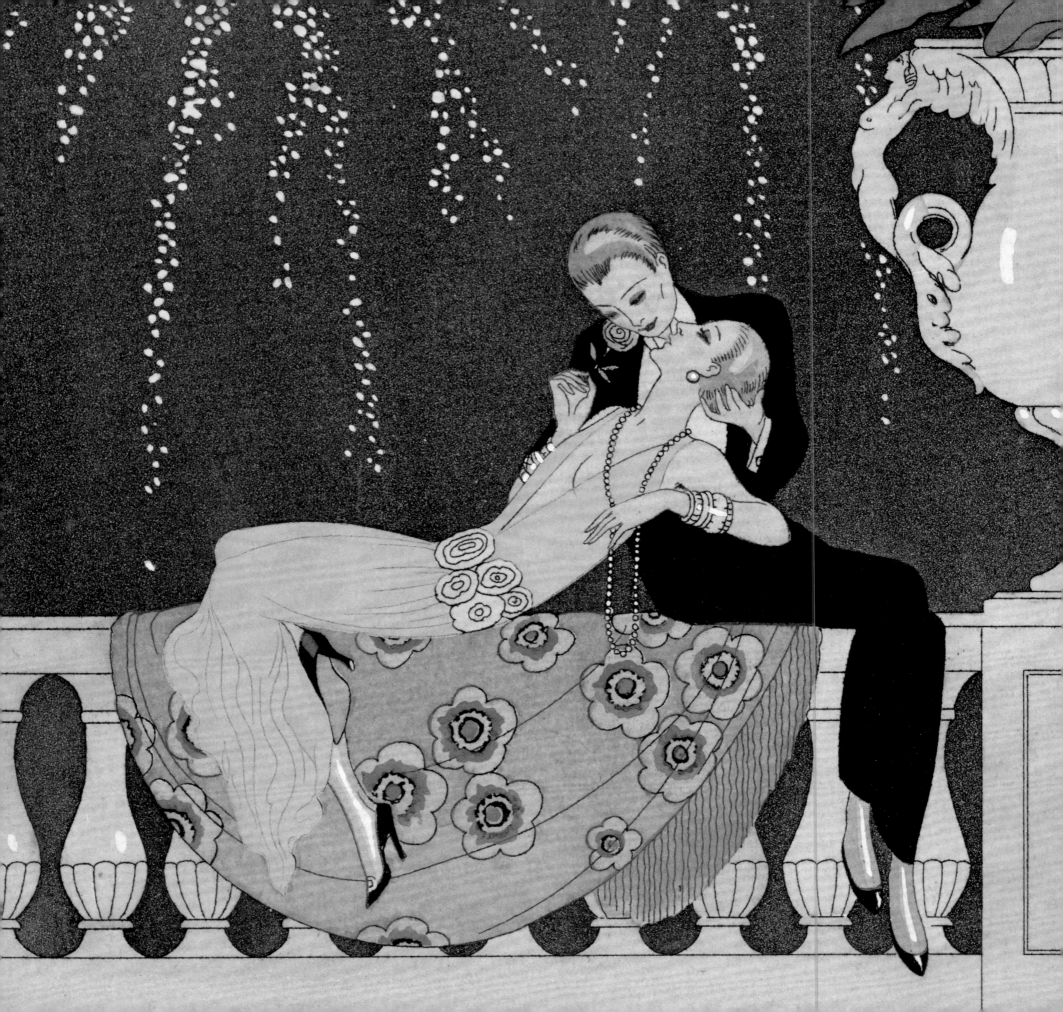

Georges Barbier

Le Feu (The Fire) (detail), 1925,
for *Fêtes Galantes* by Paul Verlaine

© Private Collection. The Stapleton Collection/
The Bridgeman Art Library

MEDIUM: Pochoir print

RELATED WORKS: J.A.M. Whistler
(1834–1903), *Nocturne in Black and Gold*, 1874

Marcel-André Bouraine

**Figure of a Female
Warrior,** *c.* 1925

© Estate of Marcel-André Bouraine/
Christie's Images Ltd

MEDIUM: Bronze

RELATED WORKS: Paul Manship,
Indian, 1914

great rival in sportswear, Jean Patou, developed the shorter tennis skirt. Suzanne Lenglen (1899–1938), the French tennis player who won Wimbledon six times in the years from 1919 to 1926, wore Patou's design. Barbier's *L'Eau*, 1925 (*see* page 120), which was reproduced in the 1926 *Falbalas et Fanfreluches* almanac, shows a Japanese-inspired design depicting the latest fashion in swimwear, particularly the striped costume. Like much Art Deco fashion the design assumes an almost bosom-less wearer. Note also the soft turban headwear of the woman with the parasol – rubber bathing caps at this time were not popular.

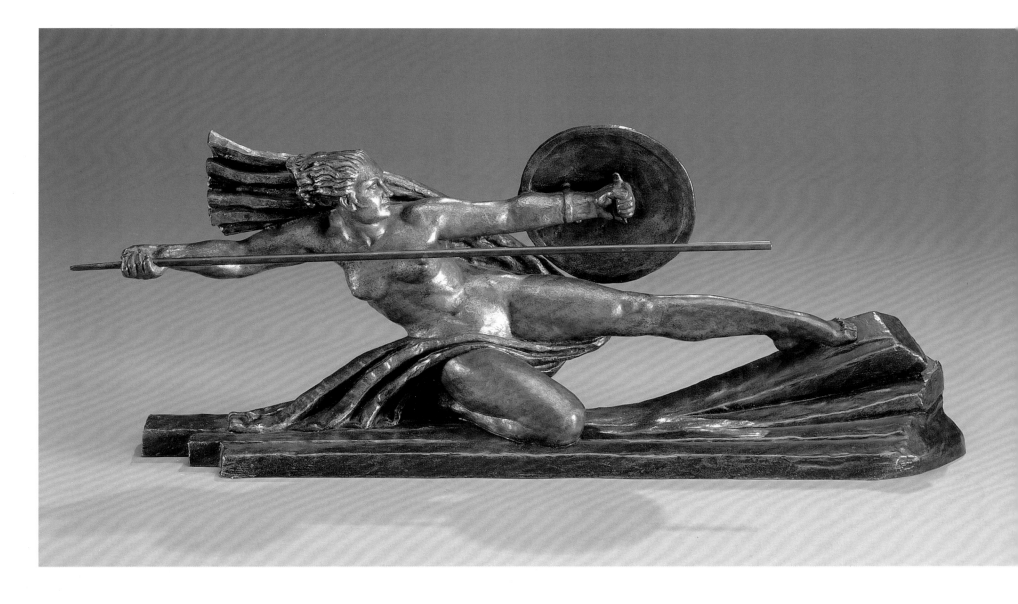

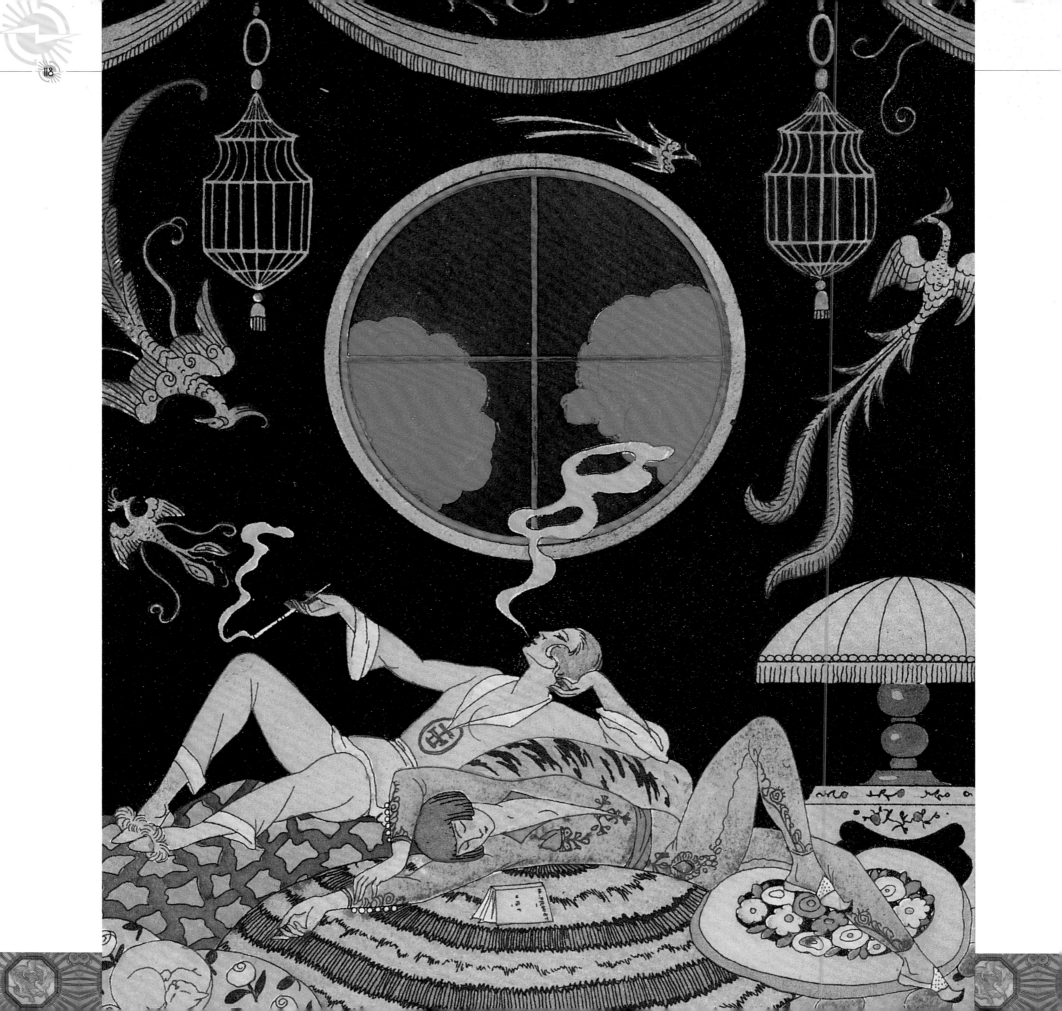

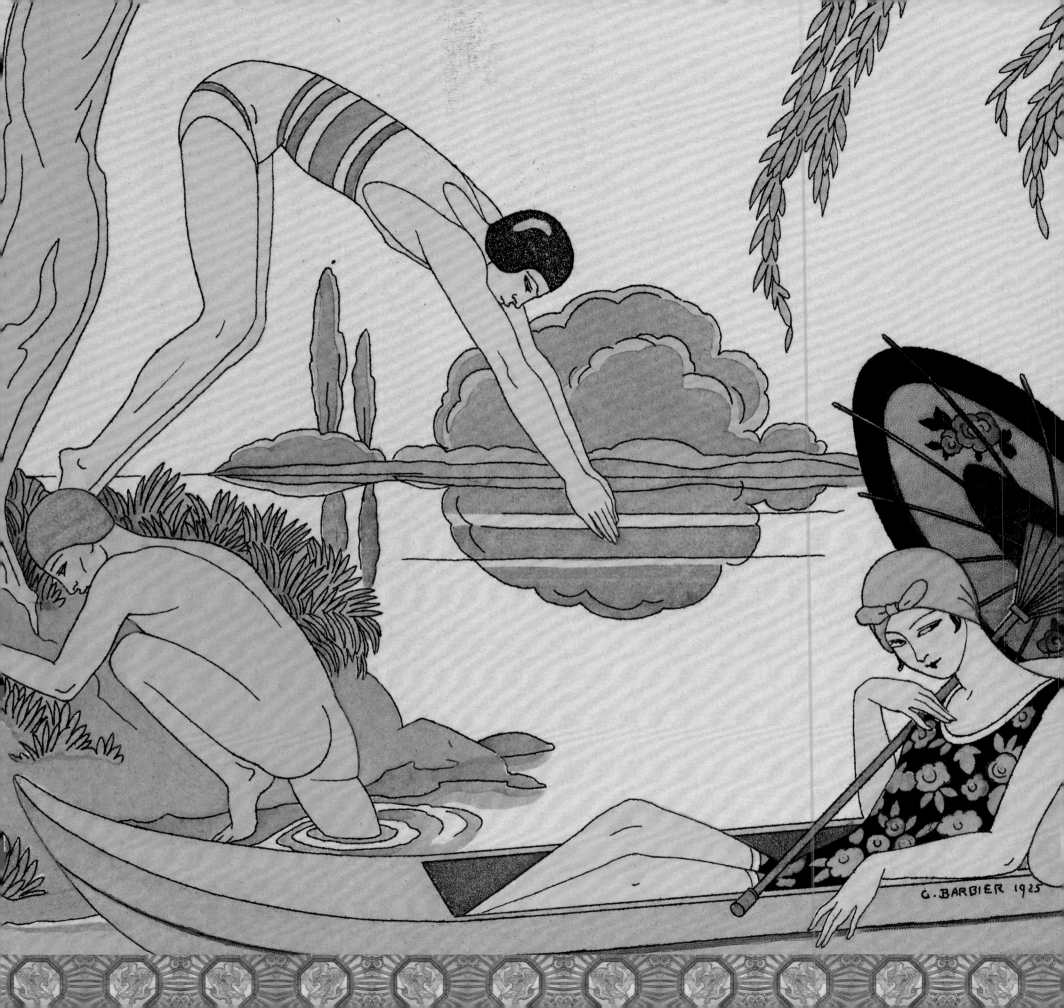

Georges Barbier *(previous left)*
La Paresse (detail), 1924–25
© Private Collection. The Stapleton Collection/
The Bridgeman Art Library

MEDIUM: Pochoir print

RELATED WORKS: Felix Vallotton
(1865–1925), *La Paresse*, 1898

Georges Barbier *(previous right)*
Le Soir (detail), 1925–26
© Stapleton Collection/Corbis

MEDIUM: Pochoir print

RELATED WORKS: Henri Matisse
(1869–1954), *Decorative Figure*, 1908

A Career Cut Short

Georges Barbier died in 1932 at the height of his creative powers, having been referred to three years earlier as 'one of the most characteristic witnesses of an age'. In his short career he had established a link between the elegant eighteenth century and his own time through carefully constructed images of the elite leisure class. He had distinguished himself as a member of the *Société des Artistes Décorateurs*, an influential body formed in 1901 to improve the decorative arts at the high end of design and craftsmanship. Although he worked on designs for jewellery, books and even wallpaper, he is remembered for his contribution to Art Deco fashion, not just in *haute-couture* journals, but as a designer of costumes for stage and film. He designed Rudolph Valentino's costumes for the film *Monsieur Beaucaire* in 1924, the same year he began working with Erté on costumes for the Folies Bergère. At Barbier's death, Erté was to remark 'far too young'.

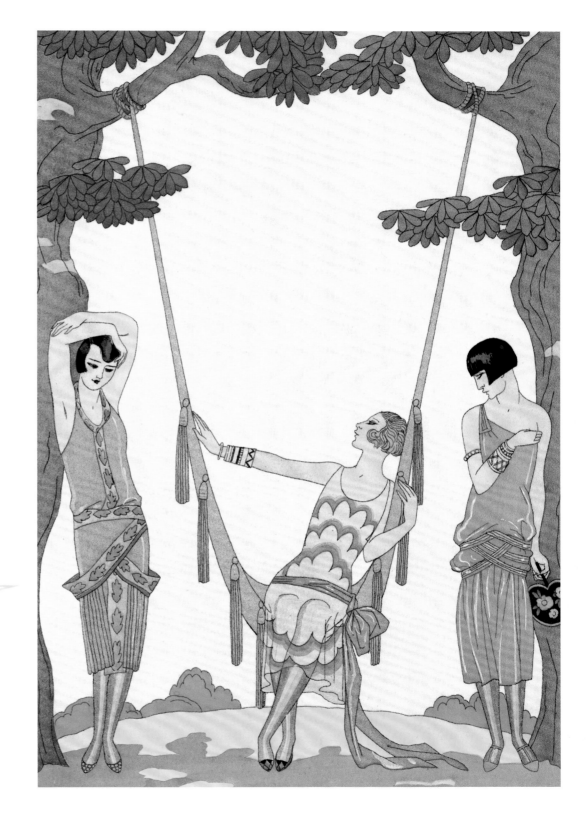

Georges Barbier
L'Eau (detail), 1925
© Stapleton Collection/Corbis

MEDIUM: Pochoir print

RELATED WORKS: Henri Matisse
(1869–1954), *Luxe, Calm et Volupté*, 1905

Georges Barbier
***Summer*, 1925,**
from *Gazette du Bon Ton*
© Private Collection, The Stapleton Collection/The
Bridgeman Art Library

MEDIUM: Pochoir print

RELATED WORKS: Georges Barbier,
The Taste for Shawls, 1922

GEORGES LEPAPE
(1887–1971)

Early Commissions

Having graduated from the École des Beaux Arts in Paris, the newly married Georges Lepape was fortunate in meeting the top couturier Paul Poiret, who subsequently commissioned him to illustrate *Les Choses de Paul Poiret* in 1911, an album of his most recent *haute-couture* collection. Lepape used a highly stylized form of illustration that in many ways became the benchmark for the Art Deco fashion style, using oriental motifs redolent of Léon Bakst (1886–1924), the Russian illustrator who was so influential in developing stage and costume design for the Ballets Russes. In one plate from the album (*see* right) we see the use of kohl-rimmed eye make-up that suggests exoticism, a style that was to become prevalent, initially among movie stars such as Theda Bara (1885–1955) in the early Art Deco period. Bara starred in a number of exotic silent films, such as *Cleopatra* (1917) and *Salome* (1918), depicting her as a sultry heroine. The early Art Deco style transmuted between fashion, theatre and cinema, particularly silent films when 'the look' conveyed emotion in the absence of audible speech. Poiret was the first to introduce the turban into *haute couture*, influenced by the Ballets Russes.

Designs by Paul Poiret
(1879–1944)

Paul Poiret's designs were illustrated by many of the artists featured in this book, but perhaps Lepape stands out, having illustrated a whole album of them. Of all the Art Deco fashion and costume designers, Paul Poiret was unquestionably the most significant since it was he that had initially advocated the liberation of fashionable *haute couture* from the restraints of the corset. Until then, women wore whalebone corsets designed to emphasize a narrow waistline. Opening his own couture

company in 1902, Poiret was influenced and inspired by the freedom of movement associated with the costumes of the Ballets Russes, and began to design *haute-couture* garments that reflected that freedom, such as his high-waist, straight *Directoire* dresses. He was also influenced by the simple and clear lines used by contemporary designers at the Wiener Werkstätte in Vienna, and worked with a number of avant-garde artists – most notably Raoul Dufy (1877–1953), with whom he designed textiles. Poiret was an innovator, and his designs proved popular before the First World War. After the war he introduced the so-called 'hobble-skirt dress', which looked very chic in fashion plates but restricted the wearer to 'hobbled' walking. The illustration *Eating Al Fresco*, 1924 (*see* page 127), produced by an unkown artist for *Art, Goût, Beauté*, shows gowns (the one on the right is by Poiret) that are a prime example of the chic but impractical design that eventually led to the closure of *La Maison Poiret*.

A Sense of Movement

Lepape continued working for Poiret after *Les Choses de Paul Poiret*, which had established his career. He readily understood the need to express the freedom that Poiret had instigated in the development of corset-less gowns and he achieved a sense of this freedom by placing the model close to the edge of the frame as if trying to escape its confines; we begin to see a change in fashion style with the loss of the 'natural' waist, in favour of an artificial one just below the bust line; and billowing arms and fabric that disguises the bust suggest freedom of movement. Many of Lepape's Poiret illustrations were created for use in the quality *haute-couture* journal *Gazette du Bon Ton*; Lepape became a major contributor to the journal up until it was taken over by *Vogue* magazine in 1925.

Georges Lepape
Illustration from *Les Choses de Paul Poiret*, 1911
Courtesy of Victoria and Albert Museum, London, UK/The Bridgeman Art Library/ © ADAGP, Paris and DACS, London

MEDIUM: Lithograph

RELATED WORKS: Leon Bakst, *Queen Thamar and the Prince*, 1912

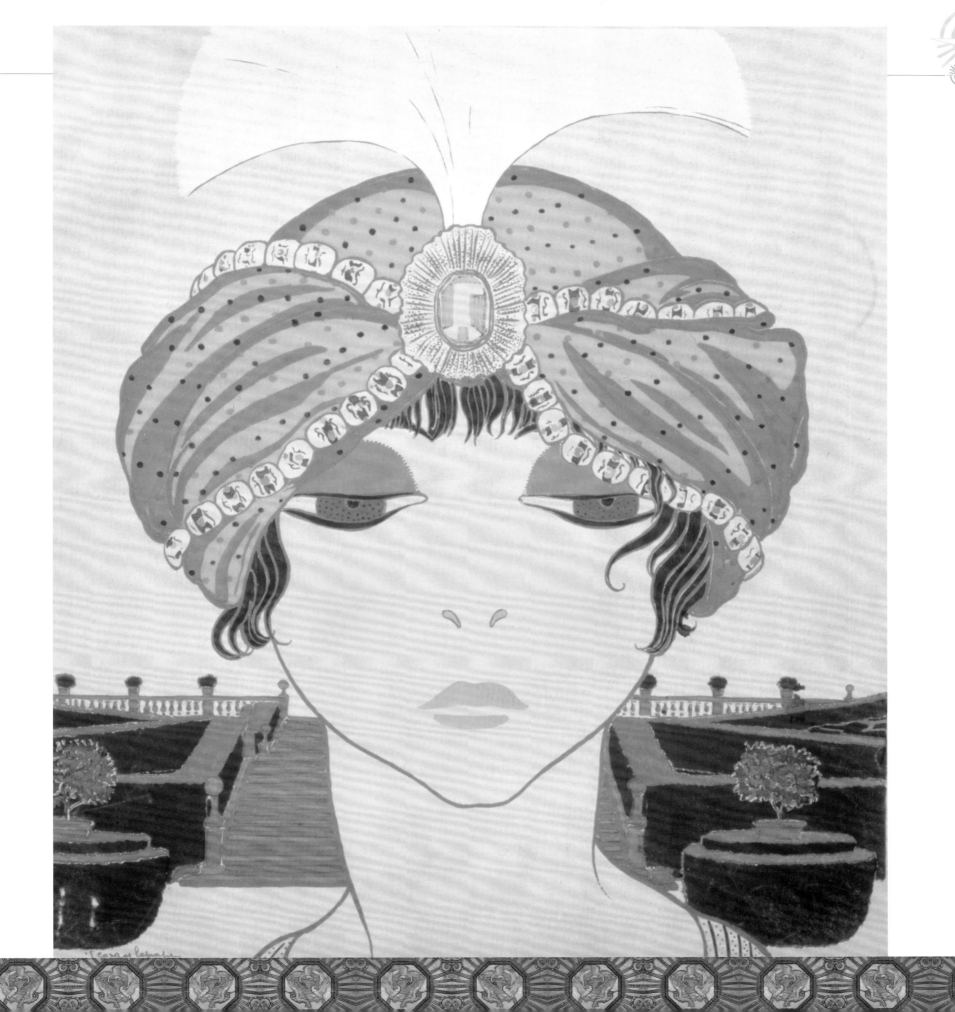

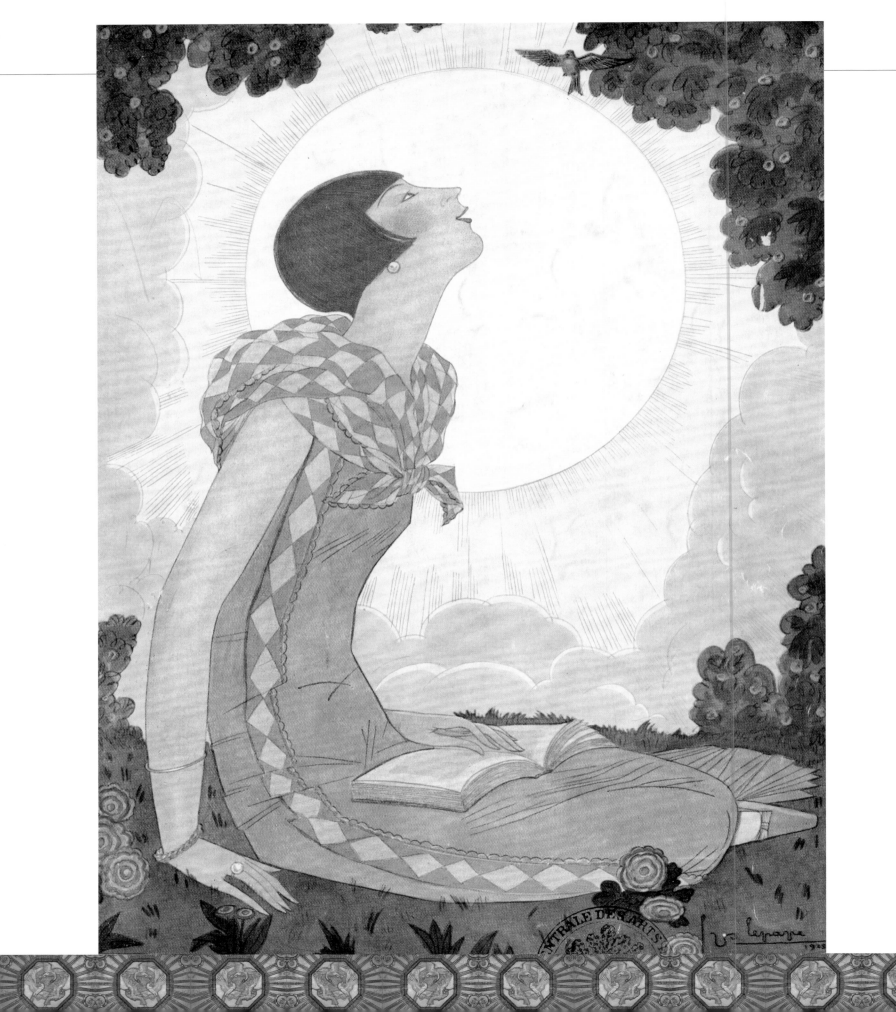

Georges Lepape
Cover of *Vogue*, 1925

Courtesy of Private Collection, Archives
Charmet/The Bridgeman Art Library/
© ADAGP, Paris and DACS, London

MEDIUM: Lithograph

RELATED WORKS: A.E. Marty,
Cover of *Vogue*, August 1926

Vogue

Vogue magazine began as a publication in the late nineteenth century, but it was the visionary excellence of the publisher Condé Nast that revived its fortunes and made it into one of the most read fashion journals of the twentieth century, both in Europe and America, where it began. The British and

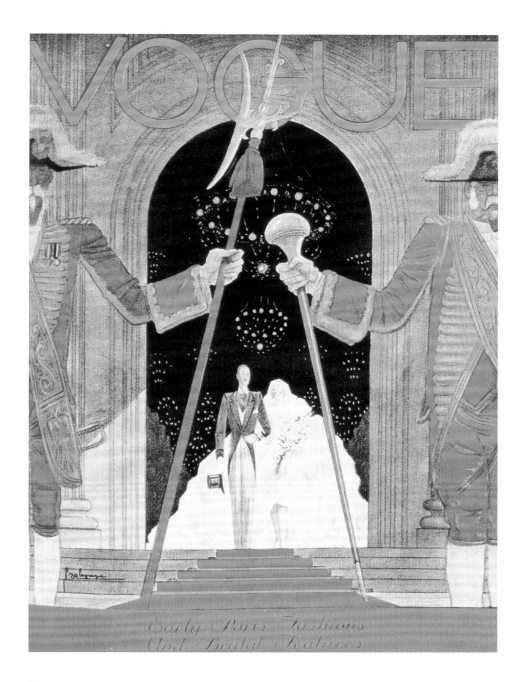

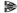

Georges Lepape
The Wedding March,
Cover of *Vogue*, March 1929

Courtesy of Private Collection/The Bridgeman Art
Library/© ADAGP, Paris and DACS, London

MEDIUM: Unknown

RELATED WORKS: Eduardo Benito
(1891–1981), Cover of *Vogue*, July 1929

French were quick to assimilate the American idea that a mass-produced journal was the quickest and most cost effective way for most people to see the latest Parisian fashions, producing their own versions of *Vogue* in 1916 and 1922 respectively. Soon after,

German and Italian versions followed. Lepape was one of the magazine's leading illustrators producing dozens of designs for their covers in France, the United States and Britain, including eight for the year 1927 alone. He even produced one aspirational cover for the French version's issue devoted to the *Exposition Internationale des Arts Décoratifs* in 1925 (*see* pages 124–25), in which a young girl with fashionable bob and slim-line dress gazes admiringly at a fluttering bird while a book rests on her lap. *The Wedding March* (*see* page 125) appeared on the May 1929 issue. The fashionable short-length dress seen here was soon to give way to longer hemlines again at the beginning of the 1930s. Even though America and Europe were entering the period known as the Great Depression, sales of *Vogue* increased dramatically as people sought refuge from the traumas of their own existence, finding solace in fashion and celebrity.

Other Interests

Lepape enjoyed a long life and career, working up until his death in 1971. By 1920 he had already completed his first decade of work for many of the top Parisian couturiers including Jeanne Lanvin (1867–1946), Worth and Paquin, with many illustrations of their work in the leading *haute-couture* journals of the time. During his career he contributed to theatre programmes such as Diaghilev's Ballets Russes and to cinema posters and book illustration. But his first love was fashion illustration, working not just for couturiers but also for perfumers and furriers – an example of the latter being an advertisement for Weil Furs,

Georges Lepape
Tout vous est aquillon. Tout me semble zéphyr…, Advertisement for Weil Furs, *c.* 1920
Courtesy of Private Collection/The Bridgeman Art Library/© ADAGP, Paris and DACS, London

MEDIUM: Gouache

RELATED WORKS: Helen Dryden (1887–1981), Cover of *Vogue*, November 1920

Unknown artist
Eating Al Fresco (designs by Paul Poiret et al.), 1924, from *Art, Goût, Beauté*
© Mary Evans Picture Library

MEDIUM: Gouache

RELATED WORKS: Raoul Dufy (1877–1953), *La Forie aux Oignons*, *c.* 1907

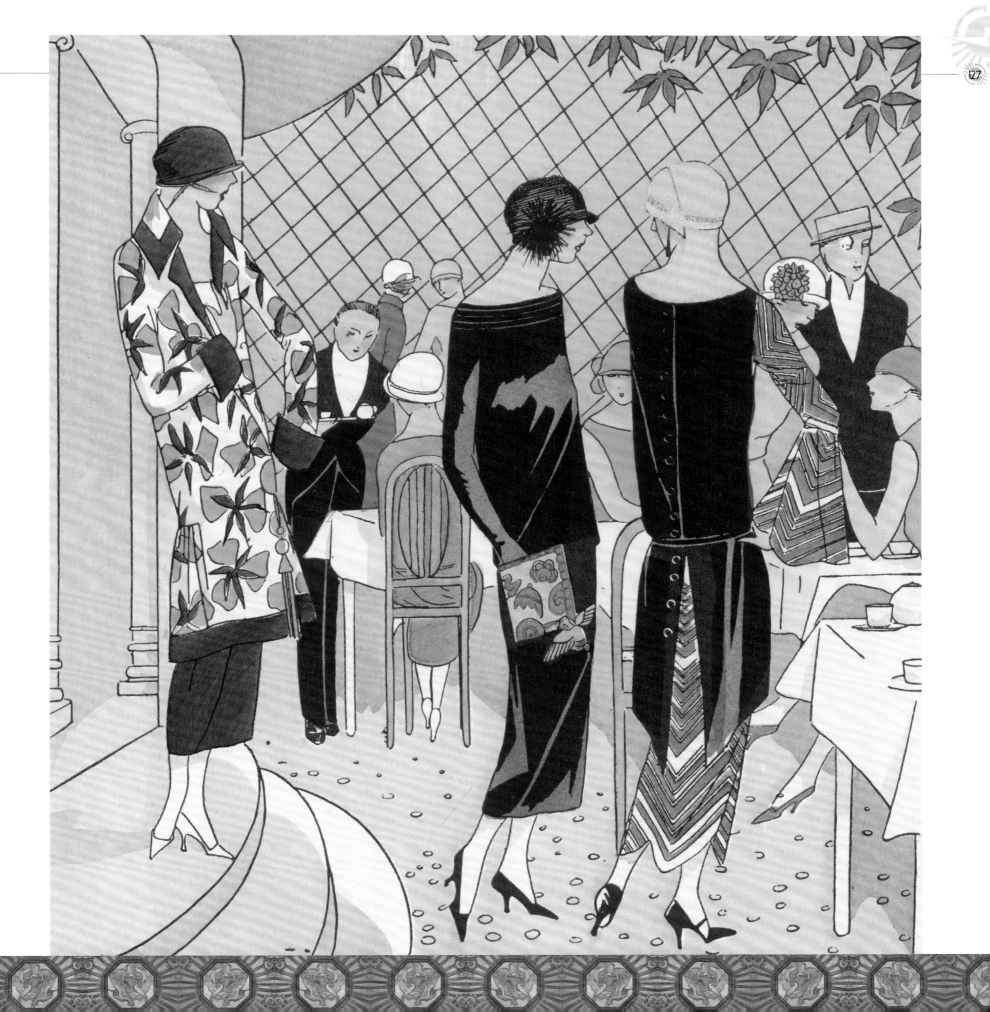

c. 1920 (*see* page 126), a business set up by three brothers in 1912. The illustration, which appeared as a *pochoir* print in *Gazette du Bon Ton*, was printed with a caption that translates as 'what feels to you like a north wind, feels to me like a summer breeze'. In 1927, Marcus Weil was responsible for introducing what he termed 'fur perfumes', fragrances specifically developed to be worn with fur coats. These proved very popular; the best known was called *Zibeline* ('sable'), redolent of the oak forests of Russia.

ANDRÉ EDOUARD MARTY
(1882–1974)

Individual Style

The contrast between the Art Deco style of Jean-Gabriel Domergue and that of French artist and designer André Edouard Marty shows the diversity of art and graphics in the 1920s and 1930s. Marty studied at the École des Beaux-Arts in Paris and at the atelier of Fernand Cormon (1845–1924). One of his first commissions came from Diaghilev's Ballets Russes, performing in Paris. A Ballets Russes poster of 1910 by Marty captures the gaiety of the ballet and its vibrant use of colour, which had a profound effect on Marty and the French design industry, particularly in the field of commercial illustration.

Fashion Illustration

Marty and Pierre Brissaud were the first illustrators to work for Lucien Vogel (1886–1954) in his ground-breaking fashion magazine *Gazette du Bon Ton* and Marty was one of four artists to maintain a continuous contract with the magazine. The *pochoir* prints he produced for the fashion plates became instant collector's items and his reputation was immediately made. He worked for many publications including *Le Sourire*, *Fémina*, *Modes et Manières d'Aujourd'hui* and *Comoedia Illustré*. His output of illustrative work was prolific and the American magazines *Vogue* and *Harper's Bazaar* were quick to reproduce his illustrations, which advanced his reputation. Marty's August 1926 *Vogue* cover (*see* left) illustrates his soft tones, refined brushwork and flat two-dimensional depiction of a young and fashionable woman of culture. It was to inform the reader of the essence of Parisian style.

Haute Couture Idealized

The popularity of the illustrated fashion plate or *pochoir* print gave graphic designers in Paris much work and increased the output of the type foundries. The appetite for fashion magazines with illustrations of the latest creations from the *maisons de haute couture* was insatiable, only dipping during the war years. To couturiers, the advantage of drawn illustrations was the illustrator's ability to idealize the shape of the dress and accentuate its finer details. Every female could have a

André Edouard Marty
Cover of *Vogue*, August 1926
© Estate of André Edouard Marty/Private
Collection/The Bridgeman Art Library

MEDIUM: Unknown

RELATED WORKS: James Abbe
(1883–1973), Photograph of Gilda
Gray, 1924

André Edouard Marty
***L'Oasis ou La Voute Pneumatique*,**
1921, from *Gazette du Bon Ton*
© Estate of André Edouard Marty/Bibliotheque des
Arts Decoratifs, Paris, France, Archives
Charmet/The Bridgeman Art Library

MEDIUM: Lithograph

RELATED WORKS: Georges Lepape,
Poster for *Bal de la Couture*, 1925

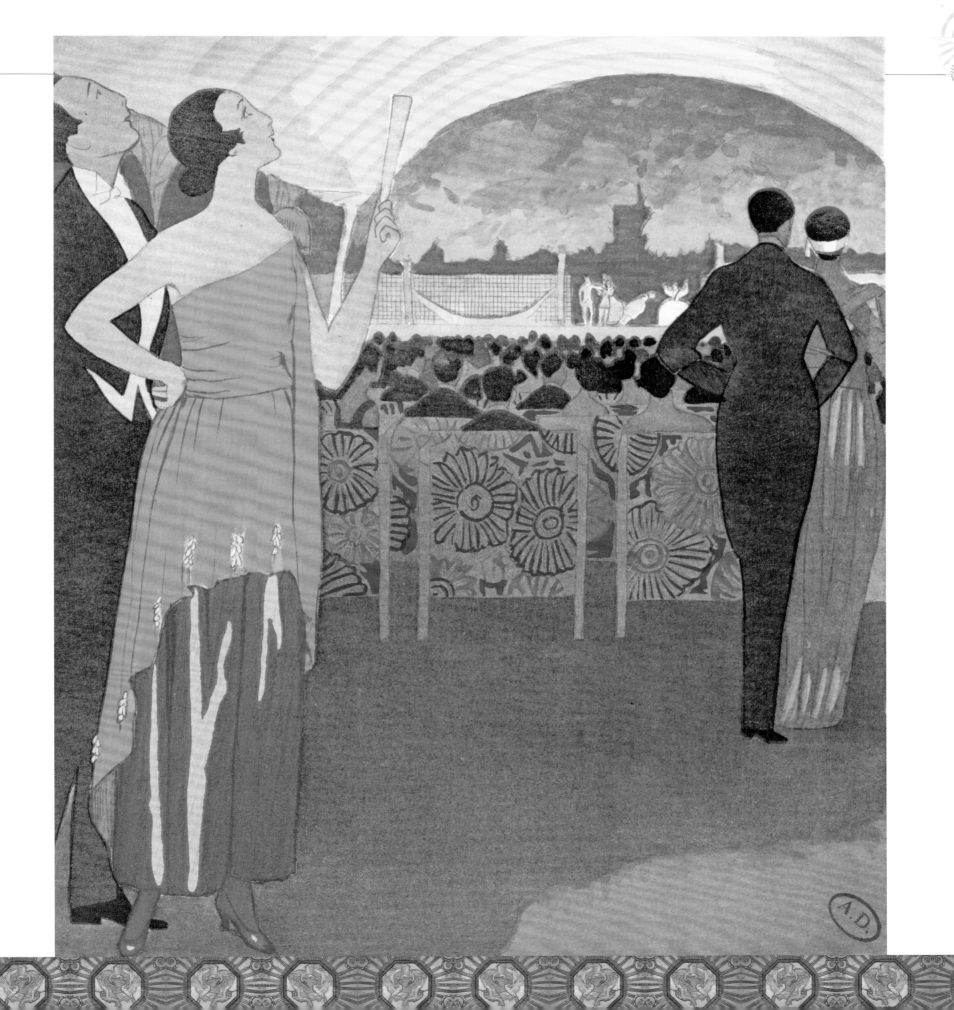

André Edouard Marty *(previous left)*
Worth Dance Dress, 1920,
from *Gazette du Bon Ton*
© Estate of André Edouard Marty/Mary Evans
Picture Library

MEDIUM: Lithograph

RELATED WORKS: Robert Bonfils,
En Écoutant Satie, 1920, from *Modes et
Manières d'Aujourd'hui*

Charles Martin *(previous right)*
Le Bain (The Bath) **(detail), 1913,**
from *Modes et Manieres d'Aujourd'hui*
© Bibliotheque Nationale, Paris, France,
Archives Charmet/The Bridgeman Art Library

MEDIUM: Lithograph

RELATED WORKS: Georges Lepape,
Directoire-style boudoir, 1911, from *Les
Chose de Paul Poiret*

swan-like neck, long legs, high cheek bones and the latest hair creation to match the clothing: the short bob, Eton crop and shingle were *à la mode*. Marty and Brissaud were experts in the field of fantasy landscapes – Marty imitating the form of Japanese prints and desirable settings to bring to life the soirees and social gatherings of the elite society of Paris. Two plates from *Gazette du Bon Ton* illustrate his technique: in *Worth Dance Dress*, 1920 (*see* page 130), an evening dress by the House of Worth is depicted with a dark landscape backdrop to highlight the delicacy of the dress colour, the three-quarter-profile pose accentuates the feminine figure, whilst the open front of the half-over skirt accentuates the hips; *L'Oasis ou La Voute Pneumatique*, 1921 (*see* page 129), has more depth of field and informs the readers of *Gazette du Bon Ton* exactly what to wear to an evening at the ballet.

Exposition Internationale, 1925

André Marty was appointed a member of the prestigious jury for the 1925 *Exposition*, for which he created special deluxe editions of *pochoir* prints to capitalize on the vogue for them. As a member of the *Compagnie des Arts Français* (CAF) of Louis Süe (1875–1968) and André Mare (1885–1932), he designed a screen and wall hangings for the Pavilion Fontaine. The contemporary pictorial decoration of the screen is in the style of the elegant *fêtes galantes* painted by Antoine Watteau (1684–1721). In the 1930s Marty was commissioned to create costumes and set designs for ballet, film and theatre. In his long and productive life of 92 years he produced over 50 deluxe limited books of illustrations, which are historic social documents of the period and remain his legacy.

CHARLES MARTIN (1848–1934)

Early Work

The early *Le Bain*, 1913 (*see* page 131), has rather classical connotations in the image of the woman swathed in cloth, but it hints at the emerging freedom and decadence of the era's fashion, and the design of the curtains and carpet reveal the trend towards the geometric motifs and solid colours of Art Deco. This lithograph illustration by Charles Martin appeared in *Modes et Manières d'Aujourd'hui*. Both this magazine and *Gazette du Bon Ton* carried on until 1925, but not without some blips along the way. The *Gazette du Bon Ton* ceased publication during the First World War, but Paris was determined not to lose its lead as the international arbiter of fashion – across the Atlantic was the San Francisco World's Fair, a perfect opportunity to continue showing the latest Parisian fashions, and the *Gazette* managed to produce a special edition for the fair, dated June 1915, declaring in its editorial that 'France has escaped the greatest peril and marches towards certain victory'. Among its contributors were Georges Lepape, Georges Barbier and Charles Martin, who produced the *pochoirs* necessary for the issue, showing that none of the high standards of the *Gazette* had been compromised.

Mature Work

Martin's illustrations were in demand by all the leading couturiers in Paris in the interwar years. One of those was Augusta Bernard (1886–1946). On moving to Paris, where she opened her atelier in 1922, Bernard fused her first name

Charles Martin
Gowns by Augustabernard, 1933,
from *Harper's Bazaar*
© Mary Evans Picture Library/
National Magazine Company

MEDIUM: Gouache

RELATED WORKS: Muguette
Buhler (dates unknown), *Designs
for Augustabernard*, 1930s

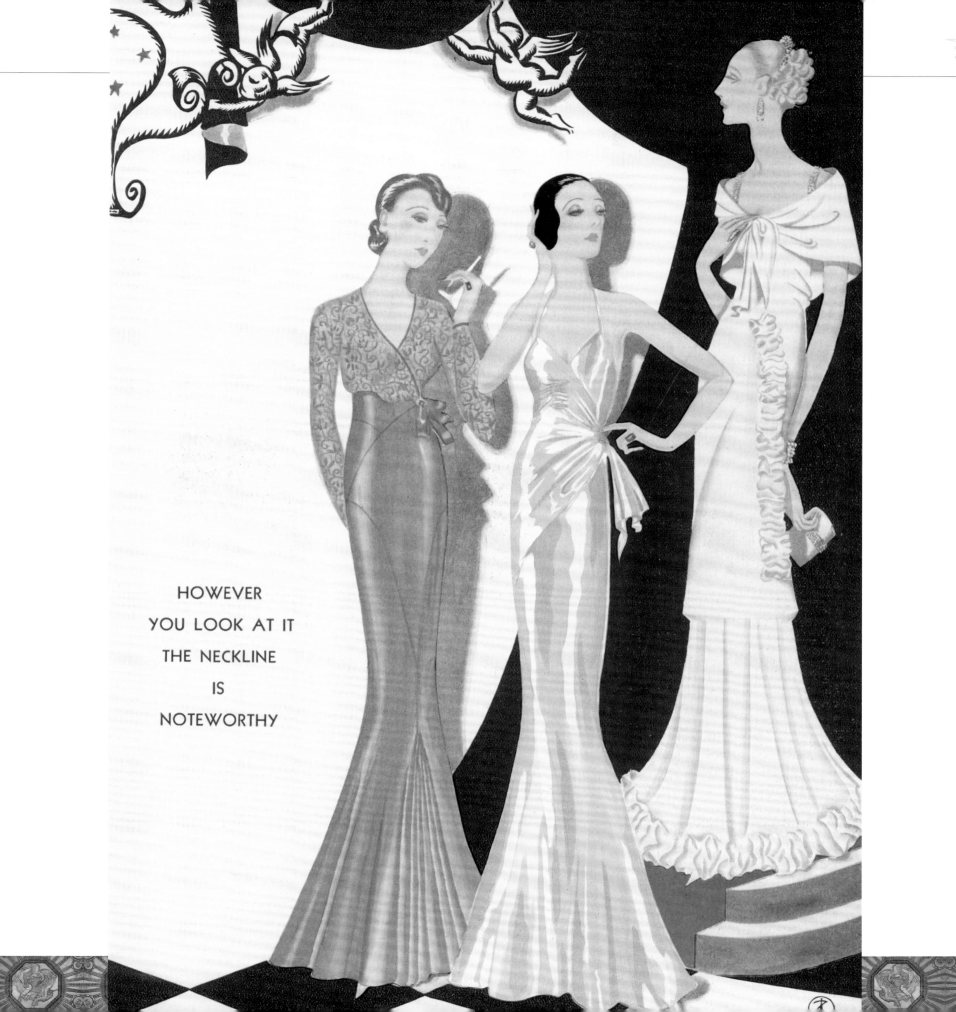

HOWEVER
YOU LOOK AT IT
THE NECKLINE
IS
NOTEWORTHY

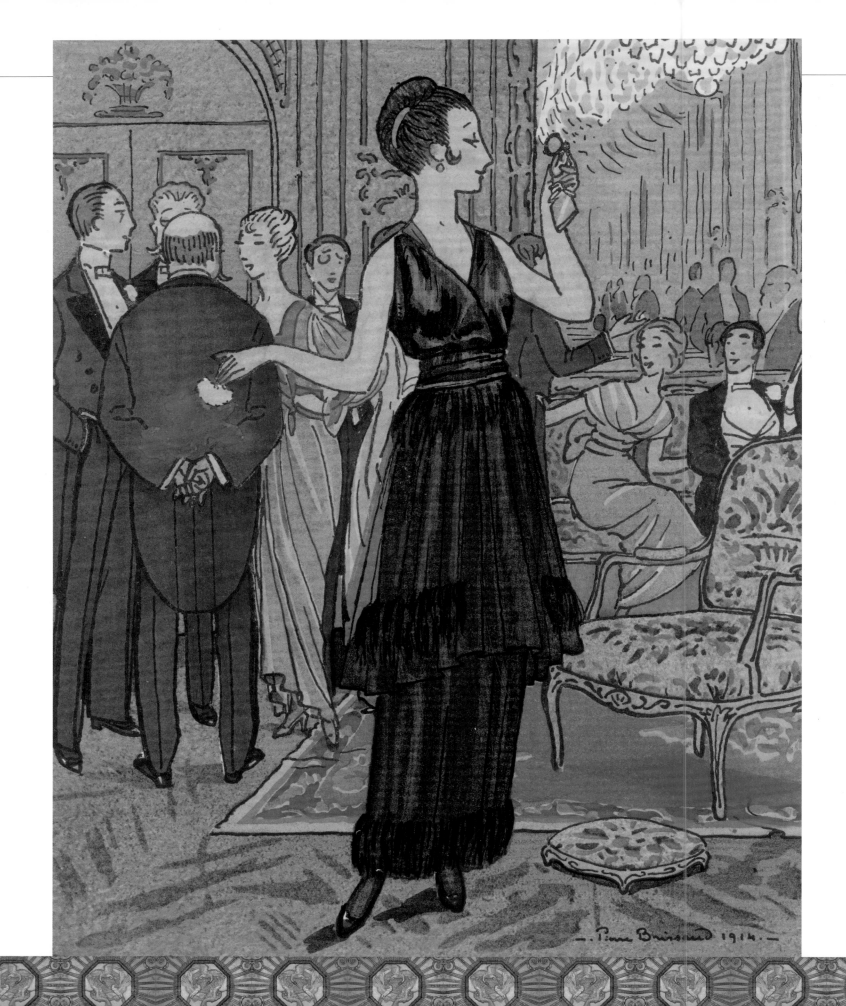

Pierre Brissaud 1914.

and surname together, to avoid confusion with other designer names. She made her name by creating elegant dresses, such as in *Gowns by Augustabernard*, 1920 (*see* page 133), fashioned from fabric cut on the bias, rather as her older contemporary Madeleine Vionnet (1876–1975) was doing. This cut creates a flowing movement to the gown combining freedom with an elegant draping quality. Such natural movement in the fabric also avoids the need for embroidery usually employed by other couturiers. Augustabernard used pale pastel colours and shaped the dresses very sculpturally, a style redolent of ancient Greek forms. Her clientele were mainly wealthy Americans, but her reputation was made after designing a dress for a French aristocrat for which she won the prestigious *Concours d'Élegance* prize in St Moritz in 1930. Augustabernard continued to build on that award creating an evening gown in 1932 that was chosen by Vogue as the 'Dress of the Year'. Although less well known now, the name of Augustabernard ranks with her contemporaries, Vionnet, Gabrielle Chanel and Elsa Schiaparelli (1890–1973). Similarly, Charles Martin is less well known today than his contemporaries, having died in 1934.

PIERRE BRISSAUD
(1885–1964)

Close Ties

The working relationship and camaraderie between André Marty and the French painter, engraver and illustrator Pierre Brissaud lasted their lifetimes. Brissaud is known primarily for the Art Deco illustrations and advertisements he produced in Paris and New York, particularly his first commissions to illustrate and idealize Paul Poiret's couture clothing, reproduced in *Gazette du Bon Ton*. Brissaud was born in Paris into a creative arts family (his father an illustrator, his brother a painter), and was trained formally at the École des Beaux Arts. On leaving, he enrolled at the notable atelier of Fernand Cormon. Those he met there, such as Georges Lepape,

André Marty and Charles Martin, would go on together as a group, including himself, to define the graphic art of the Art Deco era. In France, Brissaud created many pin-up posters which were popular in the 1920s and 1930s, advertising the joys of leisure activities and holidays. It is in his innovative illustrations for poster publicity, advertising campaigns and illustrations for the French couture houses, and French and American magazines, that the exuberance and fun of modern life during the interwar years is remembered.

Fashionable Society

Brissaud's exquisite limited-edition *pochoir* prints for *Gazette du Bon Ton* are masterful. The delicacy of the hand stencilling of each colour sharpens the image and allows intensity and depth of colour, light and shadow. For *Social Visiting*, 1920, Brissaud uses subtle perspective (the grand staircase) to distance the mother from her daughters. The close-cropped picture frames the body of the lady and she vertically fills the picture frame to the left of centre. A light source creates shadows on the children adding depth to the plane. Through the direction of bodies and heads, Brissaud imparts elegance and decorum, fitting attributes for the couture clothes each figure wears. The close-cropped, full-length image is a trademark of Brissaud's fashion illustrations. In *Evening Party*, 1914 (*see* left), the eye is drawn to the elegant hand movements of the central figure of a woman dressed in a layered, sleeveless, black evening dress. She stands in the centre of the picture frame with a party crowd in the background. Brissaud makes the geometric and floral patterns of the flooring match the walls, accentuating the flat picture plane. To the rear right he creates, offstage, a grand room of chandeliers.

Pierre Brissaud
Evening Party, 1914,
from *Gazette du Bon Ton*
© Estate of Pierre Brissaud/Mary Evans Picture Library

MEDIUM: Pochoir print

RELATED WORKS: Lucien Lelong (1889–1958), Black Silk Velvet Gown, photographed for French *Vogue*, 1934

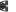

Art, Decorative Art and Sculpture Define the Era

Brissaud's artistic eye effortlessly captures the elegance of society women through quite small, normally insignificant, hand movements. It was possible to impart elegance in sculptural pieces too. The gently raised arms and flowing body line of the figure of a young woman in one 1920 bronze and ivory figurine (*see* below) by Ferdinand Preiss (1882–1943), for instance, are all that is needed to denote elegance and refinement. The girl turns her

body in the gentle wind, which lifts the layers of her drop-waisted, short ruffled dress. Preiss was regarded as one of the leading ivory carvers of the Art Deco scene in the 1920s. Similarly, Brissaud draws attention to the elegant hand movements of the central figure in *Beer Evening Dress*, 1920 (*see* right), illustrated in *Gazette du Bon Ton*. The lady, wearing a feminine dress by Gustave Beer, a German fashion designer with a couture house in Paris, adjusts her fashionable chignon with her left hand whilst holding a fan in her right. Brissaud draws attention to the detail on the back of the dress, including the oversized bow which falls to make a train for the dress. As the servants open the draped curtains to announce her entrance, one notices the tight space in which Brissaud has staged the scene. The woman and dress dominate the picture frame. The black and white square floor pattern mirrors and accentuates the monotone shade of her skirt.

Fame in New York

Having earned his reputation through the exquisite *pochoir* prints he created for *Gazette du Bon Ton*, Brissaud emigrated to live in New York. His work is visible in American publications such as *Vogue*, *Ladies Home Journal*, *Fortune* magazine and *House and Garden*, where his watercolour illustrations accentuate the light touch of his graphic skills. In France he had often been commissioned to produce illustrations for books – and he continued to be in demand from American book publishers, whilst advertising commissions were plentiful too. The free style of his graphic work suited clients such as Steinway, Hupmobile and Cadillac.

Ferdinand Preiss
Bronze and ivory figurine, 1920s
Courtesy of Christie's Images Ltd/© DACS

MEDIUM: Ivory and painted bronze

RELATED WORKS: Professor Otto Poertzel, *Butterfly Dancers*, 1920s

Pierre Brissaud
Beer Evening Dress, 1920,
from *Gazette du Bon Ton*

© Estate of Pierre Brissaud/Mary Evans Picture Library

MEDIUM: Pochoir print

RELATED WORKS: Alexandre Rzewuski (dates unknown), Silver Tissue Wedding Dress, 1921, from *Gazette du Bon Ton*

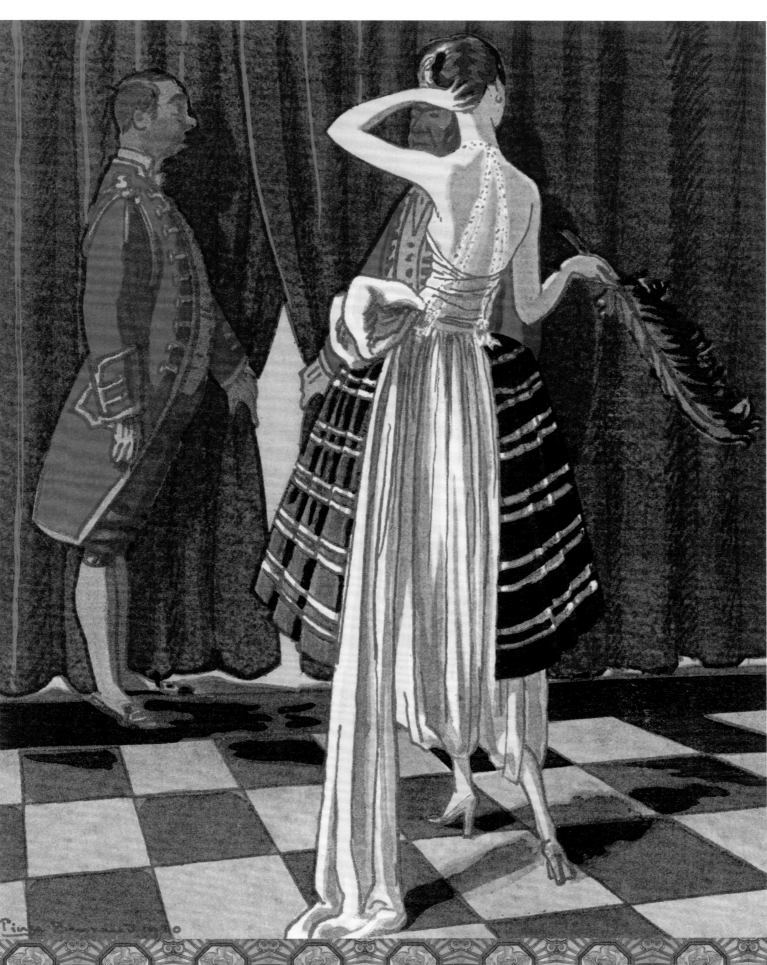

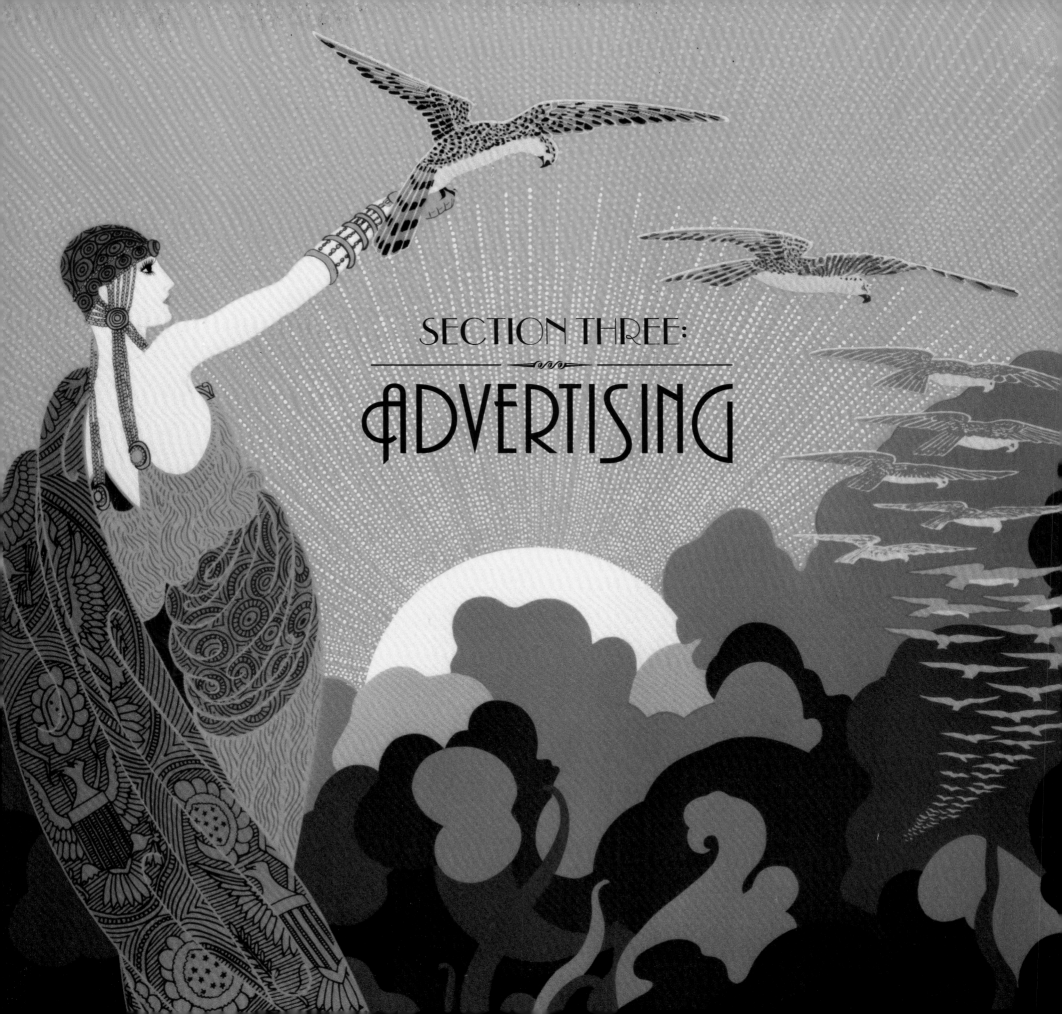

SECTION THREE:

ADVERTISING

A.M. Cassandre

Poster for the *Nord Express*, 1927

© MOURON. CASSANDRE. Lic2008-09-07-01
www.cassandre.fr

MEDIUM: Lithograph

RELATED WORKS: Fernand Léger
(1881–1955), *Mechanical Elements*, 1926

CASSANDRE (1901–68)

Early Inspiration

Adolphe Jean-Marie Mouron Cassandre (1901–68) was born
in the Ukraine to bourgeois parents, the whole family moving
to Paris in 1915. At the end of the First World War, having
decided to become a painter, Mouron enrolled at the Académie
Julian where the more progressive artists such as Fernand Léger
(1881–1955) had been taught. While still a student, Mouron
entered a design competition organized by Michelin, the French
tyre company. He adopted a *moderne* style for his entry, which
paid tribute to the Parisian avant-garde, particularly the Cubism
of Pablo Picasso (1881–1973) and Georges Braque (1882–1963),
and although he came third in the competition, the die was now
cast for an emerging style. Mouron would almost certainly have
been aware of the designs for the Michelin Building, London
1905–11 (*see* page 143), completed in 1911 and designed by
the French engineer François Espinasse. The design has been
variously described as late Art Nouveau and as proto Art Deco,
both descriptions being accurate. Its credentials as an Art Deco
building are its use of colour and bold circular motifs. It is an
example of conspicuous corporate and product advertising,
key aspects of Mouron's late poster works.

Commercial Beginnings

Shortly after the First World War, a new avant-garde began
to emerge around the architect, designer and artist Charles-
Edouard Jeanneret-Gris (1887–1965), who became known as Le
Corbusier. He and another artist, Amédée Ozenfant (1886–1966),
became disillusioned with the excessive decorative elements used
in Cubism and yearned for a simpler and 'purer' form. This new
style became known as Purism and reflected also a general interest
in forms that were inspired by modern machinery. Other artists
who had earlier been influenced by Cubism began to adopt this
iconography, particularly Fernand Léger, and Mouron, whose
posters were beginning to reflect his architectonic interests.

A.M. Cassandre
Poster for the *Étoile du Nord*, 1927
© MOURON. CASSANDRE. Lic2008-09-07-01
www.cassandre.fr

MEDIUM: Lithograph

RELATED WORKS: Paul Nash
(1889–1946), *Northern Adventure*, 1929

By 1922 he had begun his career as a commercial illustrator under the name Cassandre. His portrayal of railways and ships very much reflect the spirit of Le Corbusier who much admired the aesthetic of the ocean liner. Cassandre's 1927 poster for the *Nord Express* (*see* left), was commissioned by Chemin de Fer du Nord at a time when the French railway system was divided regionally. As with most regional railway companies, its star locomotive, in this case the *Nord Express*, was the flagship for the company, emphasizing its speed and transcontinental credentials.

The Bauhaus

The interwar years were a great experimental period for all artists and designers, the cross-fertilization of ideas happening throughout Europe. The epicentre was the Bauhaus design school in Germany, established by Walter Gropius (1883–1969) in 1919. He succeeded in attracting talent not just from Germany, but also from Holland and Russia. One of the most radical experiments at the Bauhaus was in typography, as designers such as Herbert Bayer (1900–85) sought to express specifically modernist ideas in text. Many of his ideas had been taken from the Constructivists Laszlo Moholy-Nagy (1895–1946) and El Lissitzky (1890–1941), who came to the Bauhaus in the 1920s. More than any other bodies the Bauhaus set the standard for typography and graphic design using a modern idiom. Cassandre's text *La Revue de l'Union de l'Affiche Française*, written in 1926, articulates much of the Bauhaus doctrine in that he defines poster art as for the masses rather than the artistic *cognoscenti*. Thus Cassandre distances himself from an art for the elite, his work becoming a kind of bridge between easel painting and commercial art. His poster for the *Étoile du Nord*, 1927 (*see* right), with its modern typeface suggests his adherence to Bauhaus principles of design.

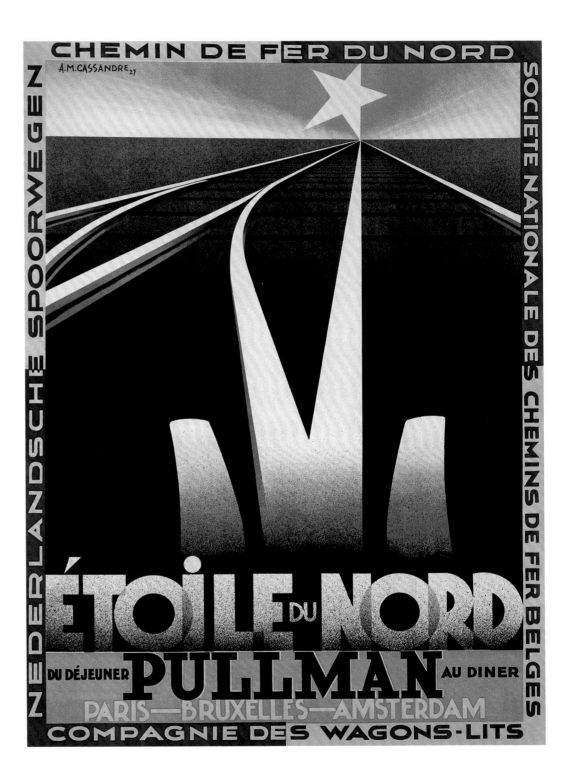

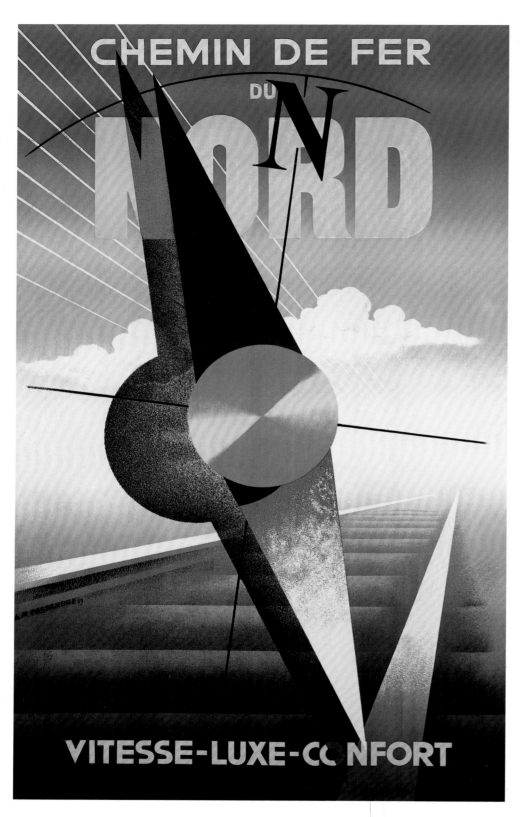

Modernism and the Golden Section

In Cassandre's poster for the *New Statendam*, 1928 (*see* page 144), it is noticeable that the focal point of the picture, namely the large ventilation cowling, obeys the rules of the so-called 'Golden Section', its centre being approximately one third in from the top and the left of the edge. The notion of the 'Golden Section' as a mathematical formula to create ideal proportions has historical precedent in ancient Greece and during the Renaissance, most noticeably in the work of the Italian artist Leonardo da Vinci (1452–1519), but was also used as a modernist device by Le Corbusier and Piet Mondrian (1872–1944) to create aesthetically pleasing designs in art and architecture. Cassandre's *New Statendam* poster was for the launch of the new RMS *Statendam* in 1929, the third ship of that name belonging to the company Holland America Line. The brochure for the vessel announced that she was 'a ship with the romance of the ships of yesterday and the comforts of the ships of tomorrow'. Although the artist refers in his design to power and majesty in the ship's structure, his text emphasizes comfort rather than speed, and the Art Deco style, whilst hard-edged, implies the luxury of the modern lifestyle.

Railways

Much of Cassandre's poster work in the 1920s was for the Chemin de Fer du Nord, a railway company that operated from the Gare du Nord station in Paris to Boulogne-sur-Mer and then

A.M. Cassandre
Poster for the *Chemin de Fer du Nord*, 1929
© MOURON. CASSANDRE. Lic2008-09-07-01
www.cassandre.fr

MEDIUM: Lithograph

RELATED WORKS: John Piper (1903–92), *Abstract Construction*, 1934

François Espinasse
Michelin Building, London (detail), 1905–11
© Paul Dawson/Architectural Association

MEDIUM: Stone, brick, metal relief

RELATED WORKS: Unknown architect, Fort Dunlop Building, Birmingham, UK, *c.* 1917

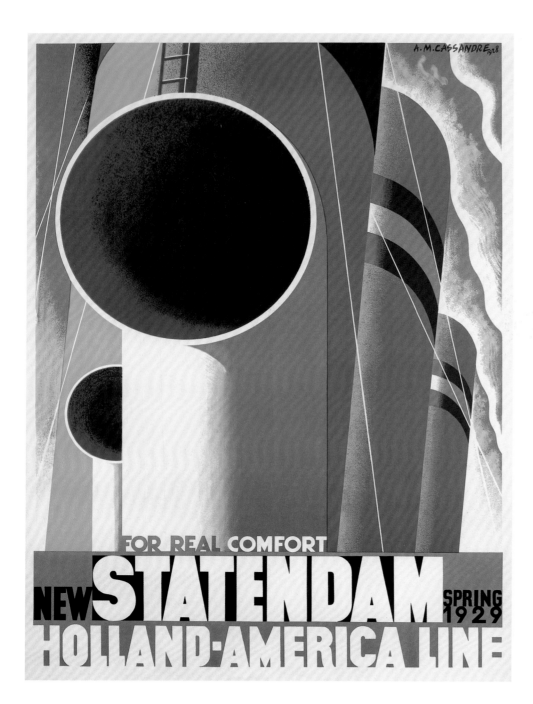

A.M. Cassandre

Poster for the *New Statendam*, 1928

© MOURON. CASSANDRE. Lic2008-09-07-01

www.cassandre.fr

MEDIUM: Lithograph

RELATED WORKS: Le Corbusier
(1887–1965), *Nature Morte*, 1920

A.M. Cassandre

Poster for the *Normandie*, 1935

© MOURON. CASSANDRE. Lic2008-09-07-01

www.cassandre.fr/TM French lines

MEDIUM: Lithograph

RELATED WORKS: C.R.W. Nevinson,
The Arrival, 1914

on to England via the cross-channel ferry. The locomotives were liveried in dark brown, a fact that Cassandre alludes to in his 1929 poster for the company (*see* page 142), using similar tones in place of the absent train. The colour brown has the serious qualities of black but with a warmer and more convivial tone and suggests solidity and reliability. The text refers not only to the train's luxury and comfort but also its speed, suggested by the disappearing tracks with only the compass needle reminding us of its destination (again, bold circular motifs remind us of the proto Art Deco Michelin Building, *see* page 143). The Chemin de Fer du Nord was established in 1845 and founded by the Rothschild brothers with Baron James de Rothschild (1845–1934) acting as its first president. Its prestigious locomotive of the Art Deco age was the type 231C, built in 1923, which rivalled its British contemporary counterpart *The Flying Scotsman*. British and French trains both used the luxury Pullman coaches for travel between London and Paris during the 1920s and 1930s, using the *Golden Arrow* and *Flèche d'Or* locomotives.

Ocean Liners

Cassandre's 1935 poster for the *Normandie* (*see* right) is probably the most iconic of all of his posters, an Art Deco masterpiece. However, the ship itself is also an Art Deco *tour de force*. Launched in 1932, it made its maiden voyage in 1935 and won the prestigious Blue Riband for the fastest Transatlantic crossing – which was just over four days, breaking the previous record by over ten hours, thanks to the revolutionary streamlined *moderne* hull design. The interior was pure Art Deco, with the centrepiece being its 700-seater, first-class dining room – at that time the largest room afloat. Having no natural light, it was illuminated by 12 tall, internally lit pillars made by the glass company Lalique.

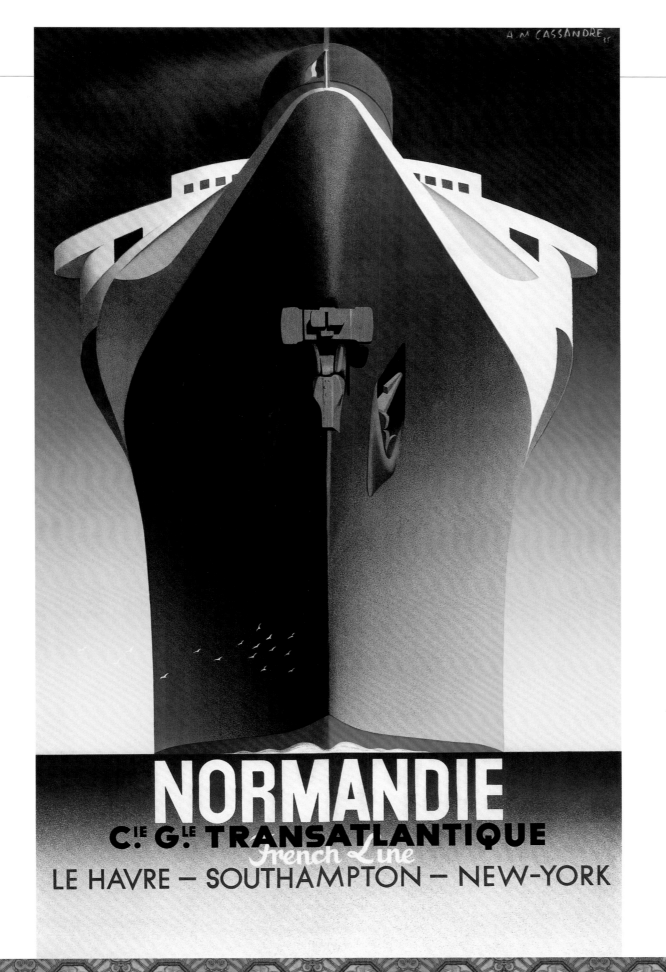

A.M. Cassandre
Advertisement for
Le Verre de Vin Nicolas, 1935
© MOURON. CASSANDRE. Lic2008-09-07-01
www.cassandre.fr

MEDIUM: Gouache

RELATED WORKS: René Vincent,
Poster for *Porto Ramos-Pinto, c. 1930*

The room was decorated with lacquered panels made by Jean
Dunand (1877–1942), one of the most gifted Art Deco furniture
artisans in France, underpinning the country's dominance of
fine craftsmanship. Cassandre emphasized this French pride by
including the tricolour at the top of the poster, the viewer's eye
being drawn towards it by the arrow of the ship's bow. The artist
produced a number of typographical variations on this design
to suit varying advertising criteria.

Late Career

Apart from his advertising posters, Cassandre developed three
of his own typefaces that are very much in the Art Deco mould,
particularly the *Bifur* face used in advertising. In addition to
his travel posters, Cassandre also produced a number of poster
designs for cigarettes and wine, most notably for Les Vins
Nicolas (*see* left) and Dubonnet. He was also made a professor
at the École des Arts Décoratifs, teaching, among others, the
graphic artist Raymond Savignac (1907–2002). In January
1936 an exhibition of Cassandre's work was held at the
Museum of Modern Art in New York. Cassandre then spent
the winters of 1936–37 and 1937–38 in the city, during which
time he undertook some Surrealist design work for *Harper's
Bazaar* magazine. After his return to Paris, he stopped making
poster designs until the 1950s, concentrating instead on easel
painting, particularly portraits. Cassandre was also involved
in stage-set designs, such as that which he undertook for the
ballet *Les Mirages* in 1947. He did very little in the 1960s and
took his own life in 1968. Apart from his posters, which have
an enduring quality, his legacy is the design of the famous
logo for Yves St Laurent.

PAUL COLIN
(1892–1985)

Arrival of the Jazz Age

The Art Deco period of the 1920s is synonymous with the
so-called 'Jazz Age'. Paris in particular fell under the spell even
before then with performances of Scott Joplin's ragtime music
at the *Exposition Universelle* in 1900. But dance was already a
significant entertainment in Paris with the Folies-Bergère and
Moulin Rouge wowing their audiences with erotic dancing from
the 1890s. By the 1920s, with the Ballets Russes having created
an appetite for exoticism gleaned from external cultural
influences, costumes had become more alluring, sensuous and
even provocative. Dance became a constant Art Deco motif –
visible in sculpture as well as design and illustration. The tightly
fitting costumes shown on the sculpture *Les Girls, c.* 1930 (*see* page
149), by Dimitri Chiparus (1888–1950), highlights this; with their
clinging skin-like outfits, the viewer is drawn to the girls' figures
in the absence of any facial individuality. Chiparus is, more than
anything else, celebrating the female form, and like many artists
in Paris was greatly influenced by the Ballets Russes. However,
he was also excited by the chorus girls dancing in the growing
number of nightclubs that had sprung up in Paris. Paul Colin
enjoyed a similar enthusiasm for this dance culture and, like many
Parisians, was to be captivated by the arrival of the black dancer
Josephine Baker (1906–1975), from the United States, in 1925.

Josephine Baker

Baker's arrival in Paris was the most extraordinary event, and
significantly changed dance as a popular form of entertainment.
Both she and Colin had already enjoyed some success in their
respective careers, but it was her debut in Paris at the music
hall Théâtre des Champs Elysées that made them both overnight
sensations. Colin had been in Paris since 1913 and had contributed

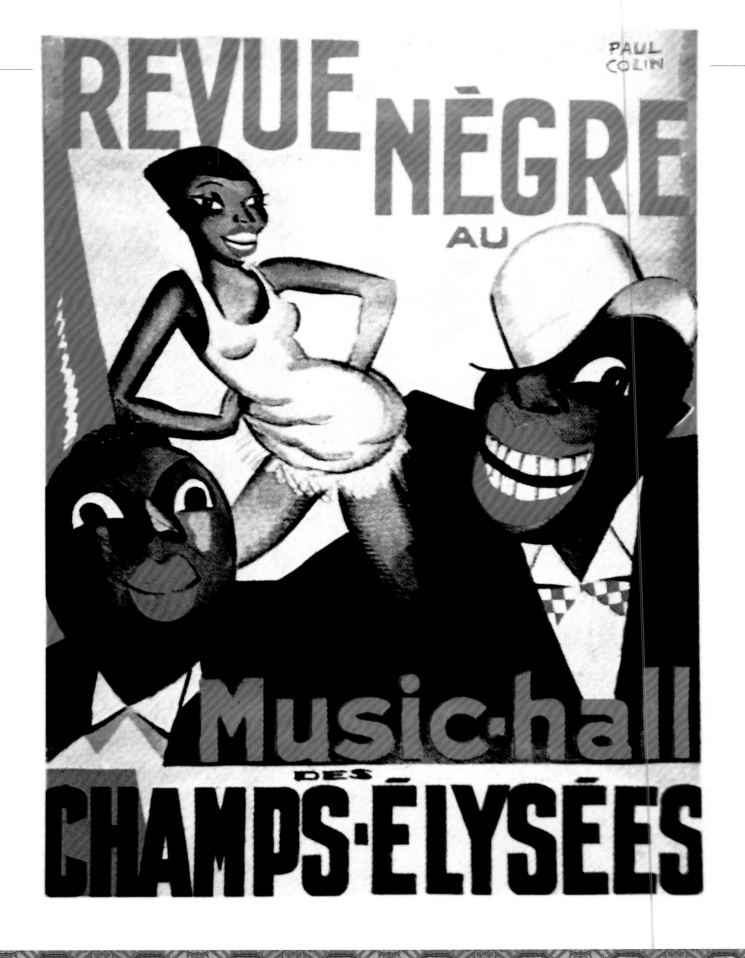

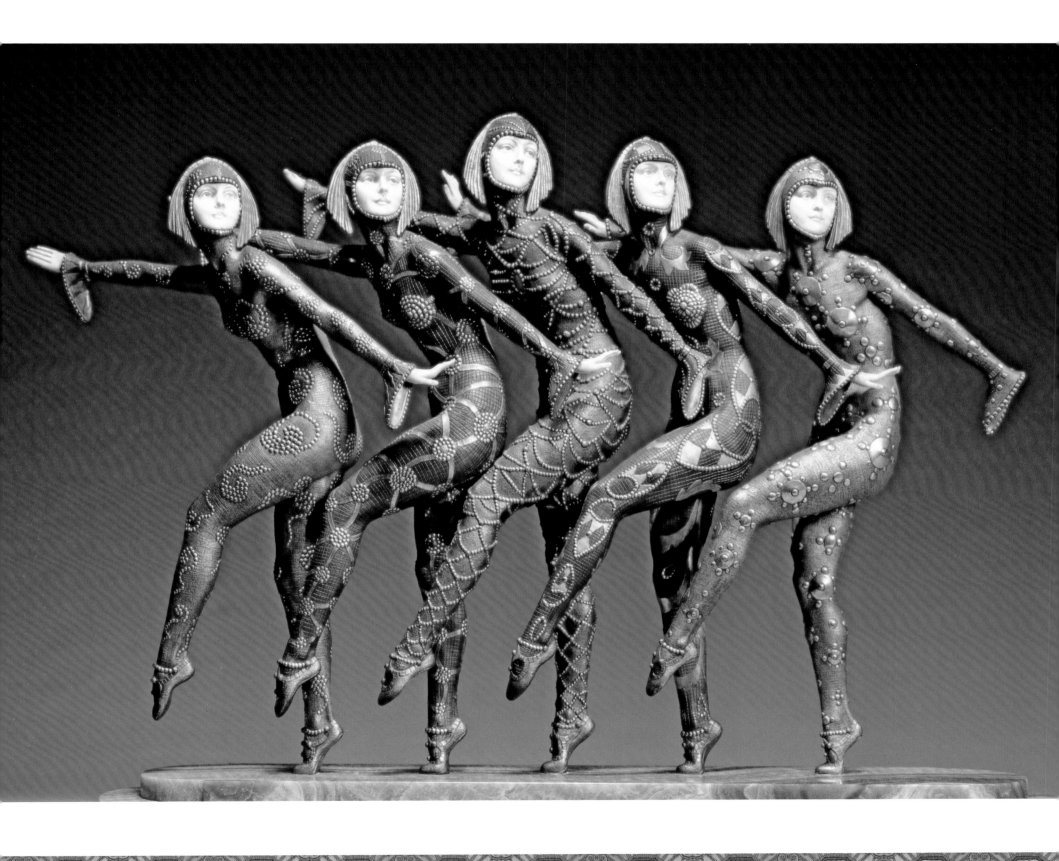

Paul Colin *(previous left)*
Poster for *La Revue Nègre*, 1925

Courtesy of Private Collection, Peter Newark
Historical Pictures/The Bridgeman Art Library/
© ADAGP, Paris and DACS, London

MEDIUM: Lithograph

RELATED WORKS: Georges Favre
(1873–1942), Poster for *Berger Grillon*, 1930

Dimitri Chiparus *(previous right)*
Les Girls, c. 1930

Courtesy of Dreweatt Neate Fine Art Auctioneers,
Newbury, Berkshire, UK/The Bridgeman Art
Library/© ADAGP, Paris and DACS, London

MEDIUM: Bronze and ivory

RELATED WORKS: Dimitri
Chiparus, *Asian Dancer*, 1928

to the stage and set designs at this theatre, and had also
developed a schema for poster design, featuring simplified,
often caricatured illustrations of the performers, that became
his hallmark. At the rehearsals for *La Revue Nègre* he saw Baker
for the first time and was immediately captivated by her sensuous
and erotic dancing, referring later to her as 'dressed in rags,
she was part boxing kangaroo, part rubber woman, part female
Tarzan … her kinetic rear end becoming the mobile centre of
her outlandish manoeuvres'. His 1925 poster advertising *La Revue
Nègre* (*see* page 148) does not immediately convey the sense of
movement but rather the essence of something new, radical and,
moreover, exciting. It depicts Baker dancing The Charleston,
accompanied by a musician and a bowler-hatted dancer.

Le Tumulte Noir

Following her success at the Théâtre des Champs Elysées,
Baker, now revered as the 'Black Venus', was offered a place
at the Folies-Bergère, where she appeared in one of her most

René Lalique
Suzanne (au Bain), c. 1932

Courtesy of Private Collection, Bonhams,
London, UK/The Bridgeman Art Library/
© ADAGP, Paris and DACS, London

MEDIUM: Glass

RELATED WORKS: Paul Daum
(1888–1944), Selection of Vases, 1920s–30s

Paul Colin
Poster for *Tabarin*, c. 1925

Courtesy of V&A Images, Victoria and Albert
Museum/© ADAGP, Paris and DACS, London

MEDIUM: Lithograph

RELATED WORKS: Jules Chéret
(1836–1932), Poster for the
Folies-Bergère, 1897

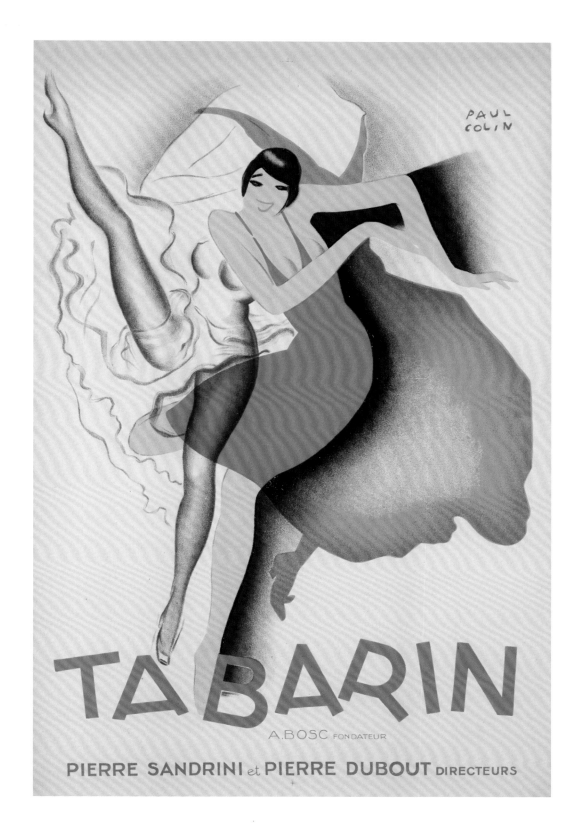

famous costumes, a skirt made from bananas – this being
the only thing that concealed her nudity. From this moment
on, Paris was in love with all things black, but in particular

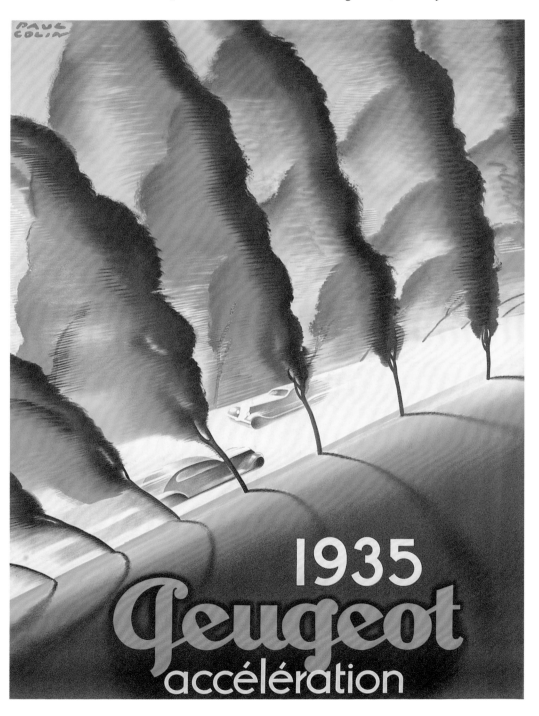

Josephine Baker, with even a perfume named after her.
Paul Colin, who obsessively sketched and drew Baker in his
studio, produced one of the most remarkable records of this
extraordinary time. Made in 1929 using the *pochoir* technique,
Le Tumulte Noir was a portfolio of 45 lithographs limited to 500
copies, which chronicled the jazz age and in particular Josephine
Baker. Like the poster for *La Revue Nègre*, the cover for *Le
Tumulte Noir* used only three colours: red and black on white.
The portfolio had two prefaces, the first signed by the Parisian
satirist Rip, and the second by Baker herself, in which she teases
her audience about 'doing' The Charleston. Many of the plates
depict Baker in some of her exotic costumes, and others focus
on the musicians and dancers making up her chorus. Nudity
continued to be a well-explored them by Art Deco artists –
whether dancing or getting out of the bath – such as in the
dance-like pose of the figure in *Suzanne (au Bain)*, 1932
(*see* page 150), by René Lalique (1860–1945).

The Assimilation of African-American Culture

Colin's early success was due to the arrival of Baker at a time
when many Parisians had, following the 'Return to Order' in
art after the First World War, largely forgotten Picasso and other
artists' forays into aspects of African culture in the early years of
the twentieth century, collectively producing what became known
as *l'art nègre*. Indeed, despite France controlling large areas of
West Africa up until the 1950s, at its own colonial exhibition in

Paul Colin
1935 Peugeot Accélération,
Poster for the Peugeot 402, 1935
Courtesy of Christie's Images Ltd/© ADAGP,
Paris and DACS, London

MEDIUM: Lithograph

RELATED WORKS: Gordon Crosby
(1885–1943), Poster for *Bentley Cars*, 1927

Paul Colin
Demandez Votre Quart Vichy, **Poster
for Vichy Mineral Water, c. 1935**
Courtesy of Private Collection, DaTo Images/
The Bridgeman Art Library/© ADAGP, Paris
and DACS, London

MEDIUM: Lithograph

RELATED WORKS: Paul Colin, Poster for
Sic: Enfin Une Boisson Rafraîchissante, c. 1935

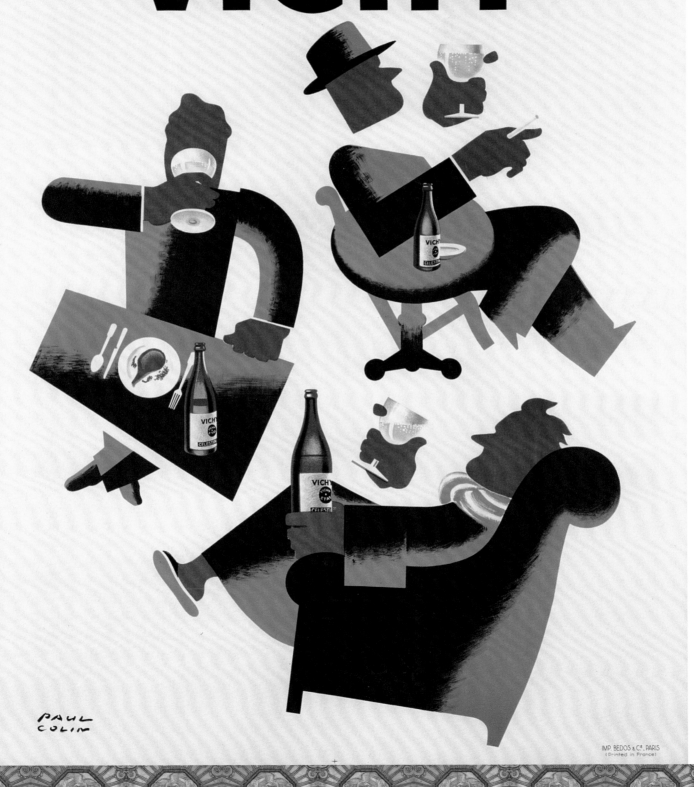

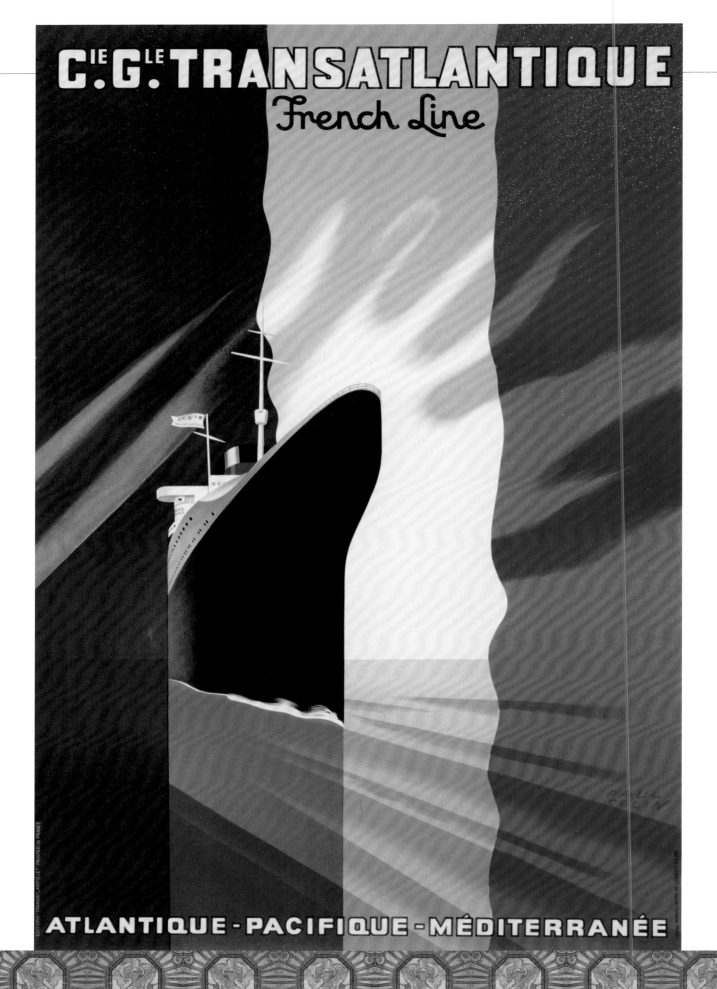

Paris in 1931 the country was beginning to play down its 'assimilation' of these cultures. Baker's arrival re-ignited France's fascination with their colonies and African culture. She continued to enjoy celebrity status in Paris until her death in 1975, the city embracing both her American jazz roots and her ethnicity in a way that was devoid of wilful exploitation and certainly without the overt racism that she would have experienced in America. Colin did not, however, confine himself to promoting Baker's celebrity, but embraced others too, producing promotional posters and advertising for the likes of the actress Marguerite Valmond, the singer-actress Suzy Solidor, the dancer Jean Borlin and the singer Carlos Gardel among others.

Entertainment Posters – the Cabaret

Paul Colin was to the entertainment poster what Cassandre was to its travel counterpart. In *Tabarin*, c. 1925 (*see* page 151), Colin utilizes the leg-kicking poses redolent of the Folies-Bergère chorus line but in a modern idiom. There are essentially three dancers depicted, reflecting a dance history: the chorus-line costume, the flounced skirts of the *fin de siècle* and the *moderne* flapper girl of the twenties, dancing the Charleston or Black Bottom. The 'flapper' symbolized the liberated woman of the 1920s, with her short skirt, bobbed hair and brash use of make-up. Her dresses were sometimes revealing and she often flouted social and sexual conventions. In the United States, the 'flapper' was also synonymous with Prohibition and 'speakeasies' where women could drink, openly flouting the law alongside their male contemporaries.

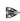

Paul Colin
Poster for the *Cie. Gle.*
***Transatlantique French Line*, 1949**
Courtesy of Christie's Images Ltd/© ADAGP,
Paris and DACS, London

MEDIUM: Lithograph

RELATED WORKS: A. Roquin
(dates unknown), Poster for the
Cunard White Star Line, 1930s

She was also a character depicted in films of the period, by Clara Bow (1905–65) and Joan Crawford (1905–77) among others. In Colin's poster, advertising a popular new cabaret called *Tabarin*, the artist has expressed the *joie de vivre* of the era in the pose and facial expression. The term 'tabarin' was an eponym in Parisian society for a comic performer.

Speed and Consumerism

In 1926 Colin established his own school, École Paul Colin, for graphic artists. He taught that a poster's message must be able to be read and understood 'at 100 km per hour', a reflection of the transient and fast-paced society he was living in. As with Cassandre's designs, when Colin designed travel posters he also emphasized speed, as in his 1935 Peugeot poster (*see* page 152). The Peugeot 402 was launched at the Paris Motor Show in 1935, replacing the then outdated 401. Its distinctive style followed the craze for 'streamlining', introduced in the US by Donald Deskey (1894–1989) as 'Streamline Moderne'. The 402 in fact resembled the American Chrysler Airflow, launched the previous year, yet its chassis was versatile, enabling different configurations of the vehicle to be made. Peugeot's adoption of 'Streamline Moderne' established a trend in Europe during the 1930s that became part and parcel of the Art Deco style. Not one to limit himself to one type of product, Colin also designed posters for products such as mineral water – *Demandez Votre Quart Vichy*, c. 1935 (*see* page 153), is graphically striking, the simultaneous viewpoints and simplified forms seemingly influenced by Cubist and Purist principles.

Ocean-liner Voyages

The Compagnie Générale Transatlantique (Cie. Gle. Transatlantique), established in the mid-nineteenth century and often referred to as the 'French Line', was a shipping company that came to prominence in 1927 with the maiden

voyage of the SS *Île de France*, the first major ocean liner launched after the First World War. Her interior designers had visited the 1925 *Exposition des Arts Décoratifs et Industriels Modernes* in Paris and decided that the ship should be styled in the prevalent Art Deco style, the first of its kind. Normally the interiors of ships, such as the older *Mauritania*, celebrated styles of the past, and by contrast the *Île de France* represented a departure, a celebration of the latest style. The dining room was also the largest afloat, with a triple height ceiling with a grand staircase entrance. Although something of a novelty at the time, the Art Deco style proved sensational, with Cie. Gle. Transantlantique adding the equally famous *Normandie* (which was to have an even larger dining room) to her fleet in 1935. One poster by Colin for the company (*see* page 154), although not as famous as Cassandre's, still manages to convey a sense of majesty and a strong national identity.

LEONETTO CAPPIELLO
(1875–1942)

A Transitional Style

One could be forgiven for not instantly recognizing the *Contratto* poster of 1922 (*see* left), as being from the Art Deco epoch, as it bears a striking similarity to poster design of the *fin-de-siècle* Art Nouveau period.

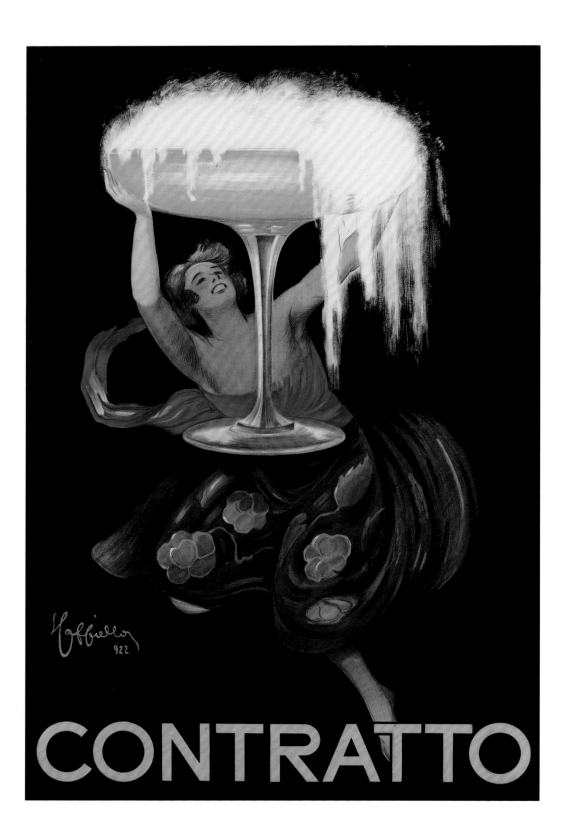

Leonetto Cappiello
Poster for the *Contratto* Wine Company, 1922

Courtesy of Christie's Images Ltd/© ADAGP, Paris and DACS, London

MEDIUM: Lithograph

RELATED WORKS: Privat Livemont (1861–1936), Poster for *Absinthe Robette*, 1896

Leonetto Cappiello
Poster for the *Cachou Lajaunie* Breath Freshner, 1920

Courtesy of Christie's Images Ltd/© ADAGP, Paris and DACS, London

MEDIUM: Lithograph

RELATED WORKS: Unknown artist, Poster for *Cachou Lajaunie*, 1928

The artist Leonetto Cappiello was in fact born fifty years
before the 1925 Paris *Exposition des Arts Décoratifs et Industriels
Modernes*. He had already made a name for himself after moving
from his native Italy to Paris in 1898, designing his first poster in
the following year for the satirical newspaper *Le Frou-Frou*. His
early career was in fact as a caricaturist working for the journal
La Revue Blanche, which published an album of his caricatures
with text by Marcel Prévost (1862–1941). Cappiello's early work
seems to pay deference to Henri Toulouse-Lautrec (1864–1901)
in its painterly qualities. Indeed, Cappiello and Toulouse-Lautrec
together with other poster artists of the period, such as Théophile
Steinlen (1859–1923), all contributed to the satirical journal *La
Rire*. These artists and others such as Jules Chéret (1836–1932)
all designed Art Nouveau posters either for music and dance halls
or consumer items such as liquor. *La Belle Époque*, as the period
between the late nineteenth century and the First World War
came to be known, was the most fertile time for the art poster,
bringing together a new and broader consumer society with
a burgeoning modern aesthetic in art.

An Innovative Approach to Poster Design

Importantly for Art Deco, what would mark Cappiello out
from these others was his innovative approach to modern
poster design, his theories for which he expounded in the
journal *La Publicité Moderne*, advocating the need to arrest the
public's attention in a fast-moving consumer society. In the
first decade of the twentieth century Cappiello produced some
startling designs for consumer products, such as his posters for
Chocolat Klaus, 1906, and *Cinzano*, 1910. Many of these designs
were against a very dark background, with the use of bright
colours emphasizing the *mis en scène*. Although a decade later,
his design for *Cachou Lajaunie*, 1920 (*see* right), is very similar
in format except that Cappiello has by this time moved the
figures closer to the viewer. The poster still does not belong
to the Art Deco period as the figure resembles a colourful
Pierrot with a wispy waist and there is little in the content
that is elegant or chic, apart from the theatrical hand and

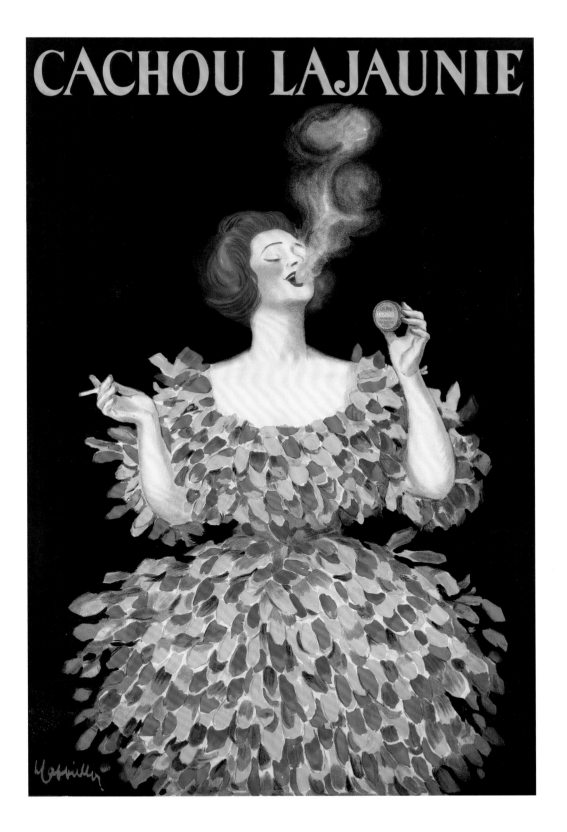

head gestures perhaps. Just prior to the making of this poster, Cappiello signed a contract with the publisher Devambez, remaining there until 1936. Cachou Lajaunie was a breath-freshening product developed by a pharmacist in 1880 and made from liquorice.

Late Career – Moving Towards the Moderne Style

By the 1930s, Cappiello's posters had changed, embracing an Art Deco *moderne* style with simplified forms. His poster for *Mossant*, (*see* left) 1938, exemplifies this. Mossant was a famous French hat manufacturer founded by Charles Mossant (1835–1908) in the previous century. Hats became very popular in the Art Deco period, and at its height Mossant was manufacturing some 2,000 per day. Of those approximately half were for American customers. Like for many other Art Deco consumer products the poster gives the item a classless appeal, reinforcing the company's slogan, 'Mossant – a hat for the whole world'. In Cappiello's poster the hats have been removed from the wearer's heads suggesting gentlemanly conduct and a welcoming *bonhomie*. Other artists, such as Olsky (dates unknown), also created posters for Mossant at this time and had a more dynamic slant towards Art Deco *moderne* than Cappiello's design, but theirs all lack its warmth, gentility and French *savoir-faire*. Unfortunately this was one of Cappiello's last designs as he died in early 1942.

Leonetto Cappiello
Poster for the *Mossant*
Hat Company, 1938
Courtesy of Christie's Images Ltd/
© ADAGP, Paris and DACS, London

MEDIUM: Lithograph

RELATED WORKS:
Olsky (dates unknown),
Poster for *Mossant* Hats, 1930s

Leonetto Cappiello
Poster for *Bénédictine*
Liqueur, c. 1928
Courtesy of Private Collection, DaTo Images/
The Bridgeman Art Library/© ADAGP, Paris
and DACS, London

MEDIUM: Lithograph

RELATED WORKS: Leonetto
Cappiello, *Contratto*, 1922

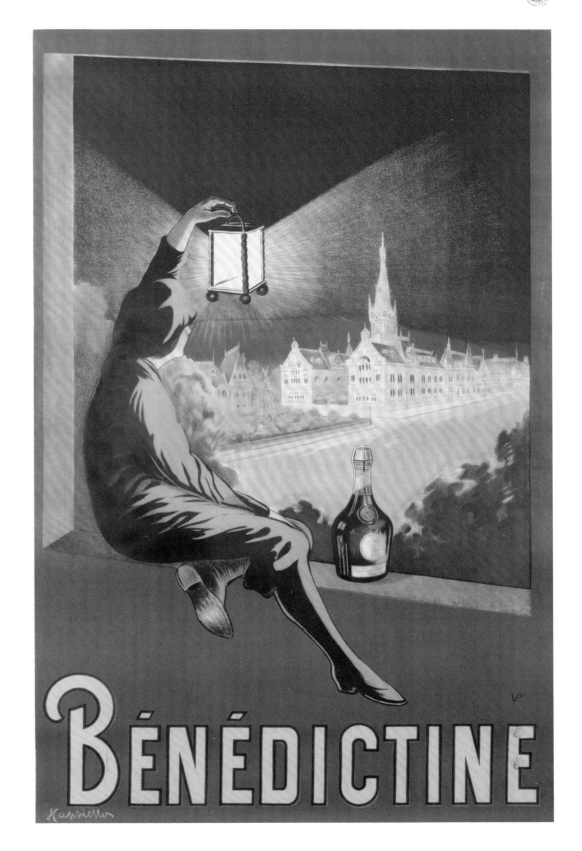

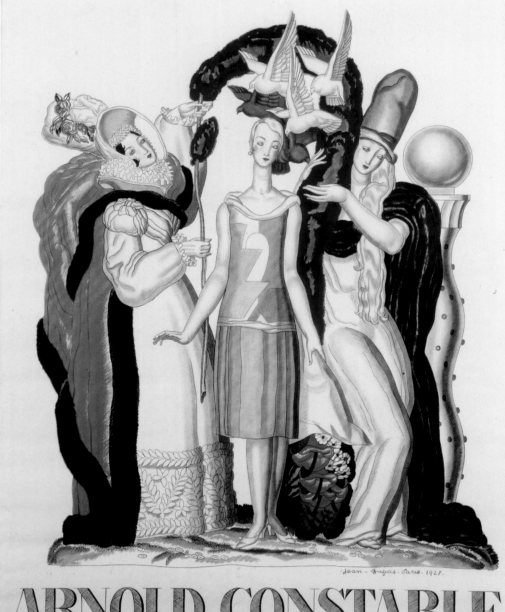

ARNOLD CONSTABLE

COMMEMORATING THE MODE OF YESTERDAY
PRESENTING THE MODE OF TO-DAY
FORECASTING THE MODE OF TO-MORROW

Made in France. Tolmer. Paris

Jean Dupas	**A.J. Ayres**
Poster for the *Arnold Constable*	Relief on Reginald H. Uren's
Department Store, 1928	Gas Board Building, Crouch End,
© Estate of Jean Dupas/E.T. Archive	London, 1937
	© Estate of A.J. Ayres/Edifice/Lewis
MEDIUM: Lithograph	
	MEDIUM: Stone
RELATED WORKS: Raphael	
(1483–1520), *The School of Athens*, 1509	**RELATED WORKS:** Eric Gill
	(1882–1940), *Prospero and Ariel*, 1931

JEAN DUPAS (1882–1964)

Neoclassical Elements

Another artist whose work bridges the gap between Art Nouveau and Art Deco is Jean Dupas (1882–1964). His work is very neoclassical in nature, with a lyrical style and a strong narrative content, a hallmark of both Art Nouveau and the more classically influenced forms of Art Deco. A similar crossover between Art Nouveau and Art Deco is well demonstrated in a bas-relief panel by A.J. Ayres (dates unknown), 1937 (*see* right), which forms part of a decorative scheme for Reginald Uren's gas board building in Crouch End, London. The figure evokes classical mythology but is depicted in a modern pictorial language, visible, for example, in the stylized hair. There is a strong narrative content that suggests the gas flame being proffered comes from nature, as represented by the fruits depicted in the lower corner. The bas-relief, as an art form used to depict a narrative, dates back to classical civilizations in Greece and Egypt. That this device was still being used in 1937 suggests its enduring qualities; it was a continuous thread that ran through both Art Nouveau and Art Deco.

Career

Jean Dupas is one of the few artists who painted in oils to whom the tag 'Art Deco' can be applied. Although he designed a number of posters and advertisements he was essentially a fine

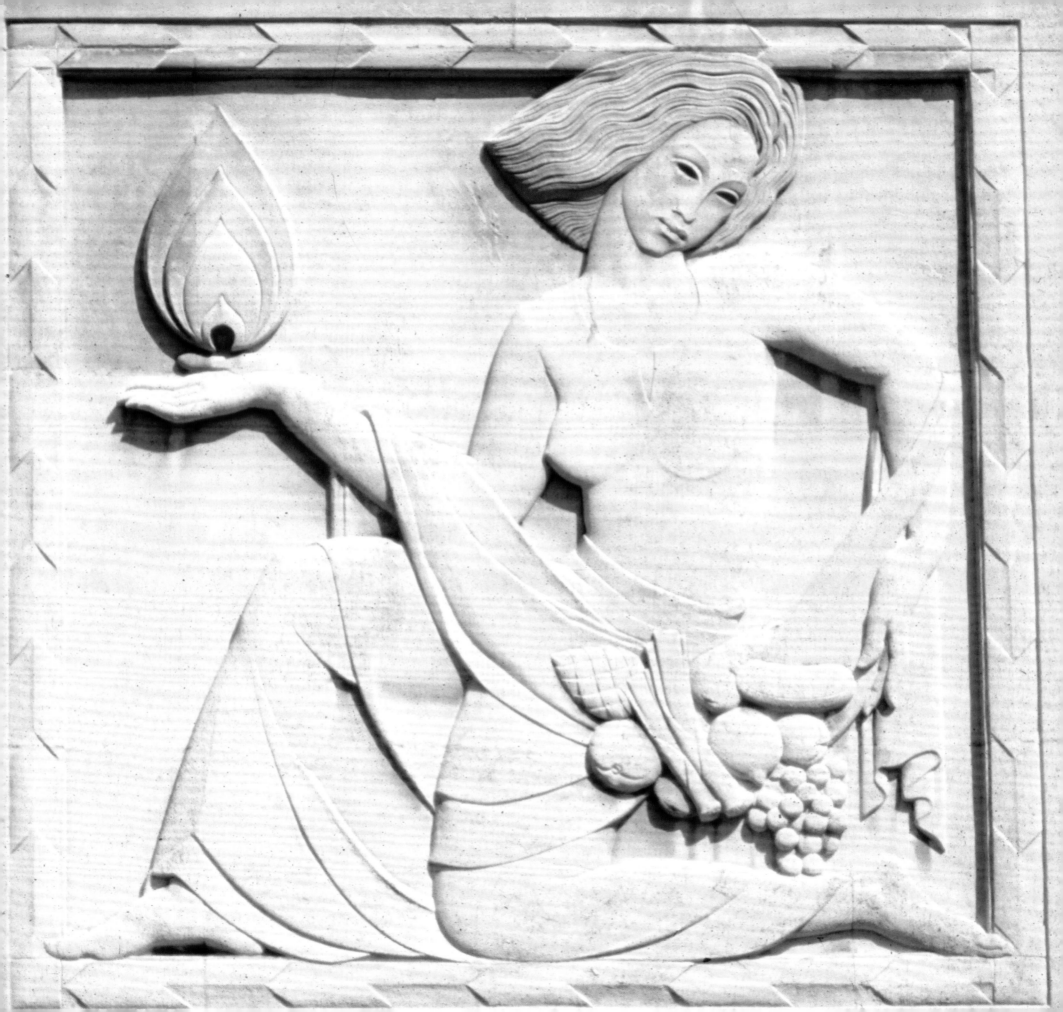

artist who painted in a neoclassical manner redolent of the high-Mannerist style of the Italian Renaissance. His most famous painting was *Les Perruches* (*see* page 52), painted in 1925 and exhibited at the Paris *Exposition des Arts Décoratifs et Industriels Modernes* in the same year. He executed a number of frescoes including those for the Saint-Esprit church in Paris and *La Vigne et le Vin*, in the Aquitaine Museum in Bordeaux, Dupas's native city. He also contributed to the decorative interiors of some of the great ocean liners, such as the *Île-de-France* and the *Normandie*. His poster and advertising design output also included work for

the magazines *Harper's Bazaar* and *Vogue*, and the fur company Max. The *Arnold Constable* poster, 1928 (*see* page 160), was commissioned to advertise the New York department store that had begun trading in the 1840s. As the poster reads, they were celebrating the past and present but with an eye very much on the future. Dupas was the ideal choice for the commission.

CHARLES GESMAR
(1900-28)

In the Footsteps of the Masters

The father of poster art is Jules Chéret, who was born in 1836 and developed his early training as a lithographer to suit the requirements of advertising theatre and music-hall events. He studied fine artists in the various museums in Paris, and after spending some time in London learning about poster design, he returned and began making his own in the 1860s. By the 1880s he had created a formidable reputation for this art form and influenced many artists such as Alphonse Mucha (1860–1939), Henri Toulouse-Lautrec and Charles Gesmar. What these artists instantly recognized was the potential for poster art using lithography, which facilitated the use of strong vibrant colour, so essential in conveying an advertising message, particularly for music hall and theatre. In 1895, Chéret produced *Maîtres de l'Affiche*, an album of reproductions of the most significant posters

Charles Gesmar
Poster for *Mistinguett*, 1925
© Mary Evans Picture Library/Aisa Media

MEDIUM: Lithograph

RELATED WORKS: Zig (Louis Gaudin)
(c. 1906–36), Posters for *Mistinguett at the Casino de Paris*, 1920s

Charles Gesmar
***Bonjour Paris*, Poster for**
Mistinguett, 1924
© Christie's Images Ltd

MEDIUM: Lithograph

RELATED WORKS: Jules Chéret
(1836–1932), Poster for the
Casino de Paris, 1890s

Charles Gesmar
Poster for *Mistinguett* at
the Casino de Paris, 1922

© Mary Evans Picture Library/Rue des Archives

MEDIUM: Lithograph

RELATED WORKS: Georges
Benda (dates unknown), Poster
for *Mistinguett*, 1920s

Dimitri Chiparus
***Dancer of Kapurthala*, 1920s**

Courtesy of Private Collection, Bonhams, London,
UK/The Bridgeman Art Library/© ADAGP, Paris
and DACS, London

MEDIUM: Bronze and ivory

RELATED WORKS: Fayral (a.k.a. Guerbe,
c. 1892–1935), *Faun and Nymph*, 1924

of the time, which became so influential to Art Deco artists such as Gesmar. In Gesmar's work we can clearly see the influence of Chéret who, before he died in 1932 aged ninety six, was so highly regarded that he was awarded the *Légion d'Honneur* for his outstanding contribution to graphic art.

Career

Little is known of Charles Gesmar other than the work he undertook, since his career was very short, dying in 1928 at the tragically young age of 28. His precocious talent was recognized as early as 16 years old when he began designing posters for the Folies-Bergère and Olympia music halls. From the age of 18 until his death he appears to have worked almost exclusively for the famous music hall star Mistinguett (1875–1956), designing her costumes, stage sets for the Casino de Paris and Moulin Rouge and producing over 50, witty and colourful, promotional posters. The Moulin Rouge was established as a cabaret in 1889 and is situated in the infamous Montmartre district of Paris. It became famous for the legendary Can-Can dance in which the dancers raised their skirts, revealing their legs and sometimes their underwear, for the titillation of the (originally) all male audience. By the early Art Deco period the it was attracting mixed audiences, and although the dance was still a little risqué the hall itself had become a legitimate nightclub rather than an elaborate brothel, going on to attract top name artists including Josephine Baker, Edith Piaf (1915–1963) and Mistinguett. One of Gesmar's posters for *Mistinguett at the Casino de Paris*, 1922 (*see* left), depicts the stylish and elegant performer, and particularly her girlish, free-spirited demeanour; the elegant and yet lively spirit of the era was of course constantly reflected in diverse Art Deco works, such as Dimitri Chiparus's *Dancer of Kapurthala* (*see* right).

Mistinguett

Although less well known today, Mistinguett was, during the first half of the twentieth century, a very well known cabaret artist in Paris, depicted again and again in Gesmar's posters – whether

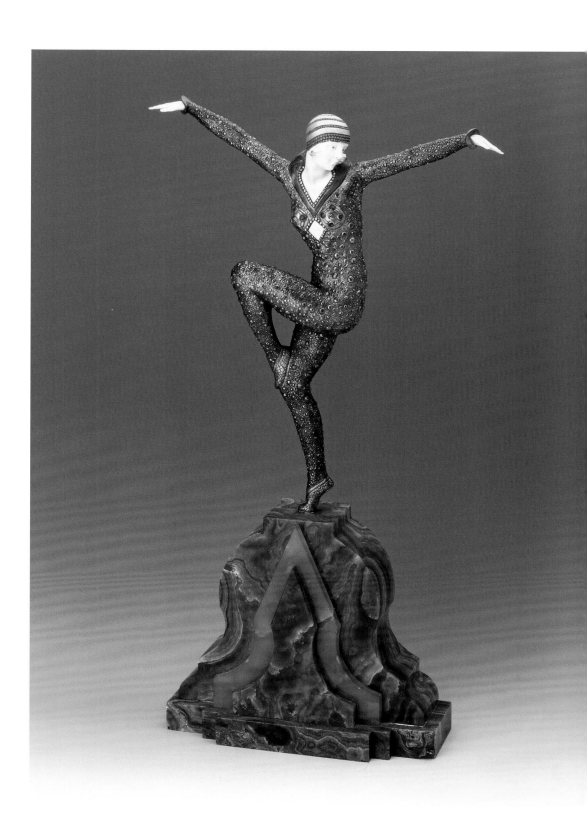

dancing in a fur-trimmed skirt with baton (*see* page 162) or at the
Casino de Paris wearing flamboyant feathers, top hat and pearls
(*see* page 163) for instance. She was born Jeanne Bourgeois in
1875, just outside Paris, and aspired to be an entertainer from
a young age, adopting her stage name at the beginning of her
career in 1895 when she debuted at the Casino de Paris. From
the beginning her performances were considered risqué and
she soon established herself as Paris's most popular entertainer
at the turn of the century, appearing at the Eldorado, the Folies-
Bergère and the Moulin Rouge. She both performed and had a
long-standing relationship with Maurice Chevalier (1888–1972)
and in 1916 recorded her signature song 'Mon Homme', which
was translated into English and performed by Fanny Brice
(1891–1951) as 'My Man', in 1921. In 1919 she famously
insured her legs for the then staggering sum of 500,000 francs
(approximately US $100,000). Apart from this 'first', Mistinguett
also performed the earliest example of a 'star' descending a
staircase for the benefit of an adoring audience, and appears to
have been the first to perform *La Valse Chaloupée* or *Apache Dance*.

RENÉ VINCENT (1871–1936)

Le Bon Marché

René Vincent was trained as an architect at the École des
Beaux Arts but elected for a career as an illustrator and graphic
designer, working for two society magazines, *L'Illustration* and
La Vie Parisienne, and designing a number of posters for the

René Vincent
Toilettes d'Eté, Cover of the Bon
Marché Summer Catalogue, 1923
© Collection Kharbine-Tapabor, Paris, France/
The Bridgeman Art Library

MEDIUM: Lithograph

RELATED WORKS: J.G. Domergue,
Poster for the *Galeries Lafayette*, 1920s

Paul Manship
Atlanta, 1921
© Estate of Paul Manship/Christie's
Images Ltd

MEDIUM: Gilt bronze

RELATED WORKS: Paul Manship,
Prometheus Fountain, 1934

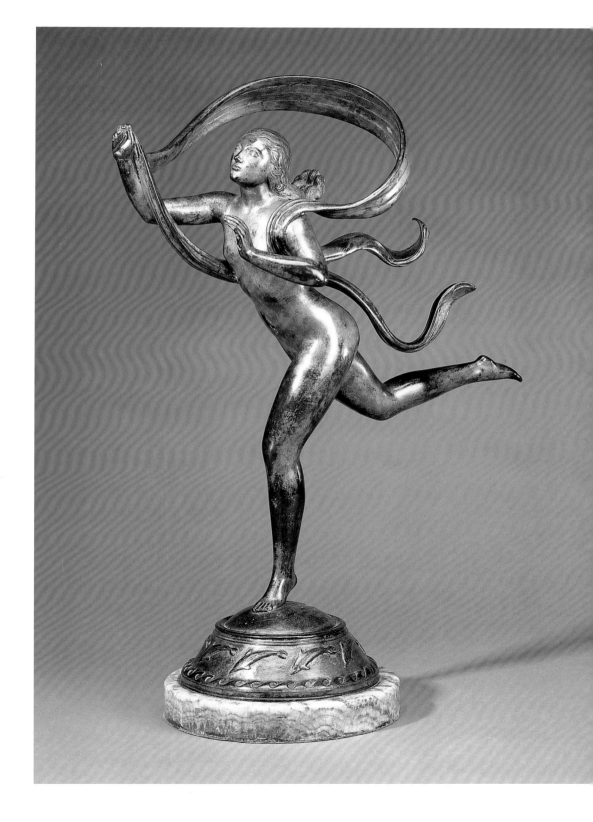

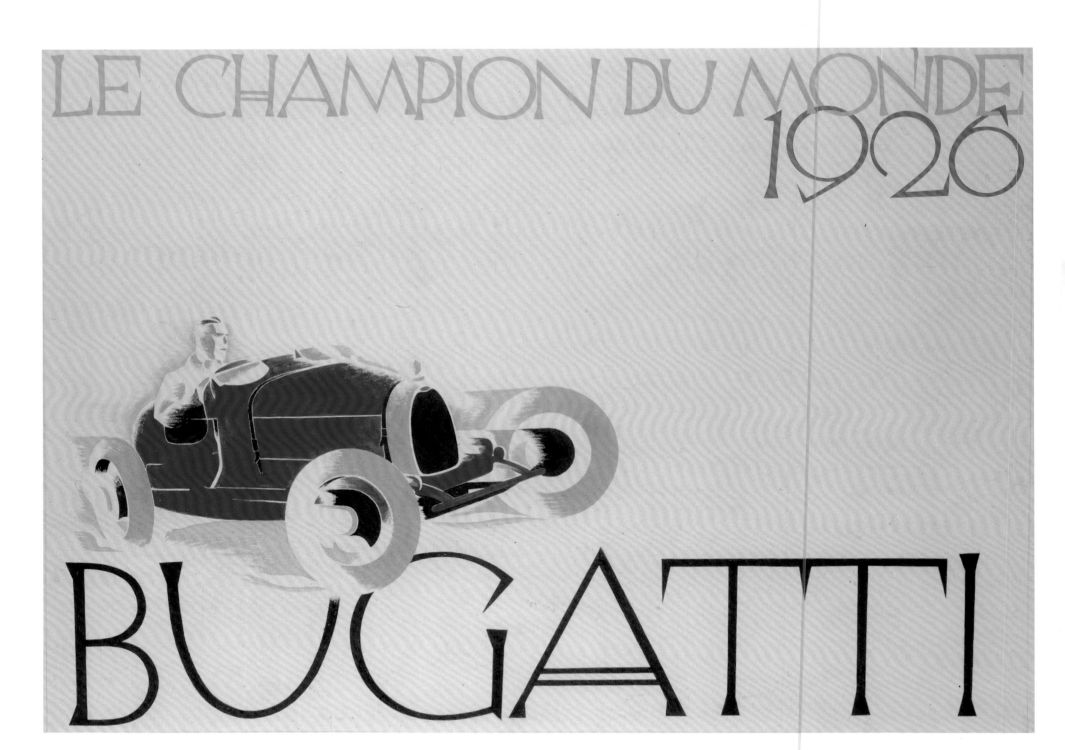

department store *Le Bon Marché*. Depending on one's definition of a department store, *Le Bon Marché* is considered by most as the world's first, opening in the mid-nineteenth century. At the turn of the century it was renowned for its ready-to-wear range, affordable to most of the middle classes that followed the latest Parisian fashion. The name *Bon Marché* was adopted for use in the US and Britain, who opened their own separate branches in Seattle and London respectively, which were not connected to the Parisian counterpart. *Toilettes d'Eté* (*see* page 166), the cover for the 1923 brochure of the Parisian store, is by Vincent, and illustrates a range of ladies' summer wear. Note the 'waist-less' dresses of the period and also the diverse range of hat shapes at this time. The model on the far left is wearing a derivative of the *kokoshnik* hat, introduced by Russian émigrés at the end of the First World War.

ERNST DEUTSCH-DRYDEN
(1887–1938)

On the Move

The Austrian Ernst Deutsch, who called himself Ernst (Ernest) Dryden after 1916, and was officially known under that name from 1931, was born in Vienna and died in Hollywood. The locations of his birth and death say much about the eventful working life he led. He worked prolifically in many fields: as fashion illustrator, fashion designer and poster illustrator, in Europe and the United States. Deutsch-Dryden is recognized as a pioneer of new techniques in poster design. He first came to attention at 23 years of age, working as an illustrator in Berlin, producing advertising posters for the likes of Mercedes typewriters and German theatres. He moved back to Vienna during the First World War, moving on to Paris in 1926. In that year he was offered the position of Art Director of the Berlin magazine *Die Dame*, and worked as their Paris fashion 'correspondent'. In November 1933, after having counted *Vogue* and Chanel as his employers, Dryden left Europe for New York

and then Hollywood, where his design reputation enabled him to integrate into the studios to design costumes for films. His life in the 1930s was lived amongst the wealthy elite and celebrities of Los Angeles – a real-life experience of the luxury he had been portraying in his Art Deco posters.

Marketing Genius

In his poster *Le Champion du Monde* for Bugatti, 1926 (*see* left), Deutsch-Dryden used clean typefaces in varying size and colour, with a neutral background to focus attention on the bright blue Bugatti racing car that he depicted almost flying at speed through the picture plane – a simple device to appeal to the wealthy's desire for speed and status symbols. However, it is in one of Deutsch-Dryden's earlier works, the 1912 *Salamander* poster (*see* page 170) for the German shoe company, that his unique talent as an illustrator is evident. Focusing on the company's product and incorporating a fashionable skirt worn with patterned stockings, he draws attention to a subtly erotic triplicate image of shoes, ankles, legs and skirts. To show any part of the leg had been an etiquette faux-pas, but Deutsch-Dryden dispensed with history and designed the layout from a low angle, which accentuated the importance of the shoes, whilst he cleverly used the red and green corporate colours of Salamander to identify and promote the product. The simplicity of the image belies the intricacy of the layout and line. By drawing attention to the below eye-line level of the skirt hem, he forces the viewer to act as voyeur. In the same period, as commercial director for the German store Kersten und Tuteur, he filled the shop windows with female mannequins dressed in negligees, with the aim of using the eroticism of the revealed nudity to appeal to both sexes.

Ernst Deutsch-Dryden
Le Champion du Monde, **Poster for Bugatti, 1926**
© Estate of Ernst Deutsch-Dryden/
Christie's Images Ltd

MEDIUM: Lithograph

RELATED WORKS: Ernst Deutsch-Dryden, Poster for *Versichern Sie doch Ihr Reisegepäck!*, 1924

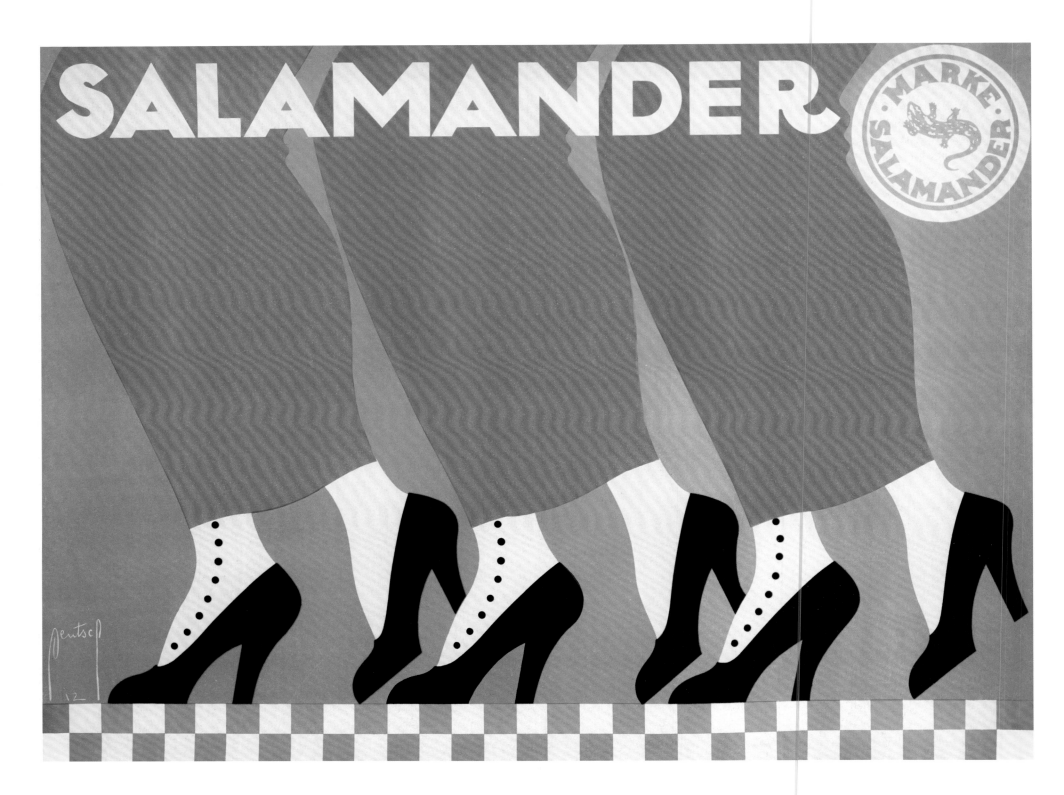

Ernst Deutsch-Dryden
Poster for the *Salamander*
Shoe Company, 1912
© Estate of Ernst Deutsch-Dryden/Mary
Evans Picture Library/Dryden Collection

MEDIUM: Lithograph

RELATED WORKS: Ernst Deutsch-
Dryden, Poster for *Tabarin*, 1912

Edward McKnight Kauffer
For the Conquered – Steel! Not Bread,
Anti-Nazi Poster, *c.* 1940
© Estate of Edward McKnight Kauffer/akg-images

MEDIUM: Lithograph

RELATED WORKS: Pablo Picasso
(1881–1973), *Guernica*, 1937

EDWARD McKNIGHT KAUFFER
(1890–1954)

Early Career

During the Art Deco period, Edward McKnight Kauffer was
based in London. Having been born in San Francisco and trained
in Paris, he moved to England in 1914 and shortly afterwards
was commissioned by Frank Pick (1878–1941), the new publicity
chief at the London Underground Group (later part of London
Transport Board), to contribute the marketing of the London
Underground. Pick realized early on that the existing publicity
had been too wordy and uninspiring, and he sought – through
commissioning new, young and visionary artists – a clearer,
punchier approach to poster design. Kauffer's designs included
striking posters advertising the destinations of the North Downs
and Reigate. Pick also commissioned a radical new architecture
for the suburban underground stations and a new clearer typeface
for use in the company logo and in station signage. These, together
with the famous underground map that he also commissioned,
are all hallmarks of the Art Deco style in Britain. Other British
companies began to follow suit with this new modernist approach
to design with an emphasis on minimal text, punchy slogans and
simplified visuals. Shell Oil commissioned Kauffer and several
other leading artists, such as Paul Nash (1889–1946), Andrew
Johnson (*fl.* 1930s) and Graham Sutherland (1903–80), to design
advertising posters for them during the 1930s – *Actors Prefer Shell*,
1933 (*see* page 172), is a good example by McKnight Kauffer,

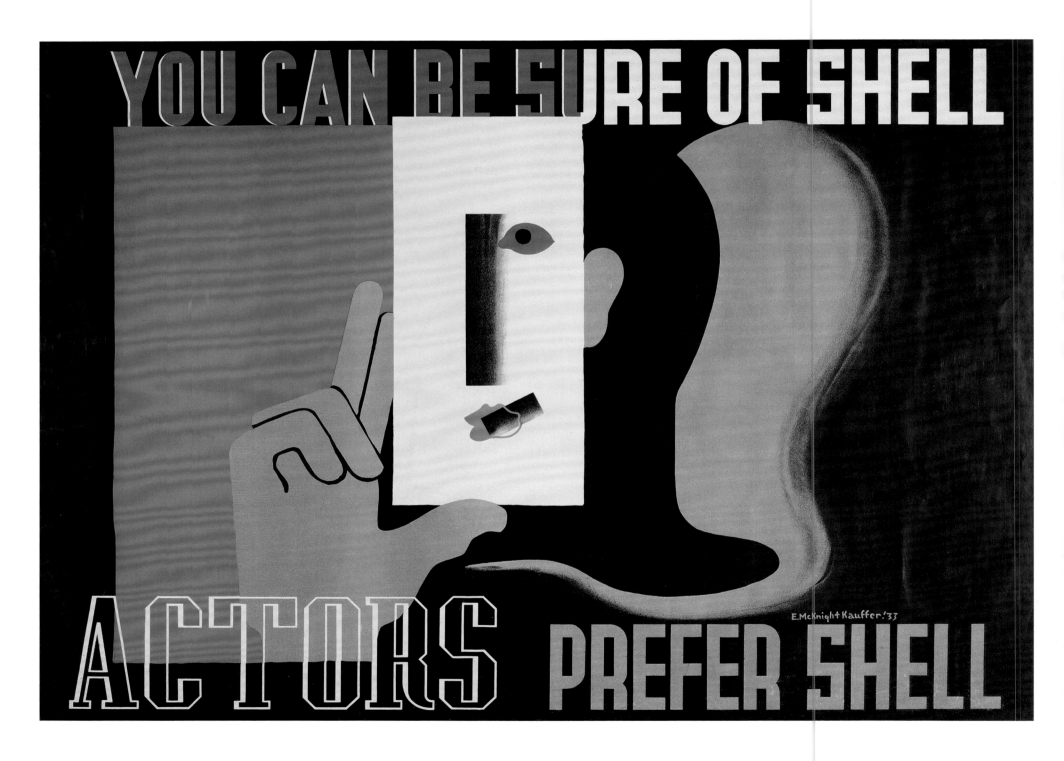

Edward McKnight Kauffer
Actors Prefer Shell, **Poster for the Shell Oil Company, 1933**
© Estate of Edward McKnight Kauffer/Victoria and Albert Museum/The Bridgeman Art Library

MEDIUM: Lithograph

RELATED WORKS: Ben Nicholson (1894–1982), *These Men Use Shell*, Poster for the Shell Oil Company, 1937

its semi-absract forms as simple as you can get. The Shell Oil Company also commissioned these artists to illustrate a number of *Shell Guide Books* designed to make the burgeoning group of motorists in Britain become more adventurous.

The Political Poster

The political propaganda poster has been around since the seventeenth century, but it was its use in recruitment in the First World War that the real potential was realized. Slightly later the so-called 'agitprop' posters were being used in the new Soviet state, to underpin the new regime. McKnight Kauffer's poster *For the Conquered – Steel! Not Bread*, c. 1940 (*see* page 171), is designed to promote anti-Nazi sentiment. The 1940s, when the poster was produced, marked the end of the Art Deco period, but the design is still very much in that style. From 1933 onwards, many artists in Britain were involved in anti-fascist propaganda, firstly against Franco's regime in Spain and then, as the Second World War approached, against Nazi Germany itself. None were more vociferous in their campaign than the British Surrealists, and although McKnight Kauffer was not a Surrealist, it is easy to make the connection visually. McKnight Kauffer did not remain in England after 1940, but he continued designing political posters on his return to the United States. After the war he designed posters for the new United Nations.

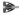

Edward McKnight Kauffer
The Quiet Hours, **Poster for the London Underground, 1930**
© Estate of Edward McKnight Kauffer/Private Collection/The Bridgeman Art Library

MEDIUM: Lithograph

RELATED WORKS: Edward McKnight Kauffer, *Winter Sales are best Reached by the Underground*, Poster for the London Underground, 1922

JOHN ATHERTON (1900–52)

Grand Themes

The American commercial illustrator John Atherton, born in Minnesota in 1900, considered that there was no division between the status of painting and of graphic art. As an accomplished artist of Magical Realism painting, his reputation in both fields leads to the conclusion that he spoke from experience. Atherton trained in Fine Art and Illustration at California School of Fine Arts and moved to New York in 1929, the year of the Wall Street Crash and the onset of the Great Depression years. His work reflects his experiences of those times. He often returns to the symbolism of the strength of man; he is noted for his use of strong colour and the bold, precise form of his compositions; his clear, readable typefaces show clarity and depth. Chosen as one of the illustrators for the advertising and publicity posters for the 1939 World's Fair in New York, the theme of which was 'Building the World of Tomorrow', he produced an image that was visually striking and yet traditional and symbolic in content. His themes underlying the poster for the *New York World's Fair*, 1939 (*see* left) were evidently to do with Man, the Earth and the Universe.

Building the World of Tomorrow

It was a defining moment in the arts world in New York, 1939, when many immigrants, respected writers, artists, architects and designers arrived from Europe at the onset of the Second World

John Atherton
Poster for the *New York World's Fair*, 1939
© Estate of John Atherton/Christie's Images Ltd

MEDIUM: Lithograph

RELATED WORKS: Albert Staehle, Poster for the *New York World's Fair*, 1939

Paul Manship
Hercules Upholding the Heavens, 1918
© Estate of Paul Manship/Museum of Fine Arts, Houston, Texas, USA, Gift of Mrs Mellie Esperson/The Bridgeman Art Library

MEDIUM: Bronze

RELATED WORKS: Lee Lawrie, *Atlas Sculpture*, Rockefeller Center, 1932–34

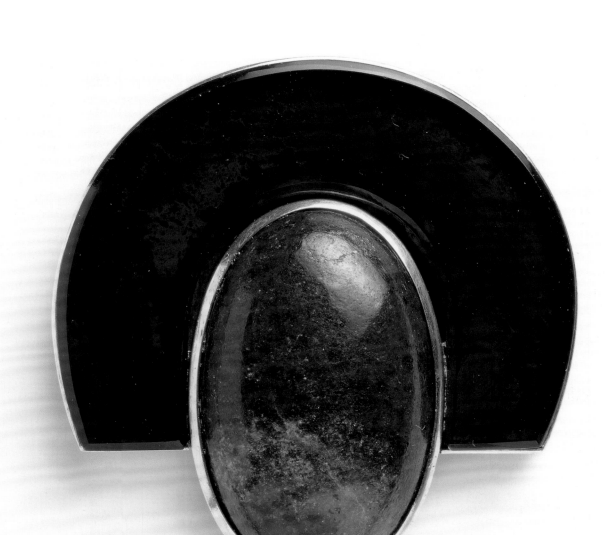

and bottom. The pictorial narrative includes visitors making their way toward New York, quite literally from across the Globe. The symbolism of the global world held in the hands of a greater, safer power reflects the worry that was surrounding the onset of war in Europe at the time. It was effectively a modern interpretation of the mythical giant Hercules upholding the heavens, as portrayed earlier in *Hercules Upholding the Heavens*, 1918 (*see* page 175), by sculptor Paul Manship (1885–1966).

LESLIE RAGAN
(1897–1972)

Cross-fertilzation of the Style

A feature of the Art Deco period is the range of goods being designed for both the elite and also for the mass market. Fashion designers were creating both for the *haute-couture* and ready-to-wear markets, the latter often being direct copies of the former. Art Deco styling was being applied to all areas of design too. In Britain during the 1930s, Art Deco cinemas were being built to accommodate large numbers of film lovers eager to see the latest Hollywood releases; American railway locomotives – for which, as we shall see, Leslie Ragan was to design advertising posters – adopted the 'streamline' effect associated with the Art Deco style; and in Europe generally, the 'style' was applied to many things from cigarette packets to telephones, tea services to radio sets and, of course, jewellery. Brooches in the latest style, for example, started life as expensive *haute-couture* accessories, but were readily copied by others. Raymond Templier (1891–1968), who came from a

War to take up residency, through forced abandonment of their home country. The concept of national identity can be seen as a contributing theme to Atherton's illustration. He depicts the globe of the world held by a symbolic figure of colossal, 'Statue of Liberty' proportions. Rising out from the North American continent, and bisecting the picture plane, are the identifiable emblems of the fair: the *Trylon* and *Perisphere*, symbols of Modernism and a new world. Noted for his strong draughtsmanship, Atherton used two typefaces in complementary colours, balancing the picture between top

Raymond Templier
Art Deco Brooch, 1934
© Estate of Raymond Templier/V&A Images,
Victoria and Albert Museum

MEDIUM: Lapis lazuli and blue glass

RELATED WORKS: Paul Brandt
(1883–1952), Various Brooches,
1920s–30s

Leslie Ragan
The New 20th-Century Limited,
Poster for the New York
Central System, 1946
© Estate of Leslie Ragan/Christie's Images Ltd

MEDIUM: Lithograph

RELATED WORKS: Leslie Ragan, Poster
for the *New York Central System*, 1951

family of Parisian jewellers, designed specifically for the elite. His bold geometric designs (*see* left), usually based on Egyptian or Oriental themes, used precious and semi-precious stones, often setting them against a platinum background to create a sharply contrasting piece of jewellery.

Railways and Locomotive Design

On such a vast continent, the railways of North America were an important part of its infrastructure before the advent of the aeroplane. Even in the first half of the twentieth century, the railways were the main affordable mode of cross-country travel. One of the largest companies was the New York Central Railroad, an amalgamation of a number of smaller railroad companies operating in the northeast corner of the United States and advertised by Leslie Ragan in his 1946 poster *The New 20th-Century Limited* (*see* right) – in which we can see echoes of Templier's bold circular and oval forms in the streamlined head of the locomotive. The railroad's main terminus was the Grand Central Station in New York, from where one could travel to Boston in the north, as far as St Louis and Chicago in the mid-west, and across the Canadian border to Toronto. These journeys were known as the Water Level Routes, snaking their way around the Great Lakes. Since the routes themselves were mainly on flat terrain, the locomotives were built for high speed. The depiction of speeding locomotives dates from the beginning of the twentieth century and the stylized paintings of Thomas Hart Benson (1889–1975). Leslie Ragan's poster designs build on those depictions, encapsulating the spirit of the railway company's enterprise, and are highly regarded as iconic Art Deco images.

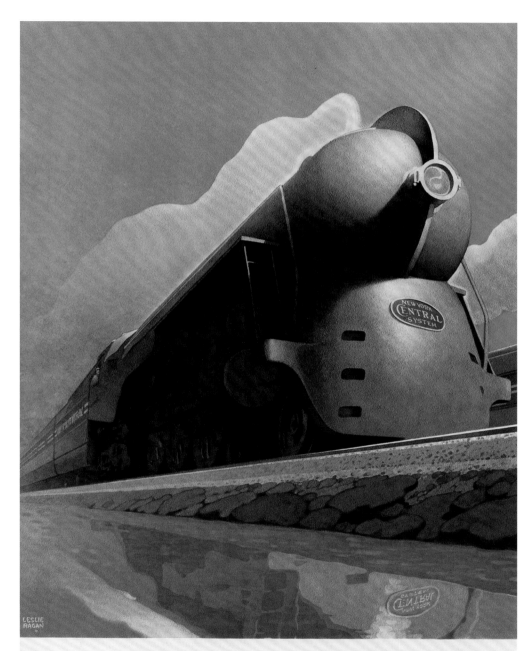

THE *New* 20TH CENTURY LIMITED
NEW YORK – *16 hours* – CHICAGO
NEW YORK CENTRAL SYSTEM

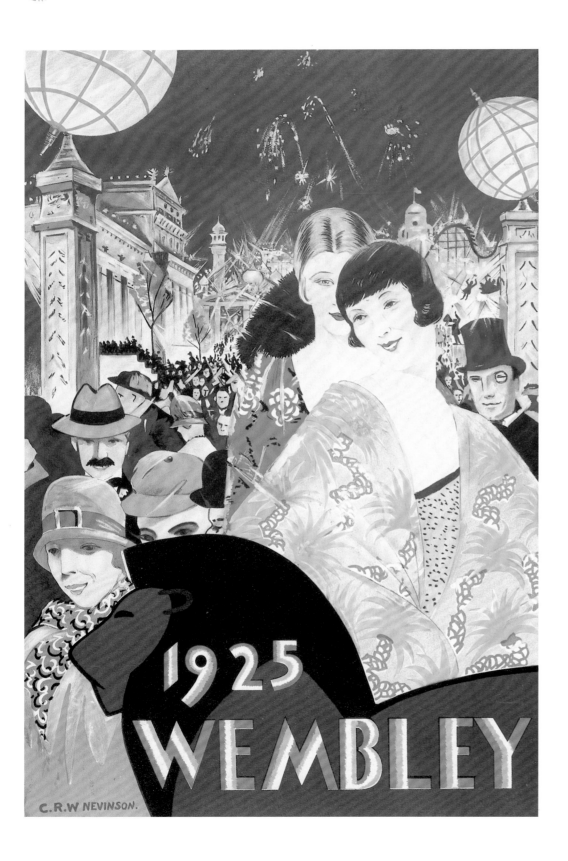

1925
WEMBLEY

C.R.W NEVINSON.

CHRISTOPHER RICHARD WYNNE NEVINSON

(1889–1946)

Britain Celebrates its Colonies

C.R.W. Nevinson was one of the first truly avant-garde British artists working at the beginning of the twentieth century. In 1914, alongside other artists of this ilk such as Wyndham Lewis (1882–1957), Jacob Epstein (1880–1959) and William Roberts (1895–1980), Nevinson submitted a painting called *The Arrival*, *c*. 1913, to the first exhibition of a newly formed avant-garde group known as the London Group. The painting, a Vorticist work, depicted a modern passenger liner steaming into harbour, its bow the most dominant feature. This proto-Art Deco design predates Cassandre's rendering of a similar subject by 20 years. Nevinson continued painting Vorticist works during the First World War, but after seeing active service himself seemed to lose the appetite for radical modernism. His subsequent design work returned to the *joie de vivre* of the 1920s, as the poster for the British Empire Exhibition of 1925 (*see* left) demonstrates. The exhibition was a colonial extravaganza held in Wembley, London, opening on St George's Day. The trend for these kinds of fairs was set in the last quarter of the nineteenth century and continued mainly in France and Britain until the Second World War. Nevinson successfully captures the optimistic mood of the time.

Christopher Richard Wynne Nevinson
1925 Wembley, **Poster for the British Empire Exhibition, 1925**

© Estate of Christopher Richard Wynne Nevinson/V&A Images, Victoria and Albert Museum

MEDIUM: Lithograph

RELATED WORKS: George Plank (1883–1965), Cover of *Vogue*, January 1927

H.G. Gawthorne
Weymouth, **Poster for Southern Railway, *c*. 1931**

© Estate of H.G. Gawthorne/V&A Images, Victoria and Albert Museum

MEDIUM: Lithograph

RELATED WORKS: H.G. Gawthorne, *Bridlington*, Poster for London and North Eastern Railway, *c*. 1930

HENRY GEORGE GAWTHORNE
(1879–1941)

The British On Holiday

Another depiction capturing the British public is *Weymouth*, *c.* 1931 (*see* right), a poster designed by Henry George Gawthorne to promote holidaying in Weymouth, Dorset, England, which captures the excitement of a beach holiday with sun, sea and sand. Gawthorne creates a pictorial narrative that evokes the atmosphere of the resort. In the foreground he places a young woman in a swimsuit that waves to an unseen friend; a couple ahead of her are making their way to the beach. Within the portrait Gawthorne uses light, soft colour to illustrate an idealized veranda, the beach, sea and ships beyond, while the caption uses bold lettering in white on black to highlight the resort name, with train and tourist information. Gawthorne began his professional career as an architect, later turning to pictorial art and graphics, publishing several books on poster design. In his posters, it is said that his trademark would be to insert his self-portrait into the scene, normally wearing a panama hat and glasses. The posters he created for the London and North Eastern Railway and Southern Railway capture the middle-class, Home Counties culture of England and the traditional, quintessential 'bucket and spade' British seaside holiday, whether in Weymouth or Mabblethorpe.

WALTER SCHNACKENBERG
(1880–1961)

Inspired by the Masters

The illustrative style of German draughtsman Walter Schnackenberg is on the cusp between Art Nouveau and Art Deco. It is clear from his illustrations that he was informed

Anne Egmans

Schnackenberg

Walter Schnackenberg
Poster for *Anne Ehmans*, 1921

Courtesy of Private Collection, The Stapleton
Collection/The Bridgeman Art Library/© DACS

MEDIUM: Lithograph

RELATED WORKS: Henri de
Toulouse-Lautrec (1864–1901), Poster
for *La Goulue at the Moulin Rouge*, 1891

Walter Schnackenberg
Poster for the *Cabaret*
***Bonbonnière*, 1920**

Courtesy of Private Collection, The Stapleton
Collection/The Bridgeman Art Library/© DACS

MEDIUM: Lithograph

RELATED WORKS: Walter
Schnackenberg, Poster for *Anne Ehmans*, 1921

by the technique and two-dimensional picture planes of the
commercial artists of Paris who frequented the Moulin Rouge in
Montmartre at the turn of the century. Born in Bad Lauterburg,
in Lower Saxony, Germany, Schnackenberg moved to Munich at
the age of 19 to attend art school. His early graphic-art illustrations
for theatre posters and advertisements are reminiscent of the style
of the French illustrators Jules Chéret and Henri de Toulouse-
Lautrec. In fact, inspired by Toulouse-Lautrec, he went to Paris,
the hub of the printmaking industry, to work as an illustrator and
as a printmaker. Many of his commissions were posters for the
popular variety theatre shows. His *Anne Ehmans* poster, 1921 (*see*
left), shows Schnackenberg's creative use of colour and typography
in the style of the Japanese woodcut. Each area of the picture is
overlaid to accentuate the two-dimensional picture plane; the flat
colour omits shadows, contrasts and modelling. The hand-drawn
lettering accentuates the temporary nature of the event.

HERBERT MATTER
(1907–84)

Photomontage in Poster Design

Herbert Matter, a Swiss designer and photographer, had a talent
for transforming Fine Art concepts into graphic design. Trained
at the École des Beaux-Arts in Geneva in 1925, his move to Paris
in 1928 found him tutored by Amédée Ozenfant and Ferdinand

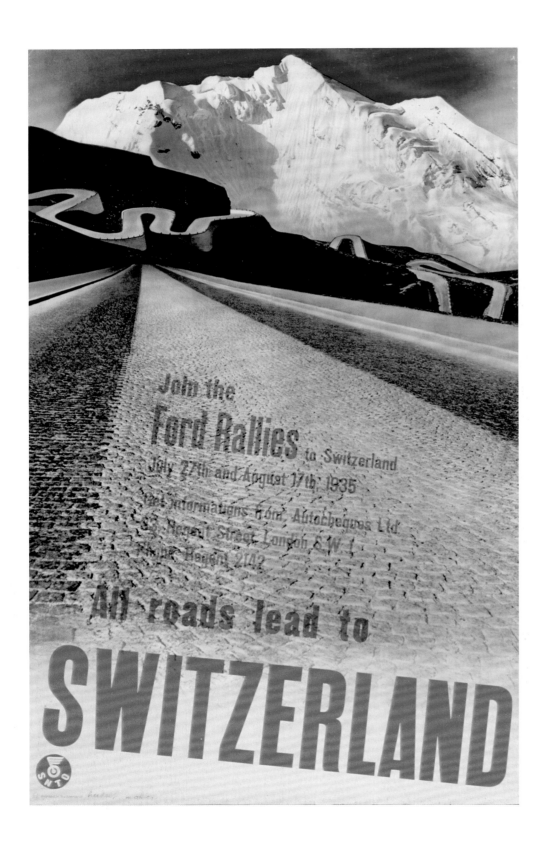

Léger at the Academie Moderne, where his exposure to Purism would influence his graphic style. An interest in collage and montage, particularly the work of Man Ray (1890–1976) and El Lissitzky (1890–1941), also informed his work. In 1929 his job at the Paris type foundry Deberny et Peignot, assisting Cassandre and Le Corbusier, combined his interest in abstract art, graphic design and poster design. He returned to Switzerland in 1932 and his posters designed in 1935 and 1936 for the Swiss National Tourist Office were a combination of photomontage, graphic art and illustration. *All Roads Lead to Switzerland*, 1935 (*see* left), a poster advertising the Ford Rallies, was part of a series for the tourist board. Matter used his own photographs with hand-drawn text in English plus versions in German, Italian and French – it was a pioneering moment in poster design. In 1936 Matter moved to the US and continued to excel in photography and poster design.

ANDREW JOHNSON (FL. 1930S)

The Orient Steam Navigation Company

This British shipping company can trace its roots back to the end of the eighteenth century when it was operating a small fleet of sailing ships. During the nineteenth century there were a number of changes of ownership until the last owners, Anderson Green and Co., began to greatly enlarge the fleet after 1878 and

Herbert Matter
All Roads Lead to Switzerland,
Poster for the 1935 Ford Rallies
© Estate of Herbert Matter/Private Collection/
The Bridgeman Art Library

MEDIUM: Photomontage

RELATED WORKS: Herbert Matter,
Posters for the *Swiss National Tourist
Office*, 1935–36

Andrew Johnson
The South Coast is the Sunny Coast,
Poster for Southern Railway, 1933
© V&A Images, Victoria and Albert Museum

MEDIUM: Lithograph

RELATED WORKS: H.G. Gawthorne,
Brighton, Poster for Southern
Railway, 1920–25

the company became The Orient Steam Navigation Co. By the twentieth century they had begun a close association with the Peninsular and Oriental Steam Navigation Co. (later P & O) and together they shared the lucrative England to Australia route. The Orient Steam Navigation Co., trading under the name Orient Line, built four ships for this purpose, which began sailing in 1909/10. After the war, the Orient Line continued to expand and in 1935 her most famous ship, RMS *Orion*, made her maiden voyage. A remarkable ship for her time, she was built to provide more comfortable conditions for the tropical journey to Australia – there was more of an emphasis on light and air, with more open and spacious decks and uncluttered cabin accommodation. Andrew Johnson captures the spirit of this with his posters from the period, notably *Orient Cruises, c. 1930s (see* pages 184–85). While presenting the leisurely pace of life aboard deck, where passengers have space to play games and take a stroll, he also emphasizes the majesty of the ship through the towering ventilation shafts and chimney – the way he elevates the ordinary into the grand can be compared to much art of the period, to objects as diverse as Lalique's *Le Jour et La Nuit, c.* 1925 (*see* page 185), where the drudgery of time takes on a more monumental, symbolic aspect.

Health, Fitness and Leisure in the 1930s

One of the features of the 1930s was the pan-European move towards a healthier lifestyle. In England for example, a number of health centres were created – most notably the Finsbury Health Centre, in the traditionally deprived London borough of Finsbury and designed by the Russian émigré Berthold Lubetkin (1901–90) in 1938. Its ethos was to educate local residents on nutrition and hygiene through a drop-in health centre, but also to provide leisure facilities such as a swimming pool and exercise area. One of the most ambitious projects for leisure was the De la Warr Pavilion built in 1935 at Bexhill on Sea in Sussex, designed by the modernist architects Serge Chermayeff (1900–96) and Erich Mendelsohn (1887–1953), in an Art Deco *moderne* style. Since 1929, when King George V spent a holiday at Bognor in

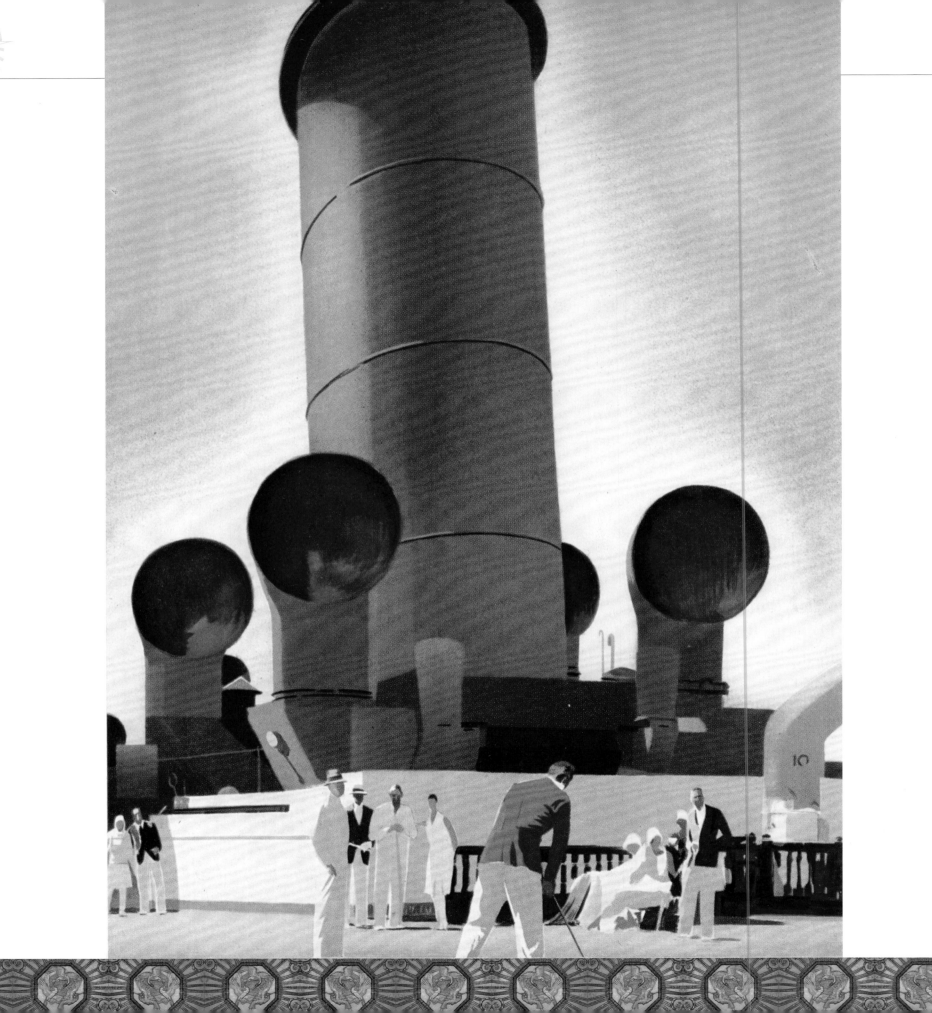

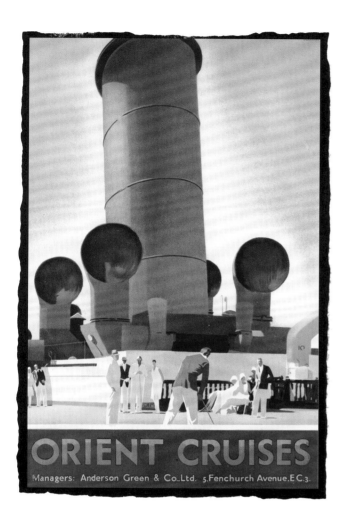

Sussex and caused the town to become known as Bognor Regis, the south coast of England had been a Mecca for the sun-seeking and fashion-conscious middle classes. Johnson captures the optimism and vitality of this health-conscious population for whom the whole of the south coast had become an alternative Riviera in his poster for Southern Railway, *The South Coast is the Sunny Coast*, 1933 (*see* page 183).

Andrew Johnson

Poster for *Orient Cruises*, *c.* 1930s

© Private Collection, The Stapleton Collection/
The Bridgeman Art Library

MEDIUM: Lithograph

RELATED WORKS: Walter Jardine
(1884–1970), Poster for *Orient Line
Tropic Cruises*, 1930s

René Lalique

Le Jour et La Nuit
(Day and Night), *c.* 1925

Courtesy of Christie's Images Ltd/© ADAGP,
Paris and DACS, London

MEDIUM: Glass and silver gilt

RELATED WORKS: Raymond Subes
(1891–1970), Mantle Clock, 1920s

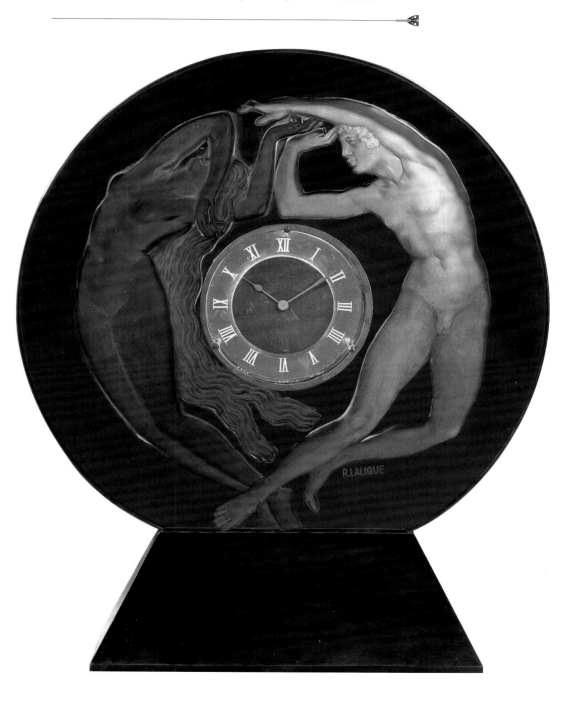

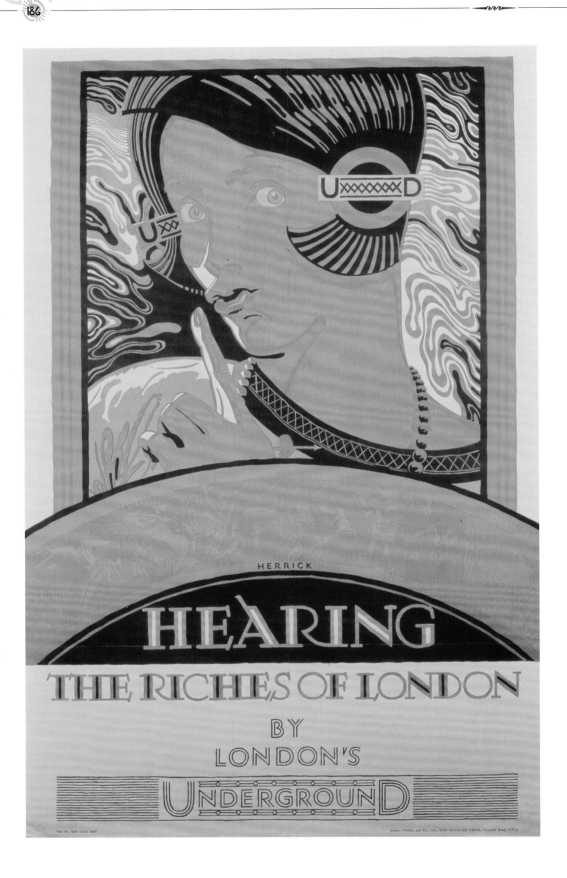

HERRICK

HEARING

THE RICHES OF LONDON

BY

LONDON'S

UNDERGROUND

FREDERICK CHARLES HERRICK
(1887–1970)

On an Ocean Wave

The English graphic artist Frederick Charles Herrick is
particularly recognized for his poster designs for London
Transport from 1920 to 1933; his work is distinctive for its
sharp, linear forms. He trained at Leicester College of Arts
and Crafts, and the Royal College of Art in London. The desire
for travel either at speed in a shiny Bugatti sports car, or more
leisurely on a Cunard transatlantic ocean liner, or by London
Transport to and fro across the metropolis, led to increasingly
numerous opportunities for graphic artists to explore innovative
techniques to capture attention. Herbert Matter had achieved
prominence using photomontage, photography and hand-drawn
lettering to excite interest in Swiss tourism. The advertising
of travel abroad, through illustration, graphics and typography,
explored the nature of going overseas. Herrick's poster,
R.M.S.P. South American Service (*see* right), promoting the
Royal Mail Steam Packet Company, portrays time, distance
and dependability. He uses a traditional naval colour scheme
of deep blue, grey and white to depict an Atlantic crossing on
crisp ocean waves. The steamer in the far distance leaves an
undulating wake as it sharply cuts through near-abstract waves
– classic hard-edged Art Deco styling, representing the optimism
and adventurism of the era.

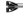

Frederick Charles Herrick
Hearing the Riches of London, Poster
for London Transport, date unknown

© Estate of Frederick Charles Herrick/Private
Collection/The Bridgeman Art Library

MEDIUM: Lithograph

RELATED WORKS: Edward McKnight
Kauffer, *The Quiet Hours*, Poster for the
London Underground, 1930

Frederick Charles Herrick
Poster for *R.M.S.P. South American
Service*, date unknown

© Estate of Frederick Charles Herrick/
Private Collection, The Stapleton Collection/
The Bridgeman Art Library

MEDIUM: Lithograph

RELATED WORKS: Unknown artist,
Poster for the *South American Royal
Mail Line*, c. 1914–26

R · M · S · P

SOUTH AMERICAN
SERVICE

THE ROYAL MAIL STEAM PACKET CO

FURTHER READING

Arwas, V., *Art Deco*, Abradale Press,
New York, 1992 & 2000

Aynsley, J., *Pioneers of Modern Graphic Design:
A Complete History*, Octopus Publishing Group,
London, 2001 (first published in hardback as
A Century of Graphic Design, Mitchell Beazley, 2001)

Bailey, D., *Shots of Style*, V&A Publications,
London, 1985

Battersby, M., *Art Deco Fashion: French Designers
1908–1925*, Academy Editions, St Martin's
Press, 1974

Bayer, P., *Art Deco Sourcebook*, Phaidon,
London, 1988

Bédoyère, C. de la, *The World's Greatest Art:
Art Deco*, Flame Tree Publishing, London, 2005

Benton, C. et al. (Eds) *Art Deco 1910–1939*
V&A Publications, London 2003
(exhibition catalogue)

Blondel, A. and Brugger, I., *Tamara de Lempicka
– Art Deco Icon*, Royal Academy Publications,
London, 2004

Bouillon, J.P., *Art Deco, 1903–1940*, Rizzoli,
New York, 1989

Bowman, S., *A Fashion for Extravagance:
Art Deco Fabrics and Fashions*, Bell & Hyman,
London, 1985

Dufrene, M., *Authentic Art Deco Interiors from
the 1925 Paris Exhibition*, Antique Collectors
Club, 1989 & 2002

Duncan, A., *Art Deco*, Thames & Hudson
(*World of Art* series), London, 1988

Duncan, A., *The Encyclopedia of Art Deco*,
Grange Books, Rochester, Kent, 2000

Ercoli, G., *Pochoir Art Deco*, Rizzoli,
New York, 1989

Heller, S. and Fili, L., *Euro Deco: Graphic
Design between the Wars*, Chronicle Books,
San Francisco, 2004

Hillier, B., *Art Deco of the 20s and 30s*,
Studio Vista, London, 1968 & 1973

Hillier, B., *The World of Art Deco*, Minneapolis
Institute of Art, Minneapolis and London,
1971 (translated from the Dutch edition
by Roz Vatter-Buck; exhibition catalogue)

Hillier, B. and Escritt, S., *Art Deco Style*,
Phaidon, London, 1997

Jong, C.W. de, *Sans Serif*, Thames & Hudson,
London, 2006

Kery, P.F., *Art Deco Graphics*, Thames & Hudson,
London, 1986

Kery, P.F., *Great Magazine Covers of the World*,
Abbeville Press, London, 1982

Klein, D. et al., *In the Deco Style*, Thames
& Hudson, London, 1991 (1987)

Lemme, A. van der, *A Guide to Art Deco Style*,
Guild Publishing, London, 1987

Lepape, G. et al., *French Fashion Plates in Full
Color from the Gazette du Bon Ton (1912–25)*,
Dover Publications, New York, 1979

Lesieutre, A., *The Spirit and Splendour of
Art Deco*, Paddington Press Ltd, New York
and London, 1974

Lussier, S., *Art Deco Fashion*, Bulfinch Press,
Boston, New York and V&A Publications,
London, 2003

Marly, D. de, *The History of Haute Couture
1850–1950*, B.T. Batsford, London, 1980

McKean, J. and Baxter, C., *Charles Rennie
Mackintosh: Architect, Artist, Icon*, Lomond
Books, Edinburgh, Scotland, 2000

Morgan, S.M., *Art Deco: The European Style*,
Dorset Press, 1990

Mulvagh, J., *Vogue History of Twentieth Century
Fashion*, Viking Press, London 1988

Neret, G., *Tamara de Lempicka: 1898–1980*,
Taschen, Köln, Germany, 1992

Ormiston, R. *Alphonse Mucha: Masterworks*,
Flame Tree Publishing, London, 2007

Parry, L. (Ed.), *William Morris*, Philip
Wilson Publishers, London, 1996
(exhibition catalogue)

Rewald, J. (Ed.), *Paul Cézanne Letters*,
Da Capo Press, 1995

Sternau, S.A., *Art Deco: Flights of Artistic Fancy*,
Todtri, New York, 1997

Whitford, F., *Bauhaus*, Thames & Hudson,
London, 1984

ACKNOWLEDGEMENTS

Michael Robinson (Author)

Michael Robinson is a freelance lecturer and writer on British art and design history. Originally an art dealer with his own provincial gallery in Sussex, he gained a first-class honours degree at Kingston University, Surrey. He is currently working on his doctorate, a study of early Modernist-period British dealers. He continues to lecture on British and French art of the Modern period.

Rosalind Ormiston (Author)

Rosalind Ormiston is a lecturer at Kingston University, Surrey, where she teaches History of Art, Design and Architecture. Her specialist subjects include Classical Civilization, Renaissance Italy and Contemporary Architecture. She has lived in New York and Piedmont, Italy, and now divides her time between London, Cumbria and Italy. She writes features for both academic journals and consumer publications. She is currently researching Cumbrian architectural practice in the mid–late nineteenth century.

INDEX

Page references in *italics* refer to
illustrations. Page references in **bold**
refer to main entries but take no account
of intervening illustrations.

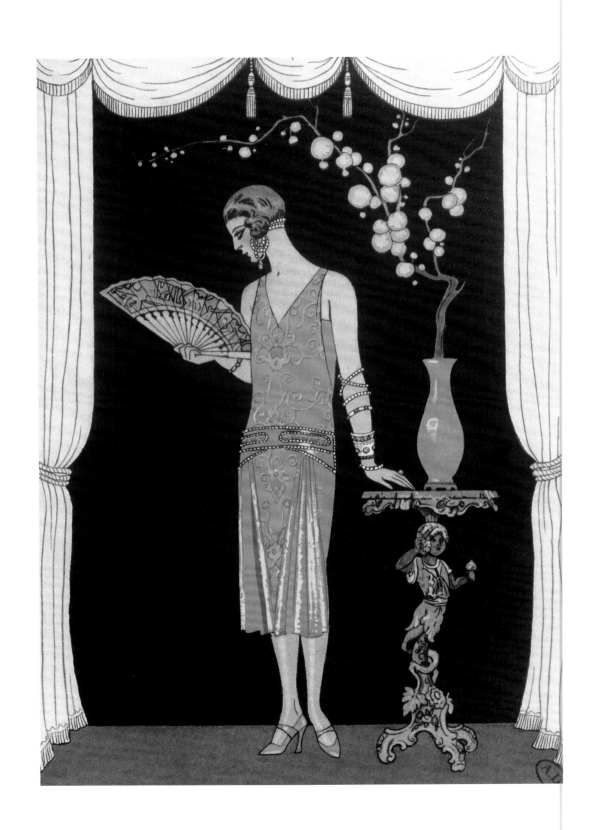